# Albert Irvin
## life to painting

'It's not a matter of painting life. It's a matter of giving life to painting.'
Pierre Bonnard

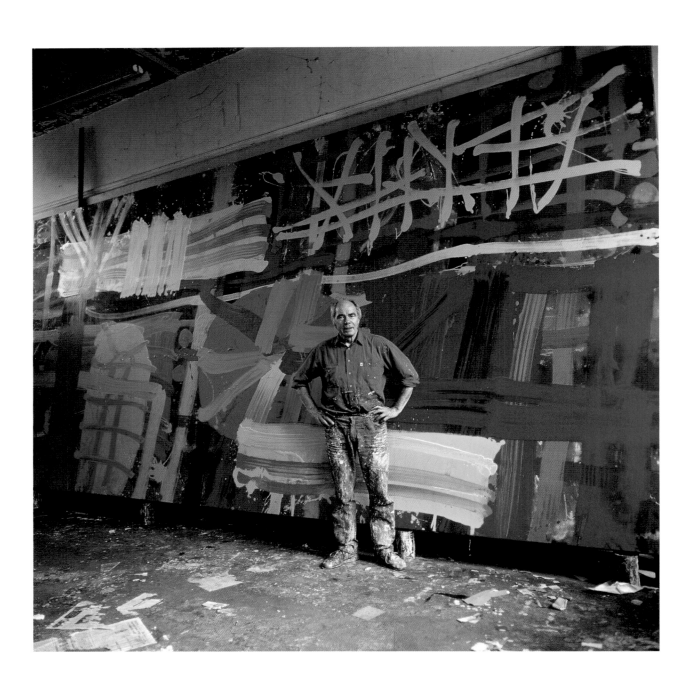

# Albert Irvin

## life to painting

**Paul Moorhouse**

**Lund Humphries Publishers, London**

## Acknowledgements

My warm thanks go to Bert and Betty Irvin whose enthusiastic involvement throughout this project has been indispensable. Many others have also made vital contributions and, in particular, I would like to thank Martin Krajewski, René Gimpel, Jackie Haliday, Kate Stephens, Lucy Myers and Anjali Raval. My special thanks go to Rosemary Harris.

Paul Moorhouse, London 1998

This book has been generously supported by Martin Krajewski

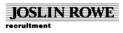

# Contents

**Thurloe**
1997
acrylic on canvas
213 x 305 cm
(84 x 120 in)

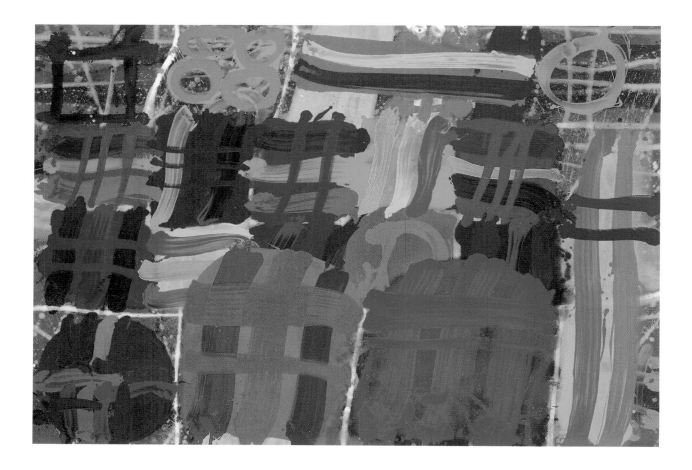

## 1. A structure for feeling

*'... any kind of painting, any style of painting – to be painting at all, in fact – is a way of living today, a style of living, so to speak. That is where the form of it lies.'* Willem de Kooning, 1951[1]

De Kooning's observation draws together painting and life and, on the face of it, the alliance seems an unlikely one. What could be more different than painting and life? It could be claimed that painting is a solitary activity, carried on behind the closed door of the studio: while outside we find the real world – the swim of events – unpredictable, endlessly changing, dangerous, joyous and irresistible. Yet De Kooning's words are grounded in truth. And although uttered almost fifty years ago, the attitude they express encapsulates the spirit of Albert Irvin's art – today, and since its beginnings.

Consider *Thurloe* (1997), one of Irvin's most recent paintings. Even to those familiar with his work, seeing a new painting can be an extraordinary experience – akin to discovering a young, emerging artist in the first flush of ambition. Given the force of its restless and exuberant energy, its freshness, and the sense it communicates of an artist in love with his chosen activity, it is even more surprising to realise that this is a work painted in Irvin's seventy-sixth year and half a century after his career began. *Thurloe* is a riot of energy. At first glance, the impression is intense and confusing. Like entering a crowded restaurant, one immediately senses the atmosphere – lively, celebratory and inviting – but where do you sit? Amidst the rush of colour and the jostling shapes, the eye seeks a resting place. And at that moment, we are drawn in.

Within the canvas rectangle, line, shape, interval and colour vie for attention. Although initially these appear chaotic, longer inspection gradually reveals an underlying order and a host of visual characters which assert their different personalities. At the bottom of the painting, and seemingly closest to the viewer, two abutting forms dominate. Formally, they are related. Both are large and flat, with rounded tops and a configuration of hatched lines in front. But in terms of colour, we find a vivid contrast. The vibrant pink and orange of one grabs attention and dominates for a while. The cooler green and blue of the other is quieter, a little passive, and enters the visual argument more slowly.

From the main players the attention is diverted by a supporting cast, crowding around and behind. These interlaced brushmarks are also set against a single zone of colour. Their smaller scale creates the illusion of depth. Although we read them as flat gestures of paint sitting on the picture surface, we also sense that they are slightly further away, deeper in the pictorial space. Near the edges of the picture area, the formal vocabulary expands into variety and complexity.

At bottom left, we find a circular shape, mainly red, containing a cluster of marks. Something of an onlooker, this shape is in the thick of the action but also slightly removed from it, being enclosed by a white circumscribing line. On the opposite side, two sinuous vertical brushstrokes hug each other, following each other's course within a haze of green. Along the upper edge a frieze of different forms, like a chorus line, provides a counterpoint to the main themes rehearsed below them. A number of these shapes – the square, quatrefoil and circle – are transparent, being adumbrated in line only. Through them we glimpse the ground of the painting. This orange field, criss-crossed by lines of white, sets the emotional key. It is at once a surface for activity, a stage for the visual drama, and a space for form and colour to inhabit.

Formal considerations are undoubtedly important for Irvin. It is hard, for example, not to be aware of the emphasis on construction in his approach to composition, an approach grounded in syntax and the relation of pictorial elements. There is a sense that the direct, affective power of abstract shapes and colours is orchestrated. The energy in his work is never simply threshing around, random or unbridled. Instead, the paintings communicate a sense of vitality precisely because that motive force is harnessed and articulated. Considered structure is a distinguishing characteristic of his art in general.

As *Thurloe* suggests, however, it would be false to suppose that Irvin's paintings are simply sophisticated essays in abstraction, devoid of meaning or subject. In common with all his work, *Thurloe* has a resonance which is both emotive and allusive. The use of colour, the defined character of each mark and shape, the way these elements relate to one another and to the picture space, and the application of paint – all have a significance which transcends formal considerations. Central to Irvin's art is its capacity to express complex subjective experiences, and in so doing to engage with questions of universal relevance arising from a shared human condition.

Early on, Irvin felt that he could not engage with this kind of subject-matter by employing figurative means or by reproducing the appearance of things in a literal way. As he has observed, the experience of being in one's own body cannot be represented adequately by creating illustrations of 'ears and elbows'. Similarly, a sense of passage through the world, geographically and in terms of one's inner reactions to it, could not be conveyed by conventional depiction. To limit his work in this way would, he believes, be to confine it to the external characteristics of things. As such, the story of the development of his art has been one of continual evolution: from figuration to abstraction in the 1950s, and thereafter through the growth of a distinctive visual language rooted in metaphor. The essence of that language is its capacity to link abstract shapes and colours with a range of experiences. These pictorial elements work associatively and evocatively – by engaging the viewer's imagination. He also exploits the capacity of these things to affect our emotions directly – like music.

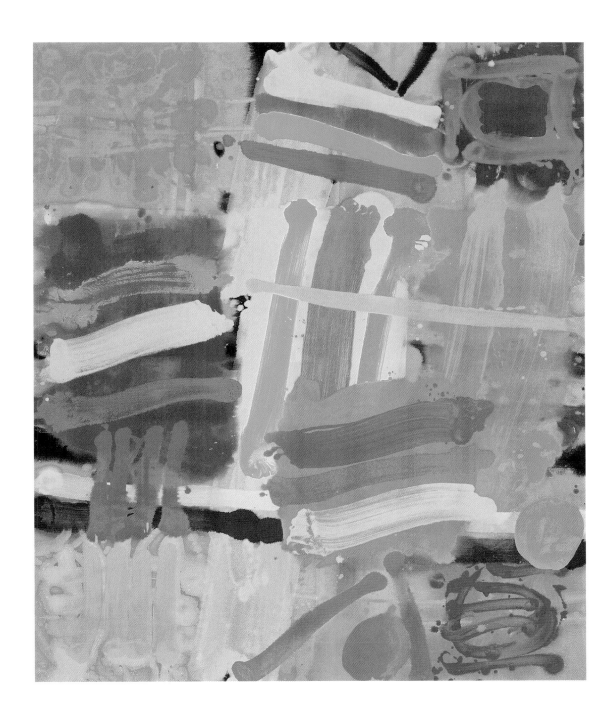

**Tabard**
1992
acrylic on canvas
183 x 153 cm
(72 x 60 in)
John Ranelagh, on
extended loan to
Churchill College,
Cambridge

Irvin's subject, he has explained, is 'the experience of being in the world'.[2] This may be understood in a number of ways. In a primary sense it refers to the situation of being physically present in the arena of our environment, occupying space and moving through it. From the outset his work has used the area of the canvas, and the disposition of forms within it, as the means of exploring the complex relationship we have with our surroundings. In Irvin's mature paintings, the picture area is identified with real space. He has commented: 'The "given" of the rectangular canvas, its vertical sides and horizontal top and bottom, are for me a metaphor for the "given" of the world: walls, floors, ceilings, streets, buildings …' As such, the passage of a brush through this pictorial space, and the trajectory recorded in the marks it leaves, stand for an actual journey.

At every moment our existence is informed by a sense, conscious or otherwise, of connectedness between ourselves and our environment. We orient ourselves through our feelings of proximity, distance, height and direction; through an awareness of being in, outside, above or below; and, crucially, through knowing our bodies in relation to those of others. Deprived of this sensibility we would be lost, physically and emotionally. Irvin's art draws on this universal condition, but not for its own sake. As an artist, he wants not simply to explain, but to return us to the world with a keener sense of its mysteries and marvels. As such, the means he has employed weave a visual poetry: representing and evoking experiences in order to heighten our awareness of them and lead us to a surer appreciation.

In a closely related way, Irvin's subject embraces the *inner* experience of being alive. We find our way, and possess a sense of ourselves, through our emotions: joy and sadness, elation and pain, changes of heart, passion, aversion and, beyond these, the infinity of subtle inflexions in mood which resist identification. Our journeys act continuously upon us, and our inner responses – our subjective lives – are attuned to their currents. In this sense, Irvin's concerns have extended to a reflection on what it is to occupy a body, having experiences which are at once unique to ourselves and yet part of a wider human context. His work identifies abstract forms and colours with 'the drama of life' and his responses to that drama. The relations of coloured lines and shapes – touching, entwining, passing over, through and behind one another – generate a pictorial argument whose dynamics evoke the play of life and the artist's emotional involvement in that spectacle. 'The painted area, the active area, is the human content, an analogue for my being in the world, for moving through the world, for living and loving.'

A further level of meaning resides in Irvin's method. Although they are carefully considered in terms of the individual decisions taken in their creation, the paintings nevertheless evolve by a process of improvisation. In this connection, an analogy employed by the composer Webern in describing his approach to musical composition is illuminating. Webern observed: 'I go out

into the hall to knock in a nail. On my way there I decide I'd rather go out. I act on the impulse, get into a tram, come to a railway station, go on travelling and finally end up – in America!'[3] In teaching sessions Irvin has often referred to this model because of its closeness to his own practice. His paintings begin without premeditation; one idea leads to another; changes of mind often alter radically the way the work is proceeding; unforeseen developments emerge and these are taken up until the work reaches its surprising conclusion. The painting is a record of the steps taken during its making. As such, its subject is the artist's activity: revealed in the marks and shapes which denote his decisions and movements within the canvas space.

Improvisation underlines the spirit of adventure central to the way the paintings are made. As in life, each work proceeds as a journey into the unknown: a passage coloured by risk, intuition, failure, success, luck, experience and – it is hoped – final resolution. In this way, each painting suggests in microcosm some of the essential elements operating in a wider, existential arena. The journey into the making of a work is identified with the Romantic idea of a life as a voyage of discovery. Irvin's art resides in this essential connection between painting and life. His paintings are not autobiographical in the sense of referring to specific events; yet, at a deeper level they are informed by his perceptions and feelings. Insofar as the decisions taken while painting are a reflection of the artist's inner being – that complex of past and present experience – they are a vital personal testament. As William Baziotes remarked about his own paintings: 'They are my mirrors.'[4] The story of Irvin's art is thus about paint, canvas and imagination – and the capacity of these things to come together to penetrate and celebrate some fundamental aspects of existence. But it is also about the man.

## 2. Starting out

To travel to his studio, Irvin must cross the face of London. The first part of his journey involves a fifteen-minute walk from his home near Wandsworth Common, along Northcote Road with its busy shops and restaurants, to the jostle of commuters at Clapham Junction. He then proceeds by Overground to Victoria and changes there onto the Underground. Continuing to Stepney Green in the East End, a further short walk from the station takes him to his destination. He usually arrives about an hour after setting out. This has been his routine for almost thirty years.

Irvin is a Londoner and his life and work are coloured by a vivid sense of urban experience. By day the heart of the capital is a barrage of noise, bustle and endless change. People come and go, weaving through the traffic, darting in and out of doorways; faces glimpsed once disappear forever – down a side-street, or simply swallowed up within a confusion of colour. During the

Irvin's parents:
Albert Henry Jesse Irvin
and Nina Lucy Jackson
on their wedding day
1921

Irvin (aged 9) with
his brother Lawrence
(aged 4), 1931

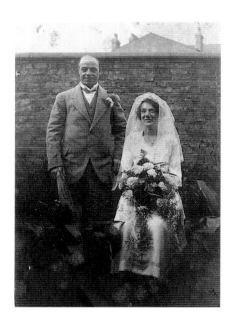

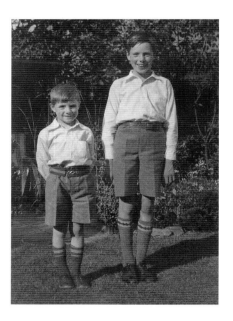

evening the pace slackens. Along by the river, everything is saturated with blue. Distant lights cast an orange glow against the sky. The traffic is an insistent murmur. And some way off the Festival Hall spills out its concert-goers in a sudden splash of convivial yellow. Irvin's art is not 'of' any of these things. His is not an art of illustration. But, at a deeper level, his work is informed by all of these perceptions and, essentially, is 'about' the urban world he has always known and to which he is closest.

Albert Irvin was born on 21 August 1922. His parents owned a grocer's shop in Stork's Road, Bermondsey and the family lived above the business until he was five years old. Following the birth of his brother, Lawrence, they moved to Plimsoll Road in Finsbury Park, north London in 1927, taking a downstairs flat in a small terraced house. This was the scene of one of his earliest childhood memories: on New Year's Eve 1929, wondering what the new decade would be like and what changes it would bring. At that point, any suggestion of developing artistic interests must have seen remote, for there were few obvious influences to nurture an incipient talent.

Both Irvin's parents came from London. His father, also named Albert like his father before him, had spent some time in the Royal Navy. After his grocery business failed, he became un-employed and subsequently supported the family through a succession of different jobs. Eventually he took a position as a night-watchman at the Ministry of Education building on Horseferry Road, near Westminster. Irvin remembers his father as a strong character. After the move to Finsbury Park, for example, he used to walk every day to Westminster and back. At twelve miles in all, this was neither a short nor a particularly easy journey. He was also a rather silent man – practical but given to few words. Irvin's mother, Nina (née Jackson) was altogether a different character. A Methodist Sunday School teacher, she spoke well, liked poetry, and had firm convictions which she articulated clearly. They met after Irvin's father left the navy and married in 1921. Neither, however, had any particular interest in the visual arts.

Irvin's early enthusiasms were of a different kind. The family home in Finsbury Park was close to Arsenal football ground and he began to support the team from about the age of ten. At this time Arsenal were in the ascendancy and commanded a large following. Everton, led by the legendary Dixie Dean, were rivals and one of Irvin's most vivid recollections is of being present to witness Dean breaking the scoring record. The atmosphere generated by capacity crowds of 70,000 provided a thrilling backdrop to such spectacles. It is difficult to over-estimate the impression made upon a ten-year-old by the drama and colour of the scene: the clash and penetration of the opposing teams, the movement of coloured shirts around the pitch, and the surge of the crowd as the trajectory of a ball takes it through space and into the back of the net.

These heady experiences were counterbalanced by others of a more spiritual nature – or at least that was the intention. Prompted by his mother, the young Irvin attended Sunday School Bible classes. He was also a regular at Islington Central Hall on Saturdays, at what was popularly known as the 'twopenny rush'. These were film shows for local children given by the Methodist minister, the Reverend Donald O. Soper, whose fierce temperament combined religious passion with socialist fervour. When not preaching the Lord's word, he could be heard espousing the cause of the workers at Tower Hill. In the Reverend's own unique way, these convictions became entwined. He would show the children the popular films of the day – Charlie Chaplin, Hopalong Cassidy, the Keystone Cops and the rest – but only after they had sung their hymns. No doubt this running order lent a singular urgency to their rendition of 'O Jesus I have promised to serve thee till end'.

In a complementary way, Soper's political convictions were refracted through biblical themes. In his speeches and sermons, socialist thought derived confirmation from its connection with the Sermon on the Mount. 'Blessed are the meek' and 'Blessed are the poor' received sanction as the ethos of the working classes. In later life Irvin never practised any particular religion. But, through these early experiences, a mark had been made. The Bible would provide certain principles 'for life and living'. And, on a lighter note, Irvin detected in Soper's brand of socialist Methodism 'a colouring agent – an early indication that my favourite colour was red!'

The family was never well off and things became harder after the shop folded. Nevertheless, this was a happy period. In 1933, Irvin won a scholarship to Holloway County Grammar School and in the following year they moved again, taking a flat in Isledon Road, Holloway. Irvin's most lasting impressions often seem connected with the patterns assumed by particular journeys, as if travelling leaves an inner trace. For the next five years, his daily route took him down Tollington Road, across the major arterial junction of Holloway Road and Caledonian Road; along Camden Road; encountering, at its connection with Parkhurst Road, one of the main local landmarks: Holloway Prison. Even today, this vast container for human life marks a stark contrast with the free movement of activity around it. Walking around the prison, along Dalmeny Avenue, he came to his destination, whose proximity to the house of the notorious murderer, Dr Crippen, would have excited the imaginations of many generations of pupils.

It was during Irvin's time at the school that the first evidence of his artistic ability became apparent. Here he encountered two teachers who were to exercise a significant influence. Mr Dixon, the English master, was a veteran of the First World War and had lost a leg in action. He introduced his pupils to literature and poetry and also took them to drama productions at the Old Vic. These were formative experiences which nurtured Irvin's interest in language and

literature, an enthusiasm which he has maintained ever since.

Around the same time Irvin also discovered a liking for drawing and an ability to make copies from photographs. His family praised this talent and he began to pursue it with increasing keenness, drawing constantly. His first efforts were directed towards commercial art and he was encouraged to make designs for posters. However, it was the art master, Mr Thompson, who deepened this growing visual awareness. Watching Thompson draw fired his sense of what was possible, revealing 'a dimension of drawing that I hadn't anticipated at all'. With this revelation came recognition 'that there were other values'. Student teachers from the Royal College of Art, with their talk of artists and galleries, stirred even keener interest. The seeds of ambition were sown. He now wanted to learn about and acquire those values and from this point he began frequenting the National Gallery. Millais's *Ophelia* made an impact. Later enthusiasms went deeper – and stayed. Rembrandt and Turner both made an enormous impression: to this day they are among Irvin's most revered artistic models. Most importantly, these experiences created the first glimmer of a wish to go to art school.

Predictably his parents foresaw little future security in an artistic career. But Irvin's course was set. He was in the sixth form and was impatient to explore the potential which he now sensed. However, the deepening crisis in Europe meant that there were other preoccupations. The distribution of gas-masks and building of air-raid shelters were a clear sign that London was preparing for the worst. Before an impasse with his parents was reached, it was swept aside by events which quickly followed the declaration of war on 3 September 1939.

## 3. Northampton

Just turned seventeen, Irvin now found himself, accompanied by his brother, on a train from Euston bound for Rugby. Together with other evacuees from his school, he was to be billeted with families in the local area while continuing his education at Towcester Grammar School. It was the first time he had lived away from home and the prospect must have given rise to some apprehension. He left behind a London bracing itself for war. What he found seemed a world away.

In complete contrast to the lifestyle he had previously known, the next few months were spent living and working on a farm. Together with a few fellow pupils, he was placed in the charge of a young farmer and his wife. This was a blissful time. He quickly discovered the art room at Towcester and, still guided by Thompson, continued to make progress. The change of scene provided a new stimulus and he did a lot of drawing, turning to studies from life. He also enjoyed the opportunities provided by his new surroundings. During the harvest they worked

Students at Northampton
School of Art, 1941
Betty Nicolson (seated)
with Joyce Baker, Irvin
and Reggie Langford
immediately behind her

Students at Northampton
School of Art, 1941
Reggie Langford and Irvin
(second and third from left)

**Reverend Walter Hussey,**
begun 1965
Portrait by Graham Sutherland
oil on canvas
32 x 26 cm (12.5 x 10.2 in)
Pallant House Gallery Trust,
West Sussex

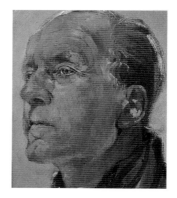

**Northampton**

on the land and the outdoor life gave a sense of greater freedom. Unfortunately, the boys' growing independence contained the seeds of their downfall. Their stay at the farm reached an abrupt end when the farmer discovered one of their number in bed with his wife.

In the meantime, Irvin had been advancing his ambitions to study art. He applied for, and received, a senior county award and was advised to seek a place at the local art school in Northampton. Although he had entertained ambitions to go to one of the prestigious London schools, it was explained that their students were to be evacuated from London and would anyway be based in Northampton. It appeared, therefore, that he was well placed to make the transition from sixth-former to art student, and was also ahead of the field.

Irvin commenced at Northampton School of Art in early 1940. For the next eighteen months he immersed himself in the rigours of an academic art-school education, receiving a thorough grounding in traditional methods and subjects. Drawing was high on the agenda. The syllabus required that the students draw intensively, working towards the examination to be taken at the end of the second year. Anatomy, perspective and architecture were part of this training, although the main thrust was in making studies from casts and from the model. Irvin augmented this concentrated activity with classes in the evening when he also painted, mostly still-life subjects.

His time at Northampton, though relatively short, was 'a blinding revelation'. The new disciplines and skills he was acquiring imparted greater confidence, and lent substance to the previously untutored talents he had harboured. He also benefited greatly from the insights of his teachers. Unlike the London art schools which drew on a range of different tutors, the tuition at Northampton was given by a much smaller staff under the principal Frederic Courtney. Irvin's main teacher was John Spencer, a recent graduate from the Royal College of Art, whose enthusiasm for Cézanne was both persuasive and infectious. Through Spencer, Irvin began to realise that there were alternative ways of representing experience which did not rely on the literal imitation of appearances. Spencer introduced the students to Cézanne's practice of encoding visual sensations in discrete painterly dabs. In the context of the traditional training in which Irvin was then steeped, such ideas were tremendously exciting.

At the same time, Spencer's respect for established values made an impression. It was clear that more advanced forms of expression had to be rooted in tried and trusted methods and procedures. Spencer's allegiance to Modernism was balanced by a very English conservatism. He promised the students: 'I'll teach you to draw like Augustus John and Rembrandt'. He also showed them how to lay out a palette, organising the colours into a logical sequence. Almost sixty years later, Irvin still practises this discipline. Irvin's teacher also infected his students with the fantasy and romance of it all. They would set off in groups, find a subject, set down their

easels, and make paintings. Needless to say, a part of it was youthful role-playing. At the same time, some elementary skills were being refined: the brush held upright at arm's length to judge proportion; the eyes squinting to simplify tonality. Significantly, some of them began to acquire a sense of what being an artist would involve.

In the context of developing deeper personal values, Irvin's introduction to the Reverend Walter Hussey can be seen as a turning-point. The two met when Irvin won a prize for a painting of a religious subject – *The Adoration of the Magi* – and was duly presented with £2.10.0 by the vicar of St Matthew's. Hussey was a deeply cultured man, with refined tastes in music and literature as well as the visual arts. He was also well acquainted with recent developments in British art. He had acquired a personal collection which included works by Graham Sutherland, Matthew Smith, Jacob Epstein, Stanley Spencer and others, and later on he commissioned Henry Moore's *Madonna and Child* and Graham Sutherland's *Crucifixion* for St Matthew's.

Irvin was invited to visit Hussey's home and the impression was immediate and profound. It was the first private house he had visited which contained pictures by artists whose work he had hitherto known only by reputation. Hussey was also responsible for fostering Irvin's love of classical music, a passion which developed second only perhaps to painting. He became a frequent visitor to the vicar's home and was dazzled by the older man's record collection and by his host's erudition in the discussions that followed each performance. Hussey's knowledge and dynamism could be overwhelming and Irvin was a little in awe of his mentor. But these qualities were tempered by warmth and enthusiasm. He had an engaging ability to humanise more abstruse issues, making them appealing and accessible. Hussey used to visit the art school and often held music sessions for the students in the library. Irvin would sit fascinated as Hussey set up a pair of record players, arranging two identical sets of 78 rpm records of Brahms's Second Piano Concerto. He would then operate the two players alternately, deftly ensuring the music's continuity as each record speeded towards its end and another was promptly set in motion. While performing this delicate balancing act, Hussey talked with bubbling energy, commenting on aspects of Toscanini's interpretation and noting his family ties to the pianist, Horowitz, the conductor's son-in-law. Hussey's taste and values went a long way in furthering Irvin's knowledge and interests. 'His enthusiasm, awareness and perception,' Irvin recalls, 'meant a great deal.'

Towards the end of his first year, the promised influx of London art students burst upon Northampton. On 11 November 1940, the incumbent staff and their charges watched in amazement as buses arrived carrying young men and women from Camberwell, St Martin's, Central, Clapham, Hammersmith and Chelsea. The change they brought to the life of the

school was dramatic. Previously rather self-contained, Northampton became a melting pot for a diversity of different artistic attitudes. Irvin now met and befriended students from further afield; people like Susan Einzig, Gerald Marks and Geza Spitzer from Central School – pupils of Bernard Meninsky, whose aesthetic derived from Gertler and Maillol and contrasted markedly with Northampton's more conservative ideals. The school also drew together numerous teachers from the different schools. These tended to be older figures, the younger ones having been conscripted. At a stroke the staff was expanded by the appearance of such teachers as R. R. Tomlinson, also from Central, who became Northampton's new Head; H. S. Williamson, the Head of Chelsea School of Art, who taught composition; and William Johnstone from Camberwell, arguably the first abstract painter in Britain.

For a brief moment, the war created a lively situation at Northampton in which it was possible to receive an art education of unusual breadth and catholicity. A colourful atmosphere flourished, charged by the cross-fertilisation of different ideas. It was a time for parties and concerts: the young Malcolm Arnold playing trumpet, and Richard Adeney accompanying on flute, were familiar faces. There were also pageants, heated arguments and relationships. During this period Irvin met Betty Nicolson, a student from Clapham, whom he was later to marry. They were part of a larger group which also included Reggie Langford, one of Irvin's closest friends at Northampton. The 'double act' of Irvin and Langford, as they became known, acquired a certain notoriety for high spirits and their popularity with the girls.

The injection of new blood also had the effect of hastening and enriching the formation of the students' visual vocabulary. Spencer's approach had already begun to influence Irvin in the direction of Cézanne. He was now frequently painting out of doors, and had started to explore the use of Cézanne's hallmark petit-tache brushwork in depicting a range of rural subjects. Farmyards, animals and market day are among the subjects of these early essays. Such influences were quickly assimilated and replaced by others of a more contemporary cast. Irvin was encouraged to look at Stanley Spencer's paintings, an enthusiasm he was able to develop through his contact with Hussey's art collection. The strength and subtlety of Spencer's approach to composition showed him the need to develop a more sophisticated grasp of formal organisation. At the same time, Irvin came under the spell of Augustus John's paintings. The Tate Gallery's portrait of Dorelia exercised a particular hold, not least for its forceful brushwork and bold use of colour.

The eighteen months or so that Irvin spent at Northampton confirmed his aspirations to be an artist, and to some extent these early enthusiasms suggest the central characteristics of his later work. An emphasis on the disposition of pictorial elements, their expressive articulation in paint, and the use of emotive colour are its foundations. At this early point in Irvin's career,

Newly qualified
navigators, 1943
Toronto Station, Canada

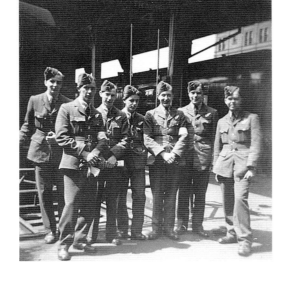

In flying gear: Irvin in
Babbacombe, 1942

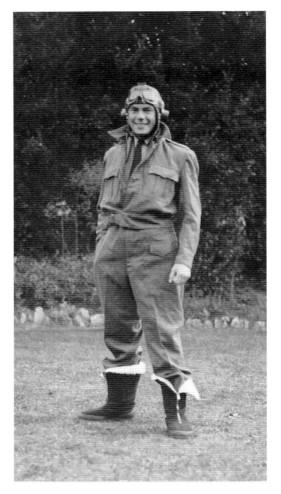

In RAF uniform: David
Gould and Irvin in
Blackpool, 1941

however, these issues had been identified but they had yet to be resolved, and a mature style lay a long way off. Moreover, his progress towards that goal was just about to receive a lengthy interruption.

## 4. Navigating

In late 1941, Irvin received his call-up papers. This event, undramatic in itself, terminated his sojourn as an art student, took him away from Northampton, and in the first instance sent him to a reception centre in Warrington. Towards the end of his time as a student he had engaged in fierce arguments with Reggie Langford about the rights and wrongs of the war. Both had sought to rationalise their responses to the prospect of conscription and after many heated debates they found themselves on opposite sides of the fence. Langford's convictions led him to register as a conscientious objector. Irvin was no less left-wing in his own political beliefs and he respected his friend's stance. Nevertheless, believing the war against Hitler to be a justifiable conflict, Irvin opted for the Royal Air Force.

This decision, which would have unlikely but undeniable significance for Irvin's art, was taken as something of a leap in the dark. Wanting to train as aircrew, he had a number of options. He could be a pilot, a bomb-aimer, an air-gunner, a wireless operator or a navigator. To this choice he brought no previous experience of flying and, indeed, had never so much as driven a car. He was not even sure, therefore, that he had the temperament for driving, let alone flying. On the other hand, at school he had shown some competence in maths, albeit of an undistinguished nature. After weighing these considerations, he chose to be a navigator – a discipline rooted in the principles of orientation and movement through the world.

Arriving at Warrington, the contrast with Northampton could hardly have been greater. Billeted in a Nissen hut, he had ample opportunity to reflect on the turn of events, the friends left behind, and the sudden replacement of a regime which encouraged personal expression by one which imposed regimentation. It was a sobering prospect. Light at the end of the tunnel appeared in the form of David Gould, whose corduroy trousers – then de rigueur among art students – marked him out as a kindred spirit. Sharing similar interests and a common predicament, the two struck up a friendship.

From Warrington, Irvin was posted to Blackpool for three months' training in Morse and he also had his first taste of square-bashing. He went with Gould, and they shared accommodation in a local bed and breakfast. This was the scene of their celebrations on Christmas Day 1941. Given their situation, the opportunities for maintaining contact with art seemed unpromising. On one of their excursions to the town they found Epstein's monumental sculpture *Jacob and*

236 Beaufighter
Squadron, 1944
North Coates,
Lincolnshire

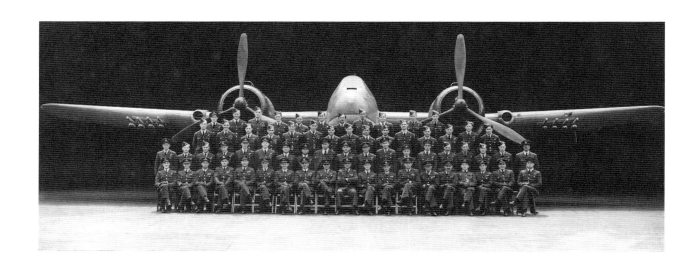

*the Angel* being touted in one of the side-shows as a spectacle for titillation. But later on they discovered the Williamson Art Gallery whose small collection provided valued respite. They even managed to keep in touch with their art education by signing on for life classes at Blackpool School of Art. It was there that Irvin painted a small painting in homage to Sickert when he heard of the painter's death.

Irvin's training continued with a posting to Compton Bassett in Wiltshire. Here he was taught wireless operation. He was also required to learn semaphore: an early encounter with the expressiveness of abstract form. At the same time, he received training as an air-gunner. This involved developing an understanding of trajectory and an awareness of the behaviour of moving objects. He later commented: 'It was quite good for the appreciation of space.' In a strange, oblique way, a stream of tracer fire curving through air later finds a faint but resonant echo in Irvin's art, not least in his subsequent attachment to Paul Klee's notion of taking a line for a walk. In both cases, a journey taken by a point as it courses through its opposite – a void – exercises a fascination which activates the senses and touches the emotions.

The idea of movement through space stands at the heart of Irvin's work and, in that connection, his first experience of being airborne was formative. Sent to Babbacombe, near Torquay, to undergo aircrew training, the new sensation of flight made a lasting impression. In the instant of leaving the ground and then seeing the land from the air, the familiar view of the sky above is replaced by a sense of air as a surrounding envelope. Our idea of the world and our position within it receives a sudden, vital refraction through this new perspective. For Irvin, this shift in perception was deeply affecting. It was also coloured by a range of considerations and responsibilities.

As a trainee navigator, he was expected to acquire an understanding of meteorology. He had to be able to recognise cloud types – indeed, weather in all its manifestations – and be able to predict its consequences for those travelling through it. Orientation became a discipline upon which his life and others' lives would depend. The relation between a position in three-dimensional space and its corresponding symbolic representation on charts and maps now assumed a hitherto unanticipated importance.

Irvin's introduction to navigation addressed this situation in memorable terms. The trainees were invited to consider the condition of a fly, moving across a railway carriage, whose position within the carriage must also be judged in relation to the ground rolling past outside. Similarly, an aeroplane weaving a course within an airmass must plot its course by taking into account the speed and direction of air as well as its own geographical position. This simile stated the facts of a technical predicament with compelling clarity. It also exposed the complex nature of a navigator's relation to the world, a way of thinking in which locating one's position in space

became second nature. In time, these considerations would be fertile soil for the growth of an artistic imagination.

Irvin completed his training in Canada. Sailing from Liverpool to Halifax, Nova Scotia, he went on to Mount Hope in Ontario where he was based for three months. This was the time when the theory he had learned had to be put into practice. Flying over a vast snow-covered landscape he now had to prove his ability to track and plot a course using the principles he had been taught. These new experiences were challenging but also thrilling. At night, the view from the air changed dramatically. When the sky was clear, the stars could show the way. At other times, it was possible to look down and be guided by the lights of the towns and cities, the pattern of streets brilliantly etched in the blackness. It was at the end of this period that Irvin graduated as a navigator and received the wings that confirmed his new status.

Travelling back on the *Queen Elizabeth*, Irvin returned to England in 1943 with the prospect of active service ahead. The prelude to this was a brief period of assignment to an operational training unit at Carlisle when the aircrews with which he would serve were formed. After that, his first taste of action came with a posting to the Middle East. But it was his attachment to 236 Squadron, during 1944, which defines Irvin's wartime experience. The squadron, which flew Beaufighters, was part of Coastal Command and was based in North Coates, near Grimsby. Following the Battle of Britain, Coastal Command began using Beaufighters in defence of its patrol aircraft. Shortly before Irvin's arrival, 236 Squadron had been equipped with Beaufighters as part of its dedicated role as an anti-shipping strike force. Its operations were therefore both offensive and extremely dangerous.

The Beaufighter was a formidable aircraft. It was nicknamed 'The Whispering Death' by the Japanese because of its suitability for quiet, low-level flying and ability to deliver a lethal blow. The Tf.Mk X – the version in which Irvin flew throughout this period – was armed with four 20 mm cannon in the nose, a .303 inch rear gun, and it also carried four 60 lb rocket projectiles under each wing. Powered by two 1,770 hp Bristol Hercules engines, it had a maximum speed of over 300 miles per hour. It was therefore well suited to the role assigned to the squadron. Its principal targets were the heavily defended harbours in the Friesian Islands, at Den Helder on the Dutch coast, and at Bremen, Bremerhaven and Wilhelmshaven in north-west Germany. Later on, when it was posted briefly to North Cornwall, the squadron was also involved in attacks on the submarine bases in the Gironde estuary on the west coast of France. In a typical co-ordinated action, the Beaufighters would lead the raid, going in first to subdue the enemy's anti-aircraft defences; they would be followed by Beaufighters from 254 Squadron, flying at low level and carrying torpedoes. The damage inflicted by such attacks was telling but, inevitably, losses were severe.

Irvin's previous experience of flying had accentuated his sense of relation to the world, heightening an awareness of space and a sensitivity to position and movement within it. His involvement in action now brought into play a new spectrum of sensations and emotions. Describing such experiences, Irvin used one word only: 'terrifying'.

## 5. Grand tour

With the surrender of Germany on 7 May 1945, the war in Europe came to an end and, as it turned out, this effectively concluded the period of Irvin's active service. Initially there had been some talk of the squadron being sent to fight in the Far East, but the collapse of Japan in August removed that possibility. So, while waiting to be demobbed, Irvin now had time to consider his plans for the future.

Almost immediately, he commenced training for a civilian navigator's licence. On completion of the course he was assigned to DC3s, flying passengers to the south of France, Rome, Naples, Vienna and Berlin. As a result he was able to travel widely, visiting European centres of culture and generally expanding his horizons. He was shocked by Berlin, virtually destroyed by Allied bombing. But elsewhere, he was able to steep himself in the great city art collections. In Vienna he visited the Kunsthistorisches Museum, the Albertina and the Academy of Fine Arts; and, in Rome, the Borghese, the Capitoline Museums and, of course, the Vatican. Through these visits he gained his first direct contact with the broad sweep of European art which previously he had known only through reproductions or visits to London's National Gallery. The glories of Italian art, in particular – and the Sistine Chapel above all – made a huge, indelible impression. It was a golden opportunity to deepen and advance his art education, restricted at that time to the few who could afford such trips, and it convinced him of the direction he would now take.

This is not to suggest that during the war his contact with art had ceased. If anything, his interest had intensified but the diet had been limited and the rations small. During periods of leave he had continued to frequent the National Gallery whose displays, because the collection was in store in Wales, were confined to single paintings. It was in the setting of these 'Painting of the Month' slots that he saw Titian's *Noli Me Tangere* and El Greco's *Christ Driving the Money Lenders from the Temple*. Nevertheless, seeing these works under such circumstances was in some ways as meaningful as viewing entire collections in Europe. Looking at just one painting had an edge and a focus which connected with deeper levels of feeling. Irvin recalls: 'You rejoiced in it, ravaged it, really got to know it.'

The lunchtime concerts given at the National Gallery during the war were part of this

Coliseum, Rome, 1945
Irvin had gained his
passenger navigator's
licence and was flying
DC3s. He is shown here
(extreme right) with
other RAF crew
members

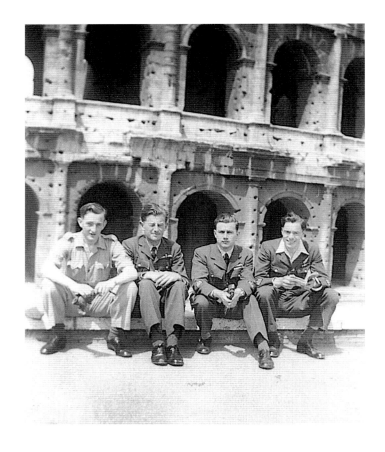

atmosphere, generating a sense that although under duress the spirit of the nation carried on. Irvin went to recitals by Myra Hess and Eileen Joyce; and, through performances of work by such composers as Howard Ferguson, he began to develop an interest in contemporary music. During this time he started to attend the Promenade Concerts at the Albert Hall, thus commencing a pattern which continues unbroken to the present. During one memorable concert which he attended with Betty, the performance was interrupted by the wail of the air-raid sirens. An announcement from the stage invited any members of the packed audience who wished to leave to do so. Nobody moved. The music then continued while the raid passed over. It was a deeply affecting moment, affirming – it seemed to Irvin – that art was not only strong, it could also be defiant!

Irvin's initial ideas for a career after the war led him to Oxford. He was thinking about ways of earning a living and, in view of his art-school background and experience in the forces, had begun to consider whether teaching might be a possibility. Accordingly, he was interviewed for a teacher-training course. By this time he had begun to read voraciously, even consuming Hansard's parliamentary reports, and he made a good impression. In particular his acquaintance with Herbert Read's book *Education through Art* seemed to strike the right note and he was offered a place on the course. Even so, he never took this up. The episode represented a slight failure of nerve, and he already had his sights set elsewhere.

Throughout his time in the RAF Irvin not only kept up his interest in art, but, whenever possible, also continued to make drawings and paintings. Although he was in the thick of the camaraderie which was a vital part of life in the services, this attachment to art also set him slightly apart. His pin-ups were postcards of works by artists he admired: Rembrandt, Van Gogh, Turner, hinting at a more serious side to his character. His closest friendships then were with individuals of a similar sensibility. In 236 Squadron he knew Howard Nemerov, an American poet connected with a circle of writers whose centre was T. S. Eliot. Through Nemerov, Irvin developed a liking for poetry and an awareness of contemporary literature. Such associations and his involvement with making art enabled Irvin to maintain a kind of private space in which the idea of being an artist remained intact and continued to grow.

Consequently, by the time the war ended he had a portfolio of work which he could present as evidence of his ability and aspirations. His first port of call was the Central School whose Head, R. R. Tomlinson, had by this time returned from Northampton. Irvin turned up, still in uniform, with his portfolio under his arm. Tomlinson examined the contents of the portfolio with interest. Eventually, he pronounced: 'Well, Irvin, I think Goldsmiths is the place for you.' Unsure whether he was being sent to Goldsmiths College or away from Central, Irvin did as suggested and travelled to New Cross where he was seen by Clive Gardiner, Goldsmiths'

Chelsea Arts Ball
1946
The notorious Goldsmiths
float is on the right

Students at Goldsmiths
College
1948
Irvin (second from left)

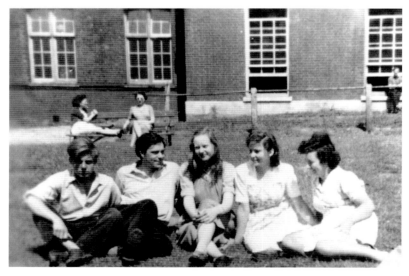

Principal. Irvin's portfolio comprised some paintings on canvas and board; also a number of drawings from life including a chalk and pastel portrait of Betty. Tomlinson's assessment proved correct for he was accepted, thus returning him to art education, the path he had been forced to abandon some four years earlier.

## 6. Back on course

Irvin was demobbed in 1946. On leaving the RAF he was presented with a striped demob suit and a trilby hat and, with some sense of relief, he became once more a civilian. In taking up his place at Goldsmiths he joined a student population whose ranks were mixed, comprising ex-servicemen like himself, as well as an intake of younger men and women coming straight from school. Although the difference in age between these groups amounted to only a few years, the intervening period in the services had brought about changes which marked out the older students. In contrast to his days as a seventeen-year-old at Northampton, the discipline Irvin encountered while in uniform had matured him. He no longer wasted time. Having received a lengthy interruption, he now valued his art-school training, immersing himself in the life of the college with commitment and energy.

The contrast with the life he had been leading during the previous five years was great. But the transition was eased by the intervening period as a civilian navigator, and by the relationships he now formed with students from similar background. Among these was Bill Mills, another ex-serviceman, who became a close friend. He also renewed his friendship with Reggie Langford, whose period as a conscientious objector had likewise ended. Irvin's relationship with Betty had continued throughout the war, and they married in 1947. Betty studied sculpture once a week at Goldsmiths evening classes. His fellow students during the next few years included the painter Bridget Riley, who would achieve distinction early in her career, Mary Quant, whose reputation as a fashion designer became synonymous with the 1960s, as well as the painter and notorious art-forger Tom Keating.

Because of the eighteen months he had already spent at Northampton, Irvin entered Goldsmiths as a second-year student. The four-year National Diploma in Design (NDD) on which he embarked entailed, in the first instance, a two-year drawing course (one year in his case) including anatomy, perspective, architecture and figure composition. Quentin Crisp, whose colourful reputation then lay ahead, was a regular model in the life class and was drawn by Irvin on numerous occasions. Irvin's teachers included Sam Rabin for life drawing, and Carel Weight and Ivor Roberts-Jones for composition. After completion of the drawing course, the students were then required to do a further two years studying painting. Maurice de Saumarez

was one of the teachers on the painting course. The traditional nature of the training Irvin received can be glimpsed in one of the aphorisms which de Saumarez imparted to his charges. 'Remember,' he told them, 'empires have fallen while a painter has been assessing the relationship between two tones.' During the four years he remained at Goldsmiths, he also had classes with Leonard Appelbee, Clifford Frith, Carel Weight, Graham Sutherland, Kenneth Martin and Clive Gardiner. Irvin sat and passed his NDD in 1949 and followed this with a one-year course of post-graduate study.

Irvin remembers Gardiner as 'a marvellous teacher'. A Slade School graduate, Gardiner's fellow students had included David Bomberg and Stanley Spencer. Irvin attended his weekly composition classes and was immediately impressed by his incisive and intelligent criticism of the students' work. A rather patrician figure, Gardiner was an intellectual with something of the atmosphere of Bloomsbury about him. His tuition was characterised by an insistence on a styleless art. In Gardiner's view, the artist should avoid adopting any set way of working and should seek, instead, to develop a wholly individual approach rooted in personal expression.

While sympathising with this ideal, Irvin later became convinced that in practice its attainment is virtually impossible. He came to feel that all artists are the inheritors of a visual legacy that cannot be ignored and in relation to which a personal approach develops. As he would discover for himself, an artist is of his time, he locates himself in relation to the milieu he inhabits, and forges his own individual vision from the art he has encountered. Nevertheless, at the time, his teacher's ideals were compelling. Another tenet of Gardiner's thinking made a more enduring impression. The students were encouraged to see success as a kind of failure because in some ways it entailed a loss of artistic integrity. Whatever the merits of this outlook, it would serve in one case at least. For it was to be many years before Irvin could extricate himself from the situation of having to struggle for recognition.

Though rooted in traditional methods, Gardiner's insights hinted at possibilities with which Irvin was still attempting to come to terms. One of his observations made a singular, lasting impression. He told the students that the greatest composition *ever* was Picasso's *Parade* and drew their attention to the power which this artist drew from spacing, grouping, interval and overlapping. In Irvin's mature work these are fundamental elements of his visual language. But in 1946, such ideas were both startling and intensely exciting.

By the time Irvin joined Goldsmiths he had formed a reasonable acquaintance with modern British art. In part this knowledge derived from exhibitions. For example, in the National Gallery's exhibition *War Pictures by British Artists* he had been able to see a virtual survey of contemporary artists working in Britain. Over twenty artists were represented, including Henry Moore (by the *Shelter* drawings), Paul Nash (by *Totesmeer* and *The Battle of Britain*), Graham

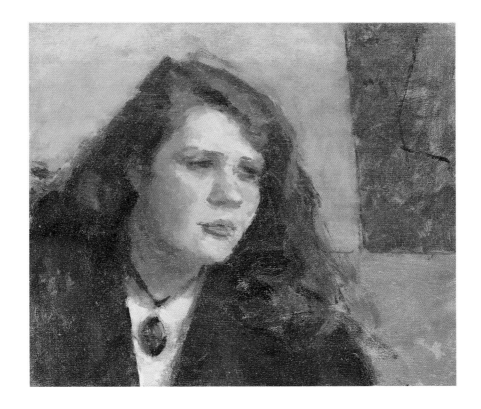

**Portrait of Audrey**
1948
oil on canvas
41 x 46 cm
(16 x 18 in)

Sutherland, John Piper, Edward Bawden, Robert Medley, John Nash, William Roberts, Rodrigo Moynihan, Richard Eurich and Winifred Knights. In 1946 the Tate Gallery had exhibited the Euston Road School painters whom he had thought 'astoundingly good'. Victor Pasmore's *Hanging Gardens in Chiswick* had attracted him especially.

There were many other opportunities for coming into contact with modern British art. Work by contemporary painters could be encountered in the theatre. During the war, while at Blackpool, he had attended an Old Vic touring production of *Macbeth* whose sets by John Minton and Michael Ayrton had interested him. Much of his information derived, however, from reproductions in a variety of publications. The *Penguin Modern Painters* series was particularly valuable in this regard, and can be credited with disseminating the work of a broad range of contemporary artists to a wide audience. The *Penguin New Writing* was similarly useful. In addition to commentaries on recent developments, it reproduced the work of such figures as Keith Vaughan, Robert MacBryde, Robert Colquhoun, Ceri Richards, Edward Burra and Leslie Hurry. But despite this growing awareness, before 1946 there were few opportunities in Britain to gain first-hand acquaintance with the European avant-garde. All this changed with the exhibition at the Victoria & Albert Museum in that year of paintings by Matisse and Picasso.

Although he had seen work by these artists in reproduction, this was the first time he had been able to see actual paintings by the leading figures of the School of Paris. The experience was deeply disturbing and profoundly impressive. He was shocked by Matisse because he had never seen colour used in that way before: so freely and so unfettered by literal description – as a thing in itself. He thought Matisse's use of colour 'sublime'. Picasso was as much a revelation but in a different way. His use of distortion, wresting the appearance of things into a new, completely independent pictorial order was unsettling, confusing, and yet seemed to open up a vast range of possibilities and implications. Though contrasting, the powerful impression made by both artists derived from the liberties each had taken, and also because they *were* liberties.

This is not to suggest, however, that Irvin was able to absorb such influences immediately. While recognising the importance of artists like Picasso and Matisse, as yet he lacked a personal artistic context in which to locate the values they represented. At this time, as with most art students at an early stage in their careers, he was being bombarded with a rich diversity of styles, periods, approaches and ideas. Exposure to the most advanced tendencies took its place alongside a developing awareness of the Old Masters and, between these extremes, he was still grappling with the practical implications of drawing and painting thrown up by the NDD. Irvin's interests diversified as his contact with a range of artistic influences grew. And, as the artistic landscape became better known, gradually his own position within it became clearer. In 1946, the breadth of Irvin's openness to a spectrum of artistic models can be seen in his parallel

enthusiasm for Sickert *and* Picasso. But already the ground was shifting.

In terms of developing a wider cultural awareness, one of Goldsmiths' strengths was its potential for offering contact with activities and disciplines beyond those offered by the art school alone. As well as the school, the college then also embraced an Adult Education Institute offering evening classes in numerous other subjects from psychology to music, as well as a centre for teacher training. This multi-disciplinary role resulted in a situation, not unlike the one he had encountered at Northampton, where students and teachers from various back-grounds interacted. Irvin took full advantage of this opportunity to pursue interests beyond his course of study. He served on the committee of the Poetry Society and as a result met such poets as Patrick Dickinson, Edith Sitwell and Louis MacNiece, who gave readings. Irvin's love of poetry, which flourished at this time, is centred on his delight in the colours and especially the rhythms of language. Though this interest is essentially literary, his responsiveness to the formal properties of the written and spoken word – its sounds, spaces, onomatopœic echoes of meaning, and syntactical relationships – can be connected to the visual characteristics of the abstract visual language he would later forge.

Socially, too, Goldsmiths provided a canvas on which the gregarious side to Irvin's character, and his instinct for celebration, could take shape and find expression. At the end of the year, the different parts of the art school would each prepare for the Christmas party by decorating the Great Hall. Gardiner saw this as a kind of subsidiary class which called upon an alternative range of talents. The students had to devise and realise imaginative themes on a grand theatri-cal scale, involving large painted figures set high against the walls and ceiling. A typical subject was The Marriage of Heaven and Hell, with an appropriate cast of angels and devils. Ladders were brought into play, as were decorator's brushes, colour and movement within a large space. The ambition and breadth of the operation contrasted sharply with the more modest scale and tighter rein imposed by the drawing classes. Irvin delighted in this expansion of resources and context, and the freer, more generous scope for expression: another early indication of much later developments.

The students' talents sometimes had unforeseen consequences. On New Year's Eve 1946, they took part in a memorable Chelsea Arts Ball at the Royal Albert Hall, for which the theme was The Renaissance. It was a packed house, with three bands providing a musical backdrop for drinking, dancing and – the highlight of the evening – the parade of floats. The Goldsmiths students had chosen as the subject for their float a heretic being burnt at the stake, and had de-signed and erected a large tableau. This had as its apex a live nude female – a fatal choice. Since the law permitted nudity in public – provided the individual involved did not move – this idea seemed above reproach. The seeds of disaster were sown, however, when the parade was about

**Cellist**
1955
oil on board
122 x 92 cm
(48 x 36 in)

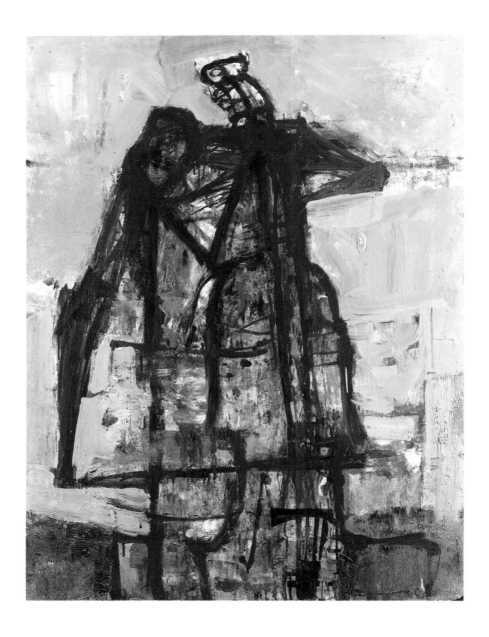

to begin and the nude – a model from the college – could not be found. Faced with the loss of their star attraction, another of the school's models who happened to be present promptly volunteered to stand in. There was a cheer as without hesitation she removed her clothes and took her place on the float. At this point, the original model arrived, somewhat the worse for drink. Outraged to have lost her starring role, she began screaming curses at the usurper. Also casting off her clothes, she then mounted the float – now being wheeled around the hall – and confronted her rival. To the delight of the audience a battle of words quickly degenerated into a wrestling match. The unseemly debacle made the newsreels, thus ensuring that Goldsmiths was banned from the Chelsea Arts Ball for ever.

Irvin's time at Goldsmiths was an important formative phase. The training he received equipped him with some essential skills and he gained a wider awareness of the art-historical landscape – from the art of the past to contemporary issues. He received a thorough grounding in the grammar, as it were, of visual expression. And, as the paintings he made as a student reveal, he had attained a certain proficiency in his craft. One of his earliest surviving paintings, *Portrait of Audrey* (1948), was done from life in Clive Gardiner's class. Depicting a fellow student, it clearly demonstrates his ability to create a convincing likeness. Even so, that ability is rooted in conventional means. Despite the strong admiration he had formed for Picasso two years earlier, his own development had remained firmly within the bounds of tradition. Indeed, as a student he regularly submitted work to the Royal Academy's summer shows and had several works accepted. Notable among these is one done in 1950, the year he left Goldsmiths. Its title, *He's not asleep, he's only thinking* is a humorous reference to the Japanese doll it depicts. But it also hints, perhaps, at something more personal – his own artistic predicament and a sense of immobility and uncertainty.

When in the same year Alfred Munnings – then President of the Royal Academy – famously denounced Picasso, Irvin's ambivalence was brought to the surface. His affinity with more advanced tendencies caused him to deplore Munnings's position. Consequently, having succeeded in having one of his works accepted at the RA, he now vowed not to show there again.[5] This decision confirmed Irvin's gravitation towards Modernism but, as yet, he had little idea what form this would take. He thus left Goldsmiths armed with some grammar, but in search of a language.

## 7. What and how?

The development of Irvin's art in the 1950s is centred on two key questions: what to paint and how to paint it? These were the issues which confronted him as he commenced his career as a

full-time painter and they remained his principal preoccupations for the next ten years. Some artists are fortunate in finding their way early on and in establishing a reputation before they reach their thirties. In contrast, Irvin was in his late twenties when he *commenced* a difficult period. This decade would see the gradual evolution of a personal vision, and a protracted transition from a means of representation grounded in depiction of the visible world to one employing abstract shape, colour and the expressive application of paint.

The start of the new decade was accompanied by an atmosphere of general optimism. The involvement of artists in the preparations for the Festival of Britain generated a buzz of excitement and Irvin was aware of the need to 'get doing it'. In practice, however, things were not that easy. His first child, Priscilla, had been born in 1949. And, after living for a while in West Norwood, from 1951 to 1957 Irvin and his wife and young daughter shared a house in Streatham with Betty's mother and brother. During this time he did occasional jobs: digging roads, and even working for three months as a commercial traveller selling ladies' doe-skin gloves. Betty, meanwhile, was making drawings as a freelance for *Architect's Journal* and later worked part-time in the drawing office of a scientific instrument manufacturer. Money was therefore short. When possible he continued to paint full time. But an immediate effect of no longer being a student was that he now felt isolated from the community of artistic ideas and activity which Goldsmiths had provided.

Towards the end of his final year, he had participated in his first group show: *Young Contemporaries*, an exhibition of work by art students of Great Britain held at the RBA Galleries in Suffolk Street, Pall Mall. In a selection that also included paintings by Gillian Ayres, Edward Middleditch, Jack Smith and Derrick Greaves, Irvin was represented by a painting titled *Golfers Interrupted*. His inclusion in the exhibition provided a link with the London Group, who initially were also based in the same building on Suffolk Street. He showed two works with the Group in 1952 – *Butcher* and *Meat Carrier* – and his subsequent participation in exhibitions with them (in 1953, 1956 and 1959) became his prime point of contact with other artists and his main platform for exposure throughout the 1950s. During his first London Group private view, at which a very young Elizabeth Frink served drinks, he was approached by Ceri Richards who asked to see his work and responded favourably. From the start, his association with the London Group was both encouraging and sustaining.

Irvin's early figurative paintings depict figures, or groups of figures, in urban or domestic situations. *Neighbours* (1950) was one of the first paintings he made after he ceased to be a student and it encapsulates some of the main themes of his work at that time. Based on his memory of a scene observed in West Norwood, it depicts two women in a street or courtyard, apparently involved in some kind of broom-flailing altercation. In a sense, therefore, the

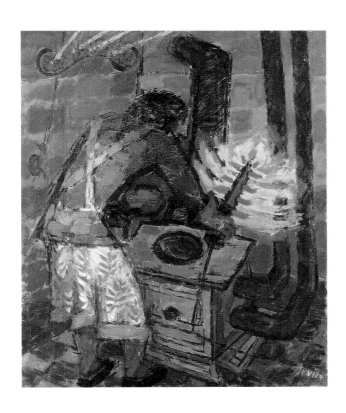

**Woman with
Gas Poker**
1951
oil on canvas
76 x 64 cm
(30 x 25 in)

**Figures Moving
in Rain**
1954
oil on board
64 x 56 cm
(25 x 22 in)

**Neighbours**
1950
oil on board
61 x 71 cm
(24 x 28 in)

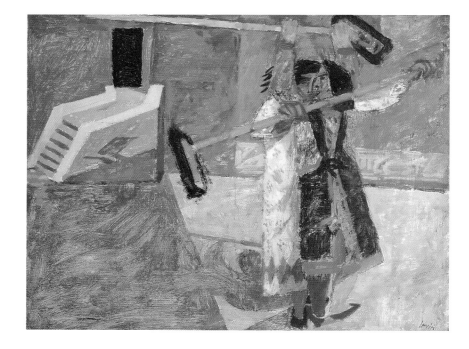

**Chicken in a Box**
1952
oil on board
66 x 97 cm
(26 x 38 in)

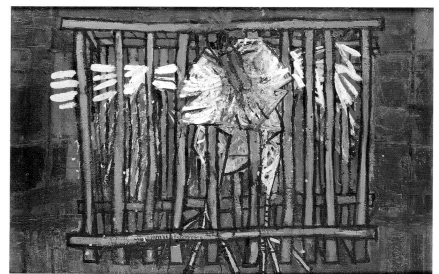

painting can be seen to have some connection with the growing interest in depicting ordinary life, a tendency that would assume a position of prominence in British art in the mid-1950s.

But in another way, Irvin's concerns can also be seen to have little to do with the kind of social realism later identified with John Bratby, Derrick Greaves, Edward Middleditch, Jack Smith and others. Unlike these artists' work, which uses harsh, unadorned visual fact to convey a vivid sense of working-class existence, *Neighbours* has an underlying sense of unreality. The backdrop seems literally that – like a stage set, without detail; simply a few shapes and some steps leading to a darkened doorway to give the flavour of an urban situation. Rather than convincing us that we are witnessing an actual event, our attention is drawn to this pictorial artifice. There is a sense of removal from literal fact, similar to that encountered in Stanley Spencer's paintings, whose influence Irvin was still absorbing. This impression is deepened by the work's composition. In the shape and relation of the figures, and their position within the setting, we detect a formal understructure. The lines of one of the brooms connects with the edge of a shadow, the diamond pattern on a dress rhymes with the shape of the ground; and the modelling of the figures is defined in flat planes – like the backdrop.

The effect of this is to emphasise those elements which are to do with picture-making. In addition to the scene depicted, we read the painting as a thing in itself. Irvin now regards such early efforts as juvenilia, but the painting is of interest because of the seeds of later development which it contains. In it we find an interest in the relation of figures to their surroundings and an emphasis on the work's pictorial aspects. There is already a discernible engagement with taking the habitable space of the real world and creating an equivalent structure which has significance in formal terms.

Although Irvin was not identifying these ideas as part of a conscious agenda, such concerns inform the paintings he made during the early 1950s and they influenced the way the work developed during that time. Until around 1952, the depictive aspect of the work remained relatively literal. *Woman with a Gas Poker* (1951), for example, shows Betty lighting a kitchen boiler, though again in the link between the pattern on her dress and the flames of the poker there is a gentle visual rhyme. It is as if Irvin is striving to shed the academic grammar of the painting and infuse it with a touch of poetry.

In a slightly later painting, *Chicken in a Box* (1952), there is the first real evidence of a dissatisfaction with straightforward depiction and a sudden emphasis on non-literal means to strengthen the painting expressively. During a visit to the Cotswolds, when they stayed with Bernard Curtis, a friend from Goldsmiths, Irvin became interested in the subject of poultry confined in their cages. In itself, this focuses and intensifies the ongoing theme of the way figures connect with their environment. But the tighter connection between the bird and its

little prison generated a more adventurous response. The use of strong, contrasted colours and the frontal presentation of the bird creates an image which is bolder and more confrontational. Formally, too, there is a surer feeling for using the relation of shapes to create visual interest. Within a structure of horizontals and repeated verticals, the flutter of the bird's wings – threading between the bars in buttery brushstrokes – carries an emotive frisson. Interestingly, also, in this immature work, we find a classic Irvin device: the balance of asymmetry, namely the use of shapes which are related but simultaneously contrasted to excite the eye and feelings. Here it takes the form of the bird's wings: one outstretched and the other confined. The advance in Irvin's thinking is clear: the subject is conveyed with greater resonance through the use of shape and colour deployed expressively rather than as straightforward description. Henceforward, the use of formal strategies to deepen the viewer's experience of the painting's subject would be a more conscious, and more contested, concern.

The debate which embroiled the art world in the 1950s centred on the relative merits of figurative and abstract art, then perceived not only as mutually exclusive but as positively antagonistic. Irvin entered this ongoing battle through discussions, which became increasingly heated and animated, with his friend Bill Mills. An ex-Goldsmiths student, Mills was a painter and a convinced advocate of abstract art. He had done occasional work for Victor Pasmore, whose conversion to abstraction in the early 1950s had sent shock waves through the British art scene. Through that contact, Mills knew the arguments well and was insistent in claiming the moral high-ground for an art that expunged illustration of the visible world. The position represented by Mills was that abstract shapes and colours were more effective expressive elements because they affected the sensibilities of the viewer directly – like musical sounds – and their emotive significance was not weakened by having to signify the appearance of some object. Irvin disputed this. His arguments, which relate to those expressed in Roger Fry's *Essay in Aesthetics*, advanced an opposed view: that a well-constructed picture combined descriptive and formal elements. He argued that painting is stronger if it is able to convey figurative significance *and* communicate feeling through expressive brushmarks, colours or shapes. This is so because the two are mutually enhancing and because a visual tension is sustained between them. A painting, he concluded – and continued to maintain – had to be 'a double-sided medallion'.

Irvin's resistance to the idea of eliminating a recognisable subject, and his progressive incorporation of elements with a pronounced formal presence, can be seen in the figurative paintings which he persisted in making. *Figures Moving in Rain* (1954) takes the implications of the earlier works further. Its ostensible subject is the relation of people moving through space. But now much greater play is made of the spiky shapes generated by their umbrellas and the reduction of the figures to flattened forms. However, *Cellist* (1955), a work completed soon

after, is much less coherent and reveals the confusion generated by his insistence on the co-existence of figurative and abstract elements. Although the work is not an unqualified success, it is worthy of note for what it reveals about Irvin's thinking at this time.

*Cellist* belongs to a series of drawings and paintings of musicians which Irvin made in the mid-1950s, a body of work which relates to his parallel interest in music and the performing arts. Irvin himself used to play the piano regularly, as well as attending, at this time, organ recitals at the Royal Festival Hall every Wednesday afternoon. This particular painting was inspired by seeing Pablo Casals play and its subject is the cellist in relation to the instrument he is playing. The handling of the paint reveals, however, a sudden violent stride forward – the result of concerns which transcend literal depiction. The new emphasis on the movement of paint, and the abstracted nature of the figure, are an attempt to invest the image with empirical information beyond its visual aspects. There is a sense that Irvin's ambition is to make an image expressing the situation of a musician dissolving in the sound he is making. In the act of expression the cellist is, as it were, becoming one with his materials – his instrument and the music he creates.

This act is of course analogous to Irvin's own situation as an artist: one in which he is seeking a way of expressing himself in a kind of performance with brushes and paintmarks. In attempting to evoke this, he has resorted to non-literal elements which take the image beyond figurative illustration to an extent hitherto unanticipated in his work. In a related painting, Irvin went further, attempting to express the experience of a figure listening to music through a similar conjugation of figurative and abstract parts. The figure's head is shown with balloon-like shapes, signifying sound, entering his ears. These works seek to express inner experiences – emotion and listening – by combining the depiction of external appearances with non-figurative elements. The resulting paintings carry greater meaning but, as images, they are somewhat awkward and unresolved. Nevertheless, the eloquence of abstraction had been recognised.

## 8. The rock face begins to crumble

When he left art school in 1950, it had seemed to Irvin that he was 'at the bottom of the hill with an alp to climb'. Five years later, he could survey his progress. In terms of his art, he sensed an increasing momentum and a strengthening of his resources, but the way forward seemed unclear. His discussions with Bill Mills had taken his work to the brink of abstraction but he held back, uncertain and unconvinced, hanging on to some figurative element which would anchor the paintings in the real, recognisable world. It seemed to him that if he dispensed with depiction completely he would be lost, and the image would spin out of control, dissolving in

confusion. At the same time, he sensed the capacity of abstract form to evoke areas of experience beyond the visual – emotion, movement, the apprehension of space – all those aspects of life which the developing subject of his work now began to embrace. Torn between these alternatives, he seemed to have reached an impasse. It was around this time that he began to take an increasing interest in Turner – particularly the late paintings – sensing in them a relevance to the predicament he now confronted. Turner's gradual dissolution of form, his evocation of space, and his progressive involvement with the substance and movement of paint as expressive elements in themselves, were all absolutely germane to Irvin's own aspirations.

In terms of his career, too, there had been a lot of effort and some progress. Interest had been expressed in his work and he had made a few sales. In 1952, David Cleghorn-Thomson, a radio critic and a former Director of Scottish Broadcasting, had bought a painting Irvin had shown with the London Group. He also occasionally had work shown in other mixed exhibitions. In 1954, he was included in *Young Artists Chosen by Collectors* at the Parsons Gallery, London. Cleghorn-Thomson was one of the selectors and chose Irvin. The exhibition included Joan Eardley, Jeff Nuttall, Anthony Whishaw, Derek Middleton and David Michie. Again, some works sold, one – *Passage Through Ruins* – going to the composer William Alwyn. Always on the lookout for the opportunity to have his work seen, he entered competitions. In 1953 the Football Association accepted his entry titled *Goal Keeper* and a couple of years later the *Daily Express* showed *The Rain Was Upon the Earth* in their *Young Artists Exhibition*. At the same time he did the round of London galleries. During this time, he showed work at Gallery One, the New Vision Centre, the Woodstock Gallery and the Drian Gallery. He also approached, with less success, the Leicester Gallery, the Hanover Gallery and the Beaux Arts Gallery. Five years out of college, he could count the fact he was still painting as some kind of achievement. But, in terms of making a mark, his progress seemed negligible.

In 1956, the Tate Gallery mounted an exhibition which for Irvin – as for many other British artists – can be seen as a turning-point. *Modern Art in the United States* comprised a large selection of twentieth-century paintings, drawings and sculpture from the collections of the Museum of Modern Art in New York. The exhibition was in six sections: Older Generation of Moderns (covering the period to 1945 and including such artists as Stuart Davis, Marsden Hartley and Man Ray); Realist Tradition (featuring Edward Hopper, Ben Shahn and Andrew Wyeth among others); Romantic Painting; Modern 'Primitives'; Sculpture; and Contemporary Abstract Art. Given its impact on so many British artists and on the British art scene in general, it is worth examining the contents of the last section in greater detail. There were twenty-eight paintings in all, the earliest dated 1942 and the latest 1954. The artists represented were Baziotes, Glarner, Gorky, Guston, Hartigan, Kline, De Kooning, Motherwell, Pereira, Pollock,

Pousette-Dart, Rothko, Salemme, Stamos, Still, Tobey and Tomlin. As such, the exhibition offered a British audience the opportunity to see, at first hand, a concise survey of recent work by the leading Abstract Expressionist painters.

The accompanying catalogue essay by Homer Cahill, the former Acting Director of MOMA, drew attention to the main characteristics and implications of these artists' work. He noted that they 'work in large scale which gives the spectator a sense of envelopment as if he were "in the middle of the picture"'.[6] Significantly, the essay also contains the following words:

> Concern with the immediately given in experience has led American artists to search out ways to activate the experience itself on canvas. One might say that they have gone back to beginnings, to 'the first division of chaos at the origin of painting', to search out the meanings of the parent medium, its darkness and luminosity, weight and body, transparency and opacity, its smoothness and roughness, its cling and flow, the rhythm of the hand that moves over the canvas and the accidents of passage cultivated for their own sake, sometimes to the point of automatism. The subject matter has become the medium, and the way it is handled – for no matter how abstract or non-objective a work of art may be, there is no possibility of abolishing subject, even when the artist is concerned solely with the elementals of painting. Subject is not something given, except in academic art. It is what comes out of the artist's experience in producing the work.[7]

This was not Irvin's first encounter with American abstract painting. In 1953, he had seen paintings by Jackson Pollock and Sam Francis in the *Opposing Forces* exhibition at the ICA. He had been impressed then, but the experience had little effect on his own work. In contrast, the Tate exhibition made it possible to see and compare work by a much larger number of artists sharing similar ideals. Despite a rich diversity of individual styles and imagery, there was an overpowering sense of a common purpose, confidence and ambition. The scale of the paintings he now saw, and their uncompromising emphasis on personal experience, moved him profoundly.

The exhibition represents an important stage in Irvin's gravitation towards abstraction. These paintings convinced him that it was not only possible to make an image after dispensing with a recognisable subject, but also that a painting could actually communicate more powerfully using only the affective potential of abstract form, colour and pictorial gesture. The work of Pollock, Kline and De Kooning, in particular, provided accumulating confirmation. For Irvin, one of the central issues was that painting should communicate feeling. In discussion he would cite Rembrandt, whose painting he adored, as an artist whose brushwork was essentially expressive. In describing its subject, each movement of the master's brush communicated a sense of the life

**Woman II**
1952
by Willem de Kooning
oil on canvas
149.9 x 109.3 cm
(59 x 43 in)
The Museum of Modern Art,
New York
Gift of Mrs John D.
Rockefeller III
Willem de Kooning, ARS, NY
and Dacs, London 1998

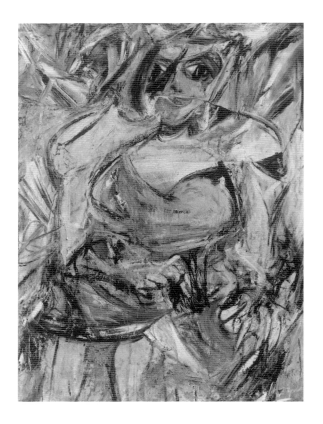

that propelled it and – crucially – gave life to the paint it applied. The paintings by the artists he now saw demonstrated that a brushmark could be released from its function of describing an object and yet could still forcefully evoke, and make visible, the energy of its creator.

Other aspects of the American artists' work seemed equally germane to his own preoccupations. He had been mainly concerned to convey a sense of relation between a figure and its context, and it had seemed impossible to retain this subject if the figure was eliminated. The paintings he admired suggested that subject and figurative description were not inseparable. He recognised that many of them removed any semblance of a recognisable figure – or any other object – but nevertheless they powerfully evoked both space *and* a human presence within that space. He came to understand that this was due in part to the dialogue between 'window' and 'wall' which is an essential characteristic of these artists' work. In *Gansevoort Street* (1949), for example, which was one of the three paintings by De Kooning displayed, we sense a recessive space enveloping fragmentary abstract shapes. But, simultaneously, the vigour of the brushwork denies this illusory window and returns us to the painting's surface. There is thus a perpetual exchange between the evocation of three-dimensional depth and the literal fact of the picture plane – the latter manifesting the artist's presence in the gestures that record his movement within that area.

The idea of a figure occupying a place was continued and amplified in the large scale of many of the paintings on show. Much larger than the easel-size work of the European art he had known previously, many of the American works he saw were like murals. As Cahill had pointed out, this created a sense of being enveloped by the painting. Its expansive scale, spreading out on either side of the viewer, created a feeling of being in the work. Irvin now appreciated that it was possible to evoke an impression of inhabiting a space not just by illustrating the appearance of that situation. Rather, scale could be used to generate an analogous *relationship* between the viewer and the image.

Irvin's hesitation in embracing abstraction had centred on the question of whether it was possible to make an abstract painting which communicated those things that concerned him. The imposing size and gestural energy of the works which most impressed him suggested that abstraction was indeed uniquely suited to expressing the subject for which he had the most ambition: the human condition – the experience of being alive and being in the world. Even so, Irvin did not immediately relinquish figuration. The implications of the work he had seen were too great, and too complex, to be assimilated overnight. Also, part of his reaction involved a sense of shock. After fifty years we have grown accustomed to the language of Abstract Expressionism and it is easy to forget how disturbing and disorienting it would have appeared to an audience coming to it unawares. The work he had seen was as much a challenge as an

**Moving Through**
1960
oil on canvas
125 x 150 cm
(49 x 59 in)

inspiration and he would have to feel his way towards it. Significantly, the artist whose work most affected Irvin was De Kooning. While he struggled to come to terms with what he had seen, De Kooning's *Woman I* (1950–2) held out the greatest hope for retaining some vestigial figurative reference.

The paintings which Irvin made after seeing the Tate exhibition do not announce an absolute conversion to the cause of abstraction, but they do reveal a marked advance in his thinking. As he later commented: 'The rock face began to crumble.' While living in Streatham he had begun to make paintings inspired by the view of the rooftops from his upstairs window. This theme continued after the Irvins moved to Battersea in March 1957. The rooftop paintings are interesting in a number of ways. Above all, they were the most abstract paintings he had so far attempted and, though still based on observation, this was now much less explicit. The view had generated an imaginative reorganisation which had its own pictorial reality. Generally speaking, these paintings took the form of an area of colour at the top of the canvas, with an arrangement of angular shapes at the bottom. As the series progressed, this hierarchy became increasingly removed from the literal appearance of the subject which inspired it, and there is a sense of greater freedom to dispose these elements in relation to one another.

These works are also notable for their absence of human figures. Previously, the presence of people had introduced a narrative element, and he had relied on figures to animate the spaces he depicted. Now the paintings drew their life from the interaction of shapes within a pictorial space and the movement of a freer brush around the canvas. Intellectually, this was a decisive step forward for it marked a transition from illustration to the beginning of an approach which is closer to metaphor. In communicating a sense of a human presence in the world, previously he had painted a picture *of* that subject. In these new paintings, the depicted figure had been removed and, henceforward, the human content would be the artist's presence *in* the painting, revealed indexically – through the marks he made and the formal strategies he unfolded. Even so, a final bridge had still to be crossed. Because they derived from observation, Irvin's paintings retained their connection with description. He had yet to find a way to an alternative approach: creating abstract images with empirical significance. In that respect, his contact with Peter Lanyon would prove invaluable.

## 9. Towards a new aesthetic

Irvin got to know Lanyon around 1957 and they met on a number of occasions in the late 1950s and early 1960s. By that time Lanyon's reputation was widening. His work was respected in St Ives, where he was based; and, in addition to two solo exhibitions in London, he had been

included in a number of group shows in Britain and abroad. Following the success of his first one-man exhibition in New York in 1957 Lanyon was in contact with a number of the leading American painters, notably Motherwell and Rothko. Through these personal connections, and also because of his work's affinities, Lanyon was thus one of a small number of British artists at that time who possessed a keen, first-hand understanding of developments among the New York School painters.

Irvin first made Lanyon's acquaintance through Nancy Wynne-Jones. An ex-student at Chelsea School of Art, she was a pupil of Lanyon's at St Peter's Loft, the St Ives art school he ran with William Redgrave from the mid-1950s to 1960. She had known Irvin since seeing his entries in the *Young Artists Chosen by Collectors* exhibition in 1954 and subsequently became a close friend and a strong supporter of his work. In addition to her home in Chelsea, Wynne-Jones had taken a studio at the Battery in St Ives, and Irvin and his wife visited her there several times. It was during these stays in Cornwall that he encountered most of the St Ives artists. At this time the St Ives art scene was at its most vital and productive. In addition to Lanyon, Irvin also met Roger Hilton, Terry Frost, Sandra Blow, Brian Wynter, Brian Wall, Wilhelmina Barns-Graham, Trevor Bell, Bob Law, Karl Weschke, Alan Lowndes and the poet W. S. Graham. Many convivial hours were passed; not least at the Tinner's Arms at Zennor, a favoured haunt of many of these painters, as well as at The Sloop, overlooking the beach at St Ives. But there were also fierce arguments, usually arising from the abstract versus figuration debate, when the voices raised in support of abstraction became a *cri de coeur*.

Lanyon, however, made the greatest impression. During visits to his studio and home at Carbis Bay he showed Irvin his work and, during meals, led the conversation. The late 1950s saw the completion of many of Lanyon's finest paintings – *Zennor Storm*, *Lost Mine* and *Thermal* – vivid, non-figurative evocations of the Cornish landscape whose brushwork carries a weight of subjective content. Central to Lanyon's ethos was the principle that the work drew on a wide range of sensory experience which *informed* the movement of paint. Rather than illustrating appearances, the images evolved from an inner fusion of imagination, knowledge, memory and feeling. Through his contact with such ideas, Irvin's own thinking shifted. Previously he had begun with a visual perception and had progressively abstracted the pictorial elements from that original idea. He now saw that it was possible to create abstract shapes, colours and marks that were impregnated with his perceptions and sensations, and which formed visual equivalents for those experiences.

One of the paintings which Irvin made towards the end of the 1950s, *Town* (1959), demonstrates the way his work now moved towards a greater sophistication. In one way this image connects with the earlier rooftop paintings. The heavy slabs at the bottom can be linked to

**Town**
1959
oil on board
51 x 127 cm
(20 x 50 in)

Nancy Wynne Jones:
artist and friend, 1958
Cornwall

Irvin with Betty and
their two daughters:
Priscilla (left) and Celia,
1961

houses and the circular filigree marks above can be seen as clouds. However, such connotations are now much less to do with description. Instead, the formal elements in the painting are invented and the colour is completely unnaturalistic. Rather than imitating an observed situation, Irvin's concerns are centred on creating an engaging and convincing pictorial drama in which the confrontation of contrasted elements is paramount. The stasis of the large, flattened forms contrasts markedly with the rolling linear tracery at the top. The use of complementary colours – green and red, black and white – heightens the sense of opposition. This hierarchy of opposites enlivens the image, giving it a vitality which is identified with the confrontation of opposed forces encountered in the real world. The painting thus invites connections with other hierarchies in nature – the meeting of sky and earth, for example. But, at a deeper level, its imagery works metaphorically and is identified with the push and pull of life.

Such developments constitute a new aesthetic in Irvin's work – one which is the basis of his art from this point onwards. The paintings he would now make are abstract in the sense that they no longer derive from observed nature. Rather than illustrating a perceived situation, they now proceed as a record of an unpremeditated activity in the area of the canvas – an activity which proceeds into the unknown, recording what is discovered. As such, the space of the picture stands as a metaphor for real space; the activity within it informed by, and identified with, wider experience.

The idea of acting within the arena of the canvas had, of course, been rehearsed by Harold Rosenberg in his 1952 article 'The American Action Painters'. In a now celebrated passage, Rosenberg wrote:

> At a certain moment the canvas began to appear to one American painter after another as an arena in which to act – rather than space to reproduce, re-design, analyse, or 'express' an object, actual or imagined. What was to go on the canvas was not a picture but an event.
>
> The painter no longer approached his easel with an image in his mind; he went up to it with material in his hand to do something to that other piece of material in front of him. The image would be the result of this encounter.[8]

The subject of the work is thus the engagement between the painter and his materials, an interaction which has existential implications since it is through the decisions which propel the painting that the artist finds and defines himself. The wide currency which the notion of action painting gained from the 1950s onwards resulted in a rash of painting, international in scope, which variously plumbed the depths and scaled the heights. The work which Irvin now began to make drew on this intellectual atmosphere. But, from the outset, the importance it attached

**Evening**
1961
oil on board
122 x 153 cm
(48 x 60 in)
Arts Council Collection

**Quite Early
One Morning**
1963
oil on canvas
102 x 127 cm
(40 x 50 in)

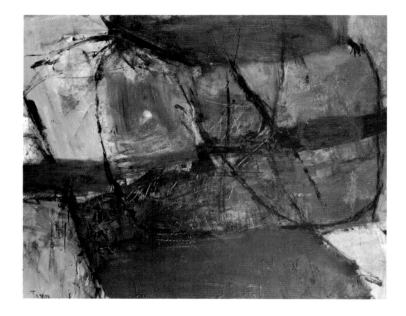

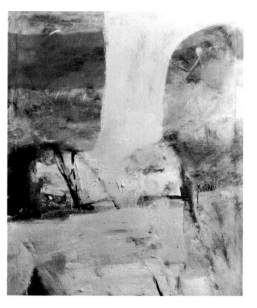

to informing the painting episode with wider experience is an integral trait. As Lanyon had maintained, a painterly gesture which is *only* that is 'scything the air'. The challenge – which Irvin now took up – was to load that gesture with the fullness of experience and make it resonate with life.

Irvin's contact with the St Ives painters, and with Lanyon particularly, was a valuable source of encouragement, for it provided that sense of artistic community which he lacked in London. Although he was still painting full-time, this was carried on in the largest room at the family home in Battersea, which he used as a studio. Also, following the birth of his second daughter, Celia, in 1959, there was greater financial pressure to secure a more regular income. In the same year, therefore, he took a part-time teaching post in the art department of Spencer Park School, a local comprehensive. The position had come up when one of the art masters there suffered an eye injury. It was his first ever teaching job and initially the transition from working in isolation to articulating his ideas in public was difficult. Nevertheless, on the strength of the headway he made, a further – if unlikely – post came his way. Spencer Park was opposite Wandsworth Prison, which also had art classes. The teachers in both institutions were in touch and, when a vacancy arose at the prison, Irvin was recommended.

This new appointment, which he carried on for a further four years, was both rewarding and strange. Having become increasingly concerned in his work with the idea of inhabiting a space, he was now confronted with the starkest manifestation of this situation: human confinement. Although the time he actually spent with the prisoners was no more than a few hours a week, the idea of incarceration coloured his thinking. In some of the paintings he made subsequently, for example *Moving Through* (1960), the containment of biomorphic shapes within segregated areas is a noticeable development in the formal vocabulary. While these teaching positions had few other connections with the development of his own work, they were nevertheless beneficial, for they forced him to return to basics and to be able to articulate and defend his position. In the case of the group discussions he ran at the prison, this was frequently far from being an easy option.

On 16 March 1959 Irvin made the following entry in his diary: 'Saw American pictures at the Tate'. Disarmingly laconic, this observation is significant, for it closes a period – almost exactly a decade – during which Irvin struggled with the idea of abstraction and finally found, in the New York School painters, the affirmation that would define the future of his own work. The Tate Gallery exhibition of 1959, *The New American Painting*, built on the tremendous interest in Abstract Expressionism that had been aroused by the earlier show. Containing eighty-one paintings by seventeen artists, it consecrated New York's dominance and affirmed the importance and power of American painting. Possibly the understated nature of Irvin's note

**Day Full of Time**
1962
oil on canvas
153 x 127 cm
(60 x 50 in)

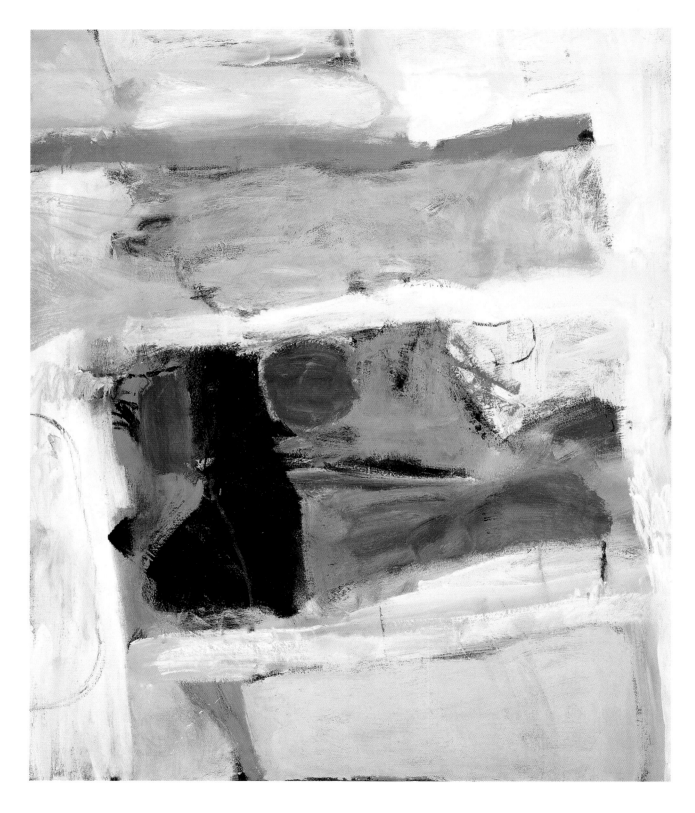

attests that the battle had already been won. Most of the British artists he knew or admired had already taken up the banner of abstraction: in addition to Pasmore, Kenneth Martin, Alan Davie, William Gear and, of course, Irvin's friend Bill Mills, were all abstract painters. Following the Tate's 1956 show, the Whitechapel Gallery had mounted exhibitions by De Stael and then by Pollock which had made an enormous impression on him. Then there was this latest exhibition, whose effect was overwhelming. But now, rather than provoking shock, paintings by De Kooning, Pollock, Kline and Rothko yielded confirmation. Some aspects of the work he still felt unable to embrace. In particular, Pollock's drip technique – denying contact with the canvas – seemed too far from the tactile brushwork and gestural expressiveness to which he now felt committed. But in other respects, the heroic scale and ambition of Abstract Expressionism, and its immersion in subjective content, were values with which he identified completely.

## 10. On the map

Wanting to get closer to the ideas and values behind this flowering of American art, in early 1960 Irvin applied for a placement on a Seminar in American Studies to be held at Schloss Leopoldskron in Salzburg. The idea for the seminars had been formed at the end of the Second World War by two young ex-Harvard graduates, then serving as army officers in Europe. They wished to set up a context for the examination and discussion of American culture and the plans they made led eventually to the first Salzburg seminars. These were initially political in character and included representatives with an interest in law, the constitution and the media. However, in response to the growing international interest in American arts, the seminar which Irvin attended included a number of alumni whose backgrounds were artistic. Among those whom Irvin befriended were Rod Carmichael and Alex MacNeish, who were running the 57 Gallery in Edinburgh; the painter Hans Fruhman, whose wife, Christa, was then setting up the Galerie im Griechenbeisl in Vienna; and the pianist Hans Kahn.

Irvin had been recommended by a former alumnus and, fortunately for him, his fees were waived. He arrived at Schloss Leopoldskron – a former Archbishop's Palace in which Mozart once lived – with seven shillings and sixpence in his pocket. The faculty consisted of Phil Adams, the Director of Cincinnati Art Museum, and John MacAndrew, an architect who had been on the staff at the Museum of Modern Art, New York. It was decided that the painters would work at the Schloss and produce an exhibition at the end of the seminar. Irvin found this situation conducive to productivity. In these surroundings, far from London but in the company of others of similar ambition, he began to make works which were a leap forward.

Although *Town* (1959) had taken him to a degree of abstraction unprecedented in his work, its abutting slab-like shapes and landscape connotations were an echo of De Stael. The paintings he now made were larger, more completely abstract, their brushwork freer. There was also an increasing emphasis on drawing, though not to model or delineate. Rather, Irvin now used a traversing, non-depictive line which seems to explore the space of the painting.

*Moving Through* (1960) was made later that year and it clearly signals these developments. The entire painting is enlivened by sensuously applied paint – scrubbed and scraped at the left in an encircling movement; fluidly brushed in brilliant orange on the right, defining a large mass. Between these two areas, a path of red draws the eye across the surface of the painting. This then takes a sharp right turn along the bottom edge – a change in direction which leads out of the space. For the first time, such elements are entirely free of figurative reference and exist, instead, in terms of the visual dynamics they create. The subject of the painting, as the title suggests, is the line which moves through – a motif which connects with Klee's idea of taking a line for a walk.

Irvin, however, invests this idea with further meaning. In common with other paintings made around this time, *Moving Through* used a street map as its source material. Around 1960, Irvin recognised the relevance of cartographic symbols to his artistic aims. He observed that maps employ a visual language to denote particular areas and features of the landscape. And, as had been an automatic way of thinking in his navigating days, a line drawn between points represented an actual course. The implications of this realisation for his work were profound. He saw that he could incorporate elements of that symbolic language also to represent the real world in his paintings. Initially, Irvin appropriated these cartographic forms directly, using the irregular shapes and twisting lines of urban locations to suggest particular places and a connecting network of streets and roads. Later, these elements served as a starting point only. The lines which circumnavigate his paintings explore the world within the painting freely and imaginatively, recording his movement within the space of the canvas. At the same time he began to use these formal elements metaphorically, identifying them with his presence in the real world and with journeys taken in life.

The paintings which Irvin made from 1960 have greater authority and they seemed to bring about a change in his fortunes. John MacAndrew bought one of the new works and, as a result of the other contacts he made in Vienna, he was presented with two opportunities to exhibit. With the exception of four London Group shows, he had shown work rarely during the previous ten years, so these were welcome developments. Christa Fruhman joined her husband at the end of the Salzburg seminar and she invited Irvin to participate in the Galerie im Griechenbeisl's inaugural mixed exhibition, thus marking the first time his work had been seen

abroad. Significantly, Carmichael and MacNeish gave him his first one-man exhibition at the 57 Gallery. In this way his solo debut was made north of the border, thus marking the beginning of a close relation with Scotland which continues to the present day. Sydney Goodsir Smith reviewed the exhibition in *The Scotsman* and it is illuminating to quote his percipient response at length:

> Albert Irvin, at the 57 Gallery, 53 George Street, Edinburgh, shows five large canvases, half-a-dozen middle-sized oblong ones and another half dozen small gouaches – all abstracts … it is the large works that impress most. Whether this is on account of their size I should not like to say, but it would seem to indicate that certain talents are happiest when they have sea room, just as others, like Paul Klee, excel in miniature.
>
> Albert Irvin's abstracts make use of a very varied range of colour, bright and clean; his shapes are generally a contrast of squares and distorted circular movements on spacious flat masses. The aerial view motif – though modish, this type of composition deriving from landscape is frequently rewarding – is seen here once or twice: *Internecine Elements*, lime green and earth brown is very satisfying indeed, tranquil and calm; I would say there is a celestial order at heart. Another large canvas is *Cloud*. Irvin's cloud is green over a black landscape, more careless than most of his work but impressive. Much more successful is his large red and yellow *Sky Image* which could well be a companion picture to *Cloud* but surpasses it. I liked this well.
>
> These bright calm works are contrasted in this particularly well hung show with a number of night pieces. *Slow Black Night* is, as it should be, sombre indeed, a huge square of night, not oppressive, but – shall we say – satanic, rather fearsome, ominous yet calm withal – a fine work. Finer still is *Fertile Sphere*, a swirling red sun on midnight blue. This is a dramatic eye-holding picture which with *Sky Image* and *Two Part Invention*, whose title I do not pretend to understand, a long mauve red and black oblong suitably hung over the mantelpiece, is a more lyrical painting in its static, undemonstrative, Irvinian way.
>
> In Irvin's work one feels the abstract idiom is the right way for him to paint, that it is his way rather than one adopted obedient in fashion – though remember that this is said in ignorance of his previous work. There is more assurance here, less, as it were, feeling for the way than is often the case with abstract painters. An excellent show that should be visited.[9]

Goodsir Smith's review identifies some of the main features of Irvin's first fully abstract paintings; and it is striking that almost all the characteristics of his mature work are already present.

Largeness of scale, bright and varied colour, space and order are the characteristics which impress most. At the same time, the 'celestial' order which this critic saw, his reading of some of the paintings in terms of an 'aerial view', and the theme of sky and landscape which emerges in Irvin's titles, all suggest an aspect of these works which was not developed subsequently. Until around 1963, Irvin made paintings which derived from maps but which tended increasingly towards a pictorial evocation of sky and atmosphere. *Day Full of Time* (1962), for example, reveals its cartographic origins in the horizontal lines which traverse the canvas, weaving between larger, flat masses. The eye tracks these shapes, and moves inside the painted area, as if tracing a route on the page of an A–Z street map of London. But in many of these works such connotations are progressively obscured by the vapour-like handling of paint and a palette of whites, greys and ochres, which evoke air in movement. In this painting, the blacks, greens and tracery of red in the centre of the image appear like a fragment of land glimpsed from above through a break in the clouds.

In related works made at the same time, these implications of atmosphere are more pronounced. The title of *Open Sky* (1962) makes these associations explicit. In this painting a wide vertical form acts as a visual conduit, inviting passage across the surface of the canvas. Smaller, subsidiary lines – a red crescent, a blue cul-de-sac, and a connected artery forming a junction – offer alternative routes. This visual infrastructure is dominated by a large, white amorphous mass at the top of the painting. In *Quite Early One Morning* (1963), the network of shapes has itself become a movement of air – apparently on the point of dissolving or disappearing behind passages of suffused light and cloud. Such paintings are abstract. The relation of these elements within the works is explicable in terms of the artist's movement within a pictorial space. But, clearly, this formal exploration resonates with perceptions and empirical associations connected with the space that surrounds us.

Atmosphere, light and weather are refracted through these early map-paintings and comparisons can be drawn with Lanyon's work of the late 1950s. Lanyon's evocation of space and landscape was enriched after he took up gliding in 1959. Arguably, the sense of movement through air which informs Irvin's paintings of the 1960s can be attributed, to some extent, to his flying experience during the war. It would be misleading, however, to overstate this link between the two artists' work – despite a shared preoccupation with informing shape and gesture with experience. Lanyon's paintings are rooted in the history and topography of his native Cornwall. In marked contrast, Irvin's is an urban world. While his paintings do not depict specific places, they are impressed with perceptions of his immediate environment: the areas of London he has known since childhood. The pictorial structure he evolved derives directly from the roads and streets which enclose the heart of the metropolis.

Even so, perhaps sensing that Lanyon had already charted the territory, Irvin began to question that strand of his own work which was leading towards the evocation of atmosphere. Also, he felt that the paintings were becoming increasingly amorphous. In reality it was Turner, more than any other influence, whose spirit had presided over the development of his work towards a greater airiness. Seeking to open up the map-structures, the dissolving light he admired in Turner's late paintings was an inspiration. But, when he came to show these works in his next solo exhibition, he saw that this growing formlessness now threatened to weaken the sense of order he sought – and would necessitate a change of direction.

## 11. Into black

Irvin's second one-man exhibition was held at the New Art Centre, London, in October 1963. He showed twenty-one paintings completed in the preceding three years. This had been a busy period marked by some success. Following his 1960 exhibitions in Vienna and Edinburgh, in 1961 he showed paintings in group exhibitions at Galerie Wulfengasse, Klagenfurt, Austria, and at the New Art Centre, and he also had a work accepted by the John Moores Liverpool exhibition. The work shown in Liverpool, *Evening* (1961), had been bought by the Arts Council and they included it in their exhibition of recent acquisitions in 1962. During that year he also showed at the New Vision Gallery, London.

It was around this time that Nancy Wynne-Jones introduced him to the painter John Hubbard. This was the first link in a chain of connections that would alter the course of Irvin's career. They met in the Queen's Elm pub, not far from the Chelsea Arts Club, on Old Church Street, Chelsea. The Queen's Elm was a well-known meeting place for a range of figures variously associated with the art world. Writers, poets, actors and painters converged there to swap gossip and argue. Hubbard knew De Kooning and Rothko, and his connection with these artists was valued by Irvin. Hubbard's wife was a partner in the New Art Centre and it was through this association that Irvin showed there in 1961, in a group exhibition entitled *Four Young Artists*, one of whom was Ian Stephenson. His inclusion in that show made an impression and afterwards he was invited to teach part-time at Hornsey School of Art. His work was also seen by Andrew Forge, who offered him a further teaching position at Goldsmiths. After so long spent working in isolation, this looked like a windfall. He resigned from Spencer Park School, and accepted both positions.

He thus returned to Goldsmiths, this time as a member of staff. Just as he had found when he had been there as a student, the college was a melting pot in which different ideas, disciplines and personalities combined to produce a rich environment of enthusiasm and

invention. He found, among his contemporaries on the teaching staff, respected older figures like Kenneth Martin and, later on, Harry and Elma Thubron. There were also many bright, younger men such as Basil Beattie, William Tucker; and, during the 1970s, John Bellany, Jon Thompson and Michael Craig-Martin. Through the friendship he formed with Beattie, he became closely involved with more recent artistic developments. In common with other artists of this slightly younger generation, Beattie was at that time absorbing the impact of the growing reaction against painterly abstraction. Through Beattie, he met John Hoyland, whose large abstract paintings had already embraced a cooler, hard-edged manner, relating them to second-generation New York School painters such as Noland, Stella, Louis and Olitski. These contacts, and his association with the students, provided the hothouse of stimulation in which Irvin's work could thrive.

Such changes in his circumstances are reflected in the way his work now progressed. After 1963, Irvin's paintings are noticeably sharper in form, their structures more defined. Also, he now began to use bright, intense colours in vibrant juxtapositions. The beginning of this new phase can be traced to a series of oils on paper, painted around 1963–4, which he exhibited in Edinburgh University in 1964. These works banished the atmospheric wash which had been a dominant characteristic of the preceding paintings. In its place are bold, flat, hard-edged forms in clearly formed structures, whose origin as map symbols is overt. The titles of some of these works – *Resting Place* and *Around the Square* – playfully allude to the theme of occupying a space and moving around it: activities at once pictorial and real.

In the larger oils which followed, Irvin pushed these implications further, infusing the image with greater expressive drama. *Place* (1964) was one of the first of these and the contrast with paintings made only a year earlier is telling. Any surviving reference to observation has been swept aside by a strident colour scheme dominated by red. Irvin's admiration for Lanyon had centred on the Cornishman's treatment of space. But Lanyon's use of earth colours in the 1950s had seemed to Irvin reticent, as if he could not cut loose from the description of nature. In *Place* Irvin deliberately gives non-descriptive colour its head, celebrating its emotive power and asserting it as a force in its own right. As a result, Irvin invests the image with greater psychological and emotional intensity. The clash of hot shapes – crossed and connected by lines and stripes – excites the eye and animates the senses.

In the works which followed, Irvin deepened this affective dimension by bolder, more vigorous brushwork and by introducing even greater chromatic contrasts. In terms of its composition, *Black Moves* (1964) retains a sense of the map-forms in which it originated. But as we follow these shapes, navigating within the picture space, we must now cross zones of colour, entering and leaving sharply contrasted areas. A dotted line of yellow changes the pace

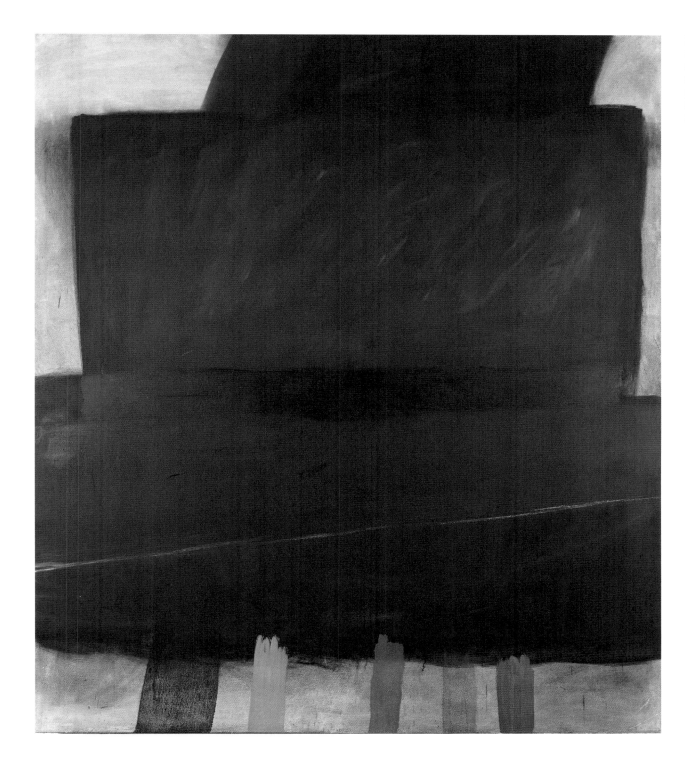

**Edge of Black**
1968
oil on canvas
203 x 178 cm
(80 x 70 in)
Ivan Chermayeff,
New York

**Into Black**
1966
oil on canvas
203 x 178 cm
(80 x 70 in)

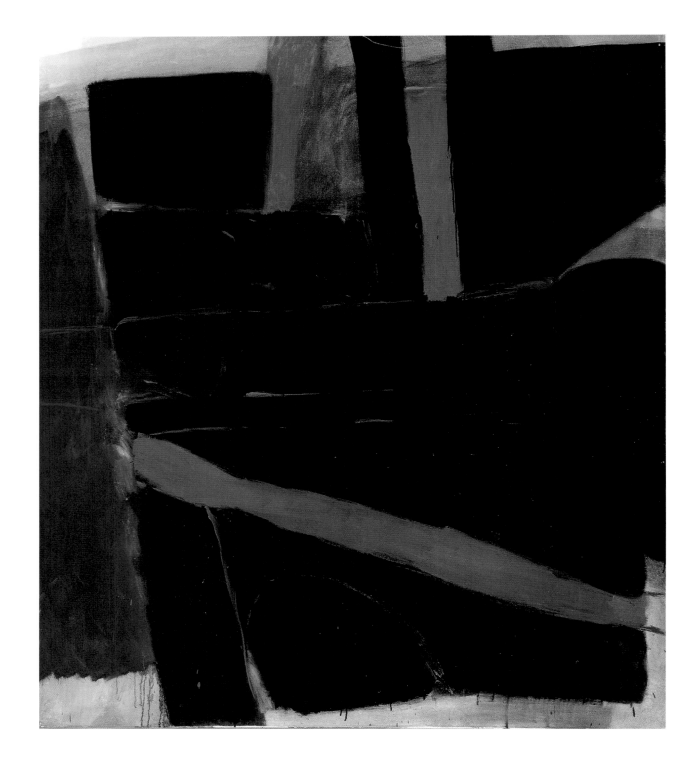

of this journey – as if the eye skips over this painted place. In *Nostos* (1965), the paths through the painting are themselves turbulent, put down with passion and sudden energy. These works announce the formation of a new, vibrant artistic vision. The image records the artist's creation and exploration of a virtual space but the pictorial means deployed are increasingly expressive of states of mind and emotion. The paintings invite us to move, metaphorically, from one place to another – and, at the same time, to explore a landscape of feeling.

During the mid-1960s, a vital aspect of these developments was Irvin's investigation of the character of the picture space itself. After *Place* (1964) and *Nostos* (1965), which used an 80 x 60 inch format, from 1965 onwards he began using the 80 x 70 inch dimensions favoured by De Kooning. *Blue Junction* (1965) exploits this new, broader format in the array of shapes which diverge from the centre in all directions. These proportions seemed to offer the greatest expanse which he could occupy while avoiding the more prosaic regularity of a perfect square. In 1967, however, he suddenly changed tack and, for almost a year, he experimented with works which were oval in format. In the end he regarded these paintings as failures. But though short-lived and ultimately doomed, this phase was intense – and also illuminating.

It began when he saw Robert Delaunay's *Windows* (1912) in an exhibition at the Tate Gallery in 1964–5. He was instantly struck by the work's beauty and attributed this, partly, to its distinctive shape. His initial thought was that the format had potential for his own work and, as a result, he later set about making a number of large oval stretchers. The first attempts were not promising. It seemed that whatever mark he made served only to confirm the dominant ellipsoid of the picture plane. The shape remained seductive but, as he continued, his frustration grew as painting after painting succumbed to the overwhelming character of the oval. Gradually he began to realise that whatever he did never seemed enough of a contribution to, or an intrusion into, the space. The problem was compounded by the difficulty of orientation while actually painting. Given the absence of sides and angles, he found that it was almost impossible to know his position in the painting and, in setting off with a loaded brush, to plot a course. In the absence of any obvious up, down or sides, the artist – as navigator – was lost.

Although he had to admit defeat, it had been a salutary lesson which focused his intentions. Hitherto, he had been concerned with developing the metaphorical implications of the painting episode – identifying his occupation of the canvas with the condition of being in the real world. This poetic alignment now deepened. He realised that, as in reality, in the picture he also needed co-ordinates – points of reference – which give a sense of location. Just as we measure ourselves in relation to our physical surroundings, the painter must know the limits of the space he inhabits physically and in his imagination. In this respect, the size and rectangular shape of the painting now assumed greater relevance. In a later interview, Irvin observed:

**The Infanta
Margareta in
a blue dress**
1599–1660
Diego Velázquez
AKG London/
Erich Lessing

**Gordale Scar**
1812–14
James Ward
Tate Gallery, London

It does become difficult to talk about, when you get a box you can describe as 'metaphysical'. You either become a philosopher and write about it or if not, if you are a musician or painter or poet, then you use your own language to make observations about the world. What I am prepared to say is that I do really feel the rectangle stands as the given of the imaginative world I inhabit when I make a painting; like verticals and horizontals of the urban world, floors and ceilings, streets and walls and so on, stand as the given of the urban world through which I have my being. In that sense I see the painting as a metaphor for my passage through the world … I like to make speculations about existence and the nature of the human being in the world in the painting.[10]

The analogy between the picture and the world had been strengthened. As a result, Irvin now felt less reliant on using map shapes to evoke his environment and could develop these shapes imaginatively and expressively.

Around 1966, he had begun to make paintings which were predominantly black. This was interrupted by the oval paintings and he now returned to that theme, producing an extended series of paintings which he exhibited at the Exe Gallery, Exeter in the spring of 1969. These impressive paintings are very different from anything Irvin had produced earlier. As well as being darker and employing fewer colours, they are simpler in composition, usually comprising a number of large, abutting, black shapes which fill the picture space. As before, traversing lines in other colours convey a sense of movement. They explore these sombre masses, penetrating their darkness. But the drama which Irvin generates now also derives from the relations between these compacted forms – pressing against each other – and from the shifts in scale between the different elements. A recurrent feature of these works is a row of colour accents at the bottom of the paintings. These few concessions to colour are dwarfed and overshadowed by the black masses above, which they touch tentatively, probing their edges. This fascination with a bold formal juxtaposition was inspired by the tiny fingers of the Infanta, seen against the expanse of her voluminous dress, in Velázquez's remarkable paintings of the young Princess Margareta Teresa; and the idea of contrast is central to the aesthetic advanced in these new works by Irvin.

While movement within the space is still an evident concern, the syntax of the composition – its organisation – is now to the fore. All artists know that complementary colours – red and green, yellow and purple, orange and blue, and so on – can be brought together to generate visual excitement. But Irvin now took this principle further, juxtaposing shapes which are contrasted in character and size to stimulate the eye. The use of *complementary forms* thus entered Irvin's armoury. These devices generate a sense of psychological drama, and invest the paintings with a tense energy. Of these developments Irvin has explained that 'the confronta-

tion and dialogue of forms, the way they conflict, flirt, escape, move, evokes life's drama'. The formal argument is now identified, not only with the journey through life, but, at a deeper level, with the physical and emotional dynamics of existence – that chaos of interconnecting and opposing forces through which we navigate.

## 12. Travelling around and creating SPACE

The year 1968 was one of the most troubled in America's history. In January, Communist forces launched a massive offensive in South Vietnam and, as casualties mounted, the tide of feeling in America against the war reached new heights. In March, hundreds of Vietnamese civilians were gunned down by US troops invading the village of My Lai. Less than three weeks later, Martin Luther King was assassinated. The resulting social unrest provided the backdrop for an extended visit to the USA which Irvin commenced in late January that year.

The three months which Irvin subsequently spent in America were the result of an Arts Council grant. Andrew Forge had recommended him, indicating that the opportunity to travel in America and gain first-hand experience of its art scene would be beneficial. Accordingly, Irvin received an award of £750 – which immediately depreciated when Harold Wilson's government devalued the pound. He then embarked on a sabbatical from Goldsmiths, travelling on a BOAC Comet to Washington, where he had friends from the Salzburg Seminar. He arrived without any set programme other than to see as much art as possible and to follow up a number of contacts he had been given. One of his first introductions was to the young black painter Sam Gilliam, who knew Kenneth Noland and was a central figure in the circle of artists based in the capital. Through Gilliam, Irvin visited the studios of a number of other younger painters and was able quickly to gauge the climate of ideas and concerns then prevailing. During this time he saw exhibitions by Frank Stella and Al Held. The large scale of their work made a strong impression. With Gilliam he also visited Washington's jazz clubs. Irvin loved jazz but here there was a sense of being closer to the wellspring. The musicians' freely improvised lines seemed simultaneously to explore and create rich musical textures. He found a thrilling vitality in sound which mirrored the expressive immediacy he had been seeking in paint.

From Washington, Irvin moved on to New York where he made a point of staying at the Chelsea Hotel on West 23rd Street. This was partly because of the connection with Dylan Thomas, whose poetry Irvin greatly admired and who had spent his last days there, and partly because it was close to Jack Tworkov's home on East 23rd Street. Irvin had met Tworkov in London when the American painter had done a term's residency at the Royal College of Art. As previously arranged, Irvin now looked him up on his home ground. Of all the American

Aerial view of
St Katharine Dock
1960s

Irvin's studio in St
Katharine Dock
1969
(from right to left)
Peter Sedgley,
Richard Leachman,
Bridget Riley, Irvin.
*Crusader* hangs in the
background

Exhibition catalogue:
*Contemporary British
Painting*
1969
Delaware Art Center,
USA

painters whose work Irvin had seen at the Tate in 1959, Tworkov was the one with whom he had closest contact. In Tworkov he found an intellectual willing to talk. The older man had succeeded Josef Albers in the Art Department at Yale and, during the 1950s, his interest in Zen Buddhism and Japanese brush painting had influenced the formation of an approach steeped in broad, gestural mark-making.

In his catalogue statement for the Tate's *The New American Painting* exhibition, Tworkov had observed: 'My hope is to confront the picture without a ready technique or a prepared attitude – a condition which is never completely attainable; to have no programme and, necessarily then, no preconceived style'.[11] Irvin felt an affinity with Tworkov's work. During his stay in New York the two men talked a great deal and Tworkov asked to see Irvin's paintings. Given the circumstances, this was not an easy request to accommodate. Nevertheless, a plan was contrived. Back in London, Basil Beattie unstretched three of the large recent black paintings, including *Into Black*, for which Betty then acted as a courier. Irvin met her at JFK airport and shortly afterwards he found himself restretching the works in Tworkov's studio, using the senior artist's tools and stretcher bars. It seemed an amazing conceit and Irvin was not a little apprehensive. His fears, however, were unfounded for Tworkov's response was both positive and encouraging. The paintings were set up in the studio and over two or three days they were seen by various invited visitors, including the composer Morton Feldman. Among these was also Rowland Elzea, the Curator of Collections at Delaware Art Center. As a result of that viewing, Elzea invited Irvin to participate in *Contemporary British Painting*, an exhibition to be held the following year at the Art Center. Elzea's selection was designed to give a 'sampling of the paths British painting has travelled since the Second World War'[12] and it comprised a range of artists of different persuasions, notably Patrick Caulfield, Terry Frost, Patrick Heron, Ivon Hitchens, R. B. Kitaj, Ben Nicholson, Victor Pasmore and Bridget Riley. It was an accolade to be included, and doubly sweet to have been selected in the studio of a distinguished older painter in the heart of New York.

Tworkov was a friend of Robert Rauschenberg, by then one of the most influential and celebrated of the artists who had succeeded the first generation New York School artists. Acting on this contact, and armed with an introduction from Andrew Forge, Irvin rang Rauschenberg and was immediately invited to his downtown studio on Lafayette Street. He found a large complex of spaces, devoted to various activities – painting, sculpture, printmaking – housed in a converted church. Although Rauschenberg was close in age, the American's relation to Abstract Expressionism was somewhat different from Irvin's. The 'combine' paintings Rauschenberg had made from the mid-1950s revealed a debt to painterly abstraction but their inclusion of figurative imagery and found objects also manifested an ironic critique of that earlier style. In

this respect, Irvin's values were closer to those of Tworkov, his senior by over twenty years. Even so, the meeting with Rauschenberg was extremely cordial – helped, no doubt, by several enormous glasses of scotch. Irvin was impressed by the energy and dissonance of Rauschenberg's work, by its emphasis on improvisation and, surprisingly, by its inclusion of activities outside painting. At the time of Irvin's visit, Rauschenberg was preparing for a 'Happening', one of the multi-media spectator events which involved the artist as an active participant. Though Irvin's prime commitment would always be to painting, the emphasis which these spectacles placed on the artist's *performance* connected with his own thinking.

It was also a time to devour the great art collections. The Museum of Modern Art was of course de rigueur. But he was equally anxious to see the Frick Collection where Rembrandt's *Polish Rider*, with its poignant intimations of a lone traveller, for Irvin, carried a powerful personal and artistic significance. He was especially keen to see De Kooning's work in greater depth. Until then, his direct acquaintance had been limited to the relatively few works loaned to London exhibitions. Accordingly, he now listed the locations of all the De Koonings in his immediate vicinity and set about tracking them down. In addition to the Whitney and Brooklyn museums, his travels took him to Utica, Ithaca, Rochester, Buffalo and Boston. Returning to Washington, at the Phillips Collection he asked to see De Kooning's *Ashville*, which was at that moment in store, and was surprised to be shown the work by James McLaughlin, the Museum's Director. It was a memorable meeting, for McLaughlin ended up by giving Irvin a tour of the art stores. He then decided to throw a party in Irvin's honour, an occasion which once again gave him an entrée to the local artistic community. Irvin's stay in the USA was to have concluded in similar vein. A farewell party was planned but never took place. Following the violent death of Martin Luther King, a curfew was imposed and the party had to be called off. It seemed a propitious moment to leave.

Returning to London at Easter 1968, Irvin encountered an atmosphere of similar social ferment. He now found himself at the centre of things, for the focus of discontent was Britain's student population. In the universities and colleges, revolution was in the air. The students at Hornsey College of Art took over the running of the school, and at Goldsmiths plans were being made for a free festival. As a teacher Irvin was, in a sense, part of the establishment. But the appetite for change – for liberation from the old values – also extended to the artistic community to which he belonged. Among his peers, the talk was of the need for an alternative to the system of dealers and galleries which controlled the sale and exposure of artists' work. At the forefront of these developments were the artists Peter Sedgley and Bridget Riley. Their idea was for the creation of an Artists Information Registry (AIR): a central repository of information about artists' work which would be available for open consultation. The theory was

**Blues**
1972
acrylic on canvas
244 x 427 cm
(96 x 168 in)
Peter Raue, Berlin

that artists could be contacted through the registry and sales made directly, eliminating the need for a dealer or other representative.

One immediate implication was the question of where to house this information bank. Out of the search for an appropriate site evolved a second, more far-reaching plan. Why not set up a centre that would accommodate the registry *and* also provide studios for artists, so that the information and the work were linked? This realisation was the genesis of SPACE – Space Provision Artistic Cultural and Educational – a privately administered company, letting studios to artists, which survives to the present. At the time, such plans were new and tremendously exciting and interest spread quickly. Irvin was among the first to get involved. He was joined by Basil Beattie, Alan Green, John Murphy, Ian McKeever and others. At first it seemed that the old Marshalsea Prison, then a warehouse, might be a suitable location but this idea fell through. Around the same time, it became clear that the warehouses at St Katharine Dock, close to Tower Bridge, would be available. Masterminded by Peter Sedgley, this possibility was pushed forward and later that year SPACE took up residency at the site. Within a short period over 150 artists established bases at St Katharine Dock, including several from further afield. Michael Craig-Martin came over from Yale and Roger Kemp travelled from Australia. A number of art colleges also joined. The Slade, Byam Shaw and Portsmouth schools set up studios.

Initially, of course, there were differences about the way the complex should organise itself. Sedgley favoured an open-plan arrangement, a true collective with artists working and participating in a shared studio space. Irvin had by this time established a close friendship with Sedgley but was against this proposal, arguing for individual, private studios. Others agreed with Irvin and in the end this view prevailed. In terms of the organisation's philosophy, however, there was unanimity. SPACE was to be run democratically and, as things turned out, this is the way it developed. Irvin responded to the focus for ideas and creativity, and the opportunity for association, which St Katharine Dock offered. Within its precincts the centre housed a comprehensive cross-section of artists – a radical alternative to traditional academies of art.

Irvin's stay in America had influenced his thinking and this, combined with the dramatic changes in his working environment, opened the way to a new phase of activity. In contrast to the confined studio space at his home at Battersea, he now occupied a much larger area which permitted greater freedom. One of the main developments was a change in the way the works were made. *Rider* (1969) was among the first paintings he completed at St Katharine Dock and its appearance reveals a completely different approach. There is a new concern to allow the physical process to create the work. Although the proportions of *Rider* are the same as the earlier black paintings, the entire image comprises thin washes of diluted colour brushed, wiped and stained into the canvas. Using five-gallon barrels of turpentine, Irvin's technique embraced

the liberal use of this diluent to alter the consistency of the paint, making it completely fluid and transparent. The result is to banish the heavy opacity of the dark paintings and to replace this with bands of translucent colour traversing the canvas.

Previously the activity of making the paintings had been recorded in the brushwork which, though broadly applied, remained controlled and deliberate. *Rider* and the related paintings *Crusader* (1969), *Excursion* (1969), *Striker* (1970) and *Saint K* (1970) increasingly deny the evidence of the artist's contact with the canvas. Brushwork is subsumed in areas of flat staining and, though structured, the character of individual passages is less circumscribed. Sometimes applied with sponges, the paint has been allowed to soak into the weave or run down the canvas surface, finding its own edges and density. Irvin's earlier paintings had proceeded in a spirit of discovery and these new works developed that theme. But, in allowing the areas of paint to move outside the artist's control – admitting chance and gravity – the journey into the creation of an image became less autobiographical. Instead it began to connect with natural forces operating in the world.

In addition to this freer movement of paint and use of high-key colour, the works Irvin made at St Katharine Dock are related in terms of composition. Although these paintings were no longer derived from maps, there is an echo of the earlier street-shapes in the large diagonal forms which cut into or across the picture space. These diagonals are also related to the small finger-like forms at the bottom of the black paintings. Whereas those minor shapes were tentative in character, as if probing and testing the picture space, here they have been enlarged and have become dominant elements. In some instances, they travel between the top and bottom edges of the canvas; in other cases they move towards its centre and stop. In *Rider*, they converge from opposite directions, mingling within a lozenge-shaped zone – a kind of meeting place – in the middle of the painting. These devices are strongly directional and convey a sense of movement. At the same time, they are dissonant shapes whose bold colour carries emotive force. They contradict the picture's vertical and horizontal edges, intruding into its space, and filling it with their resonant presence.

Irvin's work seemed to draw strength from the experience of working at St Katharine Dock. Naturally gregarious, he found the context for close association with other artists both stimulating and encouraging. This is evident in the paintings he made there, which are impressed with greater confidence and ambition. The philosophy of the new organisation also favoured him for there was growing interest in his work. *Striker* and *Excursion* were both sold to private collections, *Saint K* was bought by the Chase Manhattan Bank, and *Rider* became the first of his paintings to be considered by the Tate Gallery. Subsequently declined, it was eventually purchased by the Contemporary Arts Society and is now in Blackburn Art Gallery. SPACE's

Arriving at the studio,
Stepney Green

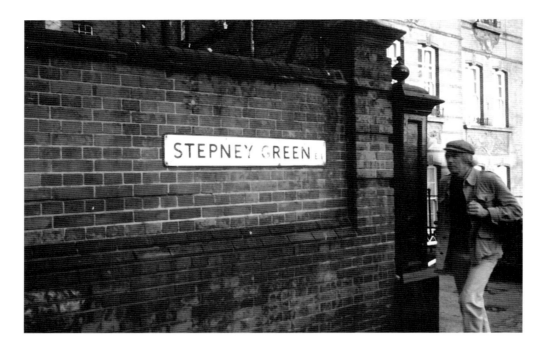

Irvin's studio,
Stepney Green

occupation of the dock site was, however, relatively short, for the lease of the building was due to expire on Christmas Eve 1970. Now supported by the Greater London Council, who recognised the success of the initiative, two alternative buildings were proposed. The first of these was an old clothing factory at Martello Street in Hackney. The other was a former Jewish School at Stepney Green. Irvin opted for the latter, partly persuaded by the immediate availability of the school, but more so because the lofty classrooms were perfect for making work on a vastly increased scale.

## 13. To Stepney Green

Irvin moved to his present studio in Stepney Green in early 1971. Initially thirty-five artists shared the site and during the 1970s these included, among others, Anthea Alley, Basil Beattie, Ian Breakwell, Hubert Dalwood, Jules de Goede, John Gibbons, Michael Kenny, Bridget Riley, Jon Thompson, Alison Wilding and Victor Willing. At the beginning Irvin and Beattie occupied adjacent rooms. Confronted by the very different character of the new space, Irvin contemplated his next move. There was a sense that events were moving quickly. In the preceding three years he had changed his workplace twice, spent three months in America, and his work had moved forward in ways he had not foreseen. At this point he did not know where the new paintings were taking him. He was going with the internal momentum he had created and with the pressure of outside influences. But his immediate impression now was that in this Victorian classroom, for the first time, he could make paintings as large as they needed to be. There were no constraints.

Irvin had been fascinated by the expressive power of scale ever since seeing James Ward's painting *Gordale Scar* at the Tate Gallery. Ward's great evocation of vastness in nature impressed him because of the way the picture uses its own overwhelming proportions to convey the awesome grandeur of the motif. Standing before the painting, the viewer must look up to take in the image and, in so doing, its vertiginous aspect is forcefully communicated. The lesson was clear. Largeness of scale is not an end in itself. But if the imaginative breadth and physical size of a painting are in proportion, then the experience it conveys is strengthened.

He had begun to make mural-size paintings while at St Katharine Dock. *Crusader* (1969) was the biggest painting he had then attempted, and at 92 x 168 inches its proportions were the largest that could be accommodated in that studio. However, the physical constraints of the place meant that for the time being he had to forgo these ambitions. The move to Stepney Green removed all such inhibitions and almost immediately he commenced a series of large paintings, each 96 x 168 inches. These included *Quest* (1971), *Voyage* (1971) and *Travelling*

**Illumination**
1972
acrylic on canvas
335 x 610 cm
(132 x 240 in)

*Alone* (1971). He began with *Quest,* which was made by brushing fluid colour onto the canvas and allowing it to cascade downwards. In *Voyage,* touch was eliminated completely. The painting evolved by throwing cans of paint at the canvas in small arcing movements. In each case the final image took the form of a wall of overlapping stains of colour surrounded on three sides by areas of bare canvas.

In one way the epic scale of these works can be seen as a riposte to the enormous canvases he had seen in America. At a deeper level, their size is intimately bound up with the particular concerns they address. Their expansiveness was an attempt to develop the pictorial arena, taking it closer to the condition of real space. While he was making these paintings, his movements around the canvas traversed much larger physical intervals. The activity within the painting involved real journeys. Their size also affected the relationship between the viewer and the image. The canvas fills the field of vision so that there is an impression of being in the picture. The shapes in the painting are apprehended in physical terms, relative to the viewer's position. Some areas are above eye-level, others are closer to the ground. Certain passages are far to the left or close at hand, near to the right. As in life, a sense of location is formed from relating one's body to its surroundings. To take in the image, the viewer must travel around the painting – visually and physically. This enlarged scale thus creates a more tangible space, at once pictorial and real, which the artist and the viewer can inhabit.

These paintings also took Irvin's earlier engagement with process a step further. In particular, his progressive withdrawal from direct contact with the canvas was taken to its logical conclusion. These works have a greater sense of anonymity. Their surfaces are no longer impressed with the artist's handwriting in the form of expressive brushwork. Instead, they evolved from a situation in which the artist created the conditions, and performed certain actions, which allowed events on the canvas to unfold in an uncontrolled way. Such developments can be related to the widespread reaction against autographic mark-making which had set in during the preceding decade. In particular, the way Irvin distanced himself from the canvas represents an awareness of the ethos of second-generation New York School painters such as Morris Louis, whose work asserted a more impersonal surface.

Despite this apparent break with his earlier practice, these paintings are nevertheless an extension of his previous concerns. Insofar as the process involved a dialogue between control in the first instance, and then a surrender to natural, accidental and unforeseen developments, this took the painting situation closer to reality. We make plans, create the conditions for things to happen, we hope and we act – and then nature intervenes: our expectations are confounded and events take a surprising new turn. The making of the paintings, like life, becomes an adventure: an analogy is implicit in some of the works' titles.

It would be misleading, however, to overstate the impersonal element in Irvin's stain paintings. One of the paradoxes of his work at this time is that while throwing and pouring paint removed the signature brushwork of the artist – and in that sense they are less personally expressive – at the same time these works are, if anything, more painterly than ever. The movement of the paint – bled, stained, dripped and spattered – and its build-up into a crescendo of colour, are an immersion in the act of painting. There is a sense that the artist's engagement with his materials has intensified. To that extent his involvement, though less direct, is even more enmeshed with the life of the painting. These developments also need to be seen in a wider context. The 1960s had seen the emergence of a number of avant-garde movements, notably Minimalism and Conceptual Art, the premises of which seemed inimical to the use of canvas and colour. The death of painting had of course been rumoured and resisted since the invention of photography. But as the 1960s drew to a close it seemed to many painters that their chosen means of expression was under greater duress than ever. Certainly in Irvin's circle there was a sense that continuing to paint was not only a matter of personal necessity, but was a stance taken to secure its survival. That Irvin's work should now proceed this way – aggressively flaunting the activity and the substance of paint – can be seen as sheer defiance.

In this respect, Turner was both a source of inspiration and a rallying spirit. More than any other artist, his is the presence most invoked by Irvin in the dissolving forms and translucent colours which characterise the works of the early 1970s. Turner's celebration of nature, his quest for the sublime, and his transformation of feeling into light are the unattainable benchmarks. Turner became, and remains, Irvin's 'home-bred God'. On 23 April 1969, for the first time, Irvin invited a group of friends and artists to come together to celebrate the great man's birthday. The idea for the occasion partly reflected Irvin's impatience with a culture that, on the same day, celebrated the birth of Shakespeare but ignored another national treasure. Clearly, in Britain at least, writers were rated more highly than painters. The Turner birthday party also took place as a way of celebrating painting. It ended, appropriately, with a toast – using Turner's own words: 'Painting is a rum business!'. Thus commenced a tradition which continues to the present day.

The excitement of the move to Stepney Green was heightened by the news that Irvin had been selected for inclusion in the large group exhibition *London Now in Berlin*, to be held in Berlin later that year. This generated some sense of urgency. For, in addition to making new paintings for a forthcoming one-man show at the New Art Centre, he was keen to finish a new large painting for Berlin and he worked on *Quest* with that prospect in mind. Peter Sedgley had been instrumental in setting up the exhibition. He had recently visited Berlin and had been in contact with the Senate there. They were aware of the success of the SPACE project and wanted

him to develop something similar in Germany. Out of those discussions arose a plan to stage an exhibition at the Messehalle in Berlin which would survey the London art scene, focusing in particular on the artists associated with SPACE. This was to be the beginning of a long and fertile artistic association between Irvin and Germany. For during the next decade it was there that his career would make greatest headway.

Over thirty artists were represented in *London Now in Berlin*. Apart from Irvin, the line-up included Basil Beattie, Stuart Brisley, Rose Finn-Kelcey, Ian McKeever, John Murphy, Peter Sedgley and Bridget Riley. In addition to *Quest*, Irvin showed three 80 x 70 inch canvases. The exhibition was well received and drew a great deal of local interest. It was particularly successful for Irvin as he sold all four canvases to the Berlin-based dealer Folker Skulima, who also invited him to show at his gallery the following year. This contact with Skulima precipitated a sequence of events and raised the tempo considerably. Through Skulima a further exhibition was set up with Galerie Klaus Lüpke in Frankfurt, also in 1972. Most significantly, as a result of these two shows, plans were made for a solo exhibition at the Städtische Kunstsammlungen Ludwigshafen-am-Rhein, to be held in 1974. This was particularly gratifying, for it would be Irvin's first exposure in a museum setting and the largest group of paintings he had ever shown. In the interim, however, there now occurred an event which changed the course of his work.

One of Skulima's clients, Hermann Wiesler, Professor of History of Art at the University in Berlin, admired Irvin's work and they met on a number of occasions. Professor Wiesler, who was later engaged to write the catalogue essay for the Ludwigshafen exhibition, asked Irvin to consider doing a painting for the ceiling of the library in his Berlin house. Irvin had not previously worked to order and, initially, was reluctant to accept. In addition to the geographical implications, there were numerous technical difficulties. There was also the size of the image to take into account: at a colossal 11 x 20 feet, this would be by far the largest area he had ever attempted. Perhaps it was the sheer audacity of it all that convinced him. Whatever the reason, he accepted.

The first problem to be confronted was how to create the image on the ceiling. Wiesler was against painting the plaster, not least because he wanted to be able to transport the painting if the need arose to move house. As Berlin was then in the front line of the Cold War, this was undoubtedly a sensible precaution. However, the option of attaching a painting on its stretcher was not viable for, given the enormous size of the ceiling, the canvas would sag under its own weight. A compromise was therefore proposed. Irvin would paint the work on a conventional stretcher, and the canvas would then be de-stretched and stuck to the plaster. This would permit its future removal if necessary, and it also meant that Irvin could work on the painting in his studio.

Having solved what appeared to be the main practical aspects, Irvin still had to come to terms with the visual and aesthetic implications of the project. He was concerned in particular about the unusual relationship with the image, unique to this kind of situation, which the setting imposed on the viewer. Apart from seeing the work directly above as opposed to straight ahead, two other factors asserted themselves. The first of these was that, whereas with a wall-mounted painting the viewer could approach the image and vary his distance from it, in this instance that interval was fixed. Clearly the image had to be readable taking into account this invariable viewing distance. Secondly, and more problematic, was the question of orientation. Although abstract, Irvin's work has a definite top and bottom which are clear when the paintings are hung. However, because the library could be entered from either of two entrances at opposite ends of the room, it would not be obvious which way round the painting should be viewed.

With these considerations in mind, Irvin commenced work on the painting back at Stepney Green. One point in his favour was that the ceiling in his studio was approximately the same size as the one in Wiesler's library, so he could form some idea of the presence of the work in relation to the proportions of the surrounding space. Initially the image evolved in the same way as the previous stain paintings: with the stretched canvas standing vertically and the downward movement of poured paint given over to gravity. As soon as this occurred, of course, the painting fell into a defined upright orientation. The pour at the top was clearly differentiated from the cascade drawn towards the earth. But now, to take account of the circumnavigability of the image, Irvin turned the canvas through 90 degrees and repeated the pouring process. The resulting veils of paint cut directly across the previous trails. Having taken this decision, the way was then clear to turn the canvas again twice, so that in effect he was working in the round, coming at it from all sides. Throughout this process, he previewed the progress of the image by laying it flat and then climbing a ladder to look down on it from a distance which approximated the ceiling height of the library. Improvised though they were, these methods were effective, for the painting was completed, transported and subsequently fixed in position. The experience had also been unexpectedly valuable, for he now saw how these ideas might be developed in the future.

Working towards the Ludwigshafen exhibition, Irvin embarked on a series of large paintings which progressively tested the limits of all the strategies he had evolved in the preceding three years. One of the first of these works was *Blues* (1972), a painting which pushed forward into new territory yet fell back onto familiar ground. Employing the techniques he had evolved for the library painting, during its execution *Blues* was turned through 180 degrees and worked on from two sides. This represented something of a breakthrough in that he was no longer constrained by a fixation with one orientation but was able to move around the painting freely. As

**Across**
1974
acrylic on canvas
244 x 427 cm
(96 x 168 in)
Aberdeen Art Gallery

yet, however, the work remained vertical while he worked on it. The action of pouring from its top and bottom edges resulted in large amorphous clouds of colour which travelled downwards across the bare canvas, converging towards the centre but not quite meeting. As a result, a horizontal division opened up in the centre of the image, separating the massed forces on either side. In the work's closing stages, however, Irvin drew back from this new development and flooded the gulf with a vast, unifying wash of blue.

In the subsequent works, *Illumination* and *Celebration* (both 1972), he resisted this final move. For the first time he worked on these paintings while they were laid flat, using a squeegee to thrust the paint towards the centre, in some areas letting it form pools. He came to see the intervening expanse of bare canvas as a kind of no-man's land which generated a sense of confrontation between opposed elements. *Illumination* used the stretcher for Wiesler's enormous painting and at twenty feet in length is the most ambitious of these monumental works. The image continues earlier themes of movement in space: the journey taken by the paint as it bleeds into the canvas; the eye which traverses the coloured shapes, feels their irregular edges, and then leaps across the void. In this sense, the great size of this image, with its cloud-shapes suspended above and the jagged forms rising below, create a pictorial drama fraught with nature. In the visual language of the twentieth century, it is the picturesque sublime revisited. But, at the same time, the tension between these forms is an abstraction – a distillation of feeling identifiable with all its sources in life.

## 14. Doing battle

The mid-1970s were transitional years for Irvin. In 1972 he turned fifty and, as the decade drew towards its half-way point, he seems momentarily to have paused, taken stock, and then moved on. The works he completed that year – *Illumination* in particular – represent the climax of an approach he had been pursuing since his return from America. Certainly in terms of scale, he could proceed no further – nor did he need to. When these paintings were shown in Ludwigshafen in February–March 1974, their enveloping dimensions made a telling impression; and, as a whole, his first exhibition in a public gallery could be counted a triumph. The selection of thirty-three paintings surveyed five years' work, from 1968 to 1973, and in 1975 it transferred from Ludwigshafen to Berlin, where it was shown at the Opera House. The similarly favourable response it received there provided confirmation and encouragement. Even so, Irvin had mixed feelings. The opportunity of showing a large number of works had enabled him to assess their development and he was especially interested in seeing how the most recent works stood up. They were rather different in character from the rest. Having always used oil

paint, these were his first essays in acrylic. The comparison suggested that this new way of working had potential but as yet it remained unsatisfactory.

To a layman, this change in materials might appear of little significance. But for a painter, taking up a new medium with entirely different characteristics, after so long, is a decision not taken lightly. Unlike oil, which dries relatively slowly, acrylic is quick-drying, thinned with water and, when no longer wet, darkens slightly. At the very least, therefore, the different behaviour of the paint would require the formation of a new approach. Almost certainly, too, the character of acrylic would change the look of the work – in ways that would not be entirely foreseeable or subject to control. On a positive note, the adoption of new methods offered the prospect of change and a fresh way forward, a factor which undoubtedly coloured Irvin's thinking.

In part, this desire to alter the way he worked was occasioned by practical considerations. Working on a vast scale required gallons – literally – of paint dissolved in turpentine, a situation that was creating an increasingly beleaguered studio environment. But also, having pushed the process of pouring paint to some kind of conclusion, he now wished to re-establish direct contact with the paintings. When he had been using a squeegee to apply acrylic primer he had seen the way that the plastic-based medium accurately preserved each movement and gesture. Its potential for making marks which could carry a charge of feeling was clear. Using acrylic also meant that he could cover large areas, he could superimpose paint layers without lengthy drying periods, and its plasticity offered great versatility of substance and opacity. The development of Irvin's painting after 1973 is therefore inextricably linked with his investigation of this new vehicle for expression.

In particular, acrylic lent itself to an intensification of visual drama. The stain paintings shown at Ludwigshaven had demonstrated that the opposition of elements could be exploited for emotive ends. The top and bottom of the paintings seemed locked in a stand-off, as if confronting each other across a chasm. As he now saw, that confrontation was between similar elements, held in stasis. But, as dramatists know, bringing together protagonists who are *unequal* creates light and shade and generates greater interest. Irvin realised, therefore, that the pictorial tension could be raised by introducing shapes which are contrasted in character. The seeds of this approach are apparent in *Across* (1974), Irvin's first major statement in acrylic. Echoing the earlier works in oil, the top part of the painting takes the form of overlapping washes of tranquil colour. But below this the painting is a field of agitated activity – a great tangle of superimposed gestures compressed into a knot of contained energy.

The works which followed accentuate this difference. *Jubilee* (1975), for example, deploys these shapes on a mammoth stage – twelve feet high and almost twenty feet long. And the contrast between the rival parts of the painting is even greater. Six fragments of pale yellow hang in

the space at the top of the picture, suspended passively above an aggressive pushing and pulling of opaque pigment below. This lower area uses the quick-drying properties of acrylic to build up layer upon layer of paint. As before, a narrow stretch of bare canvas keeps the two areas apart. In common with *Hannibal* (1975), a predominantly orange painting, these works are extemporisations in closely matched colours and tones. As such, their expressive power arises from a sense of conflict between two antagonistic formal elements. In this opposition is encapsulated the aesthetic which underlies Irvin's work to the present day. The painting is a platform on which the artist, as it were, performs. And the drama he enacts is identified increasingly with the human condition – a situation beset by dichotomy – in which order and chaos vie for supremacy.

The spectacle of embattled pictorial forces continued throughout 1976. Working towards a run of exhibitions that year – at the New Art Centre, London; the New 57 Gallery, Edinburgh; Aberdeen Art Gallery; and Galerie Klaus Lüpke in Frankfurt – energy and intensity are linked in the series of paintings he produced. This sequence includes *Senrab* (1975), *Cephas*, *Varden* and *Rampart* (all 1976), among others. All these works are in the 7 x 10 feet format which became his favoured proportions from now on. As before, this development was triggered by practical considerations, the size being the largest that could be accommodated at the Edinburgh venue. In these paintings the Dionysian character of the lower part of the canvas was emphasised. With the use of squeegees and pieces of corrugated card, the paint has been scraped and dragged as if by a giant palette knife. The movement of the paint is wild and violent, so that the surface flickers with a dark energy.

As work on these paintings proceeded, Irvin became increasingly preoccupied with developing the space between the two parts of the image. Aware of the need to prevent the motif splitting into two distinct halves, he explored ways of marrying the combatants. In *Varden*, the turbulent mass of blue has sent up a wave which splashes over the edge of the spectrum above. *Senrab*, *Cephas* and *Rampart* all have a horizontal buffer zone which both separates and joins the top and bottom parts of the image. This device succeeds in unifying these parts but, in the case of *Cephas* especially, the intervening area seems crushed between the converging pressures. These are extraordinary paintings – a sudden efflorescence of feeling, at once passionate and urgent – in which the act of creating seems like a struggle to be.

The titles of these works reveal a further development in Irvin's thinking which occurred shortly after he began painting with acrylic. Previously the naming of the works had referred, descriptively, to a sense of movement or journeying: *Across* was one of the last of those titles. From *Jubilee* onwards, Irvin identified his paintings using the names of streets. This is a convention that he still uses. Initially the streets involved were those in the immediate vicinity

of his studio. Senrab Street, Cephas Street and Rampart Street are all within walking distance of Stepney Green. Subsequently, other London streets further afield were used. Finally the paintings drew their nomenclature from places in other cities, in Britain and abroad. In one way, this system was simply pragmatic – and much more memorable than numbering the works. But at a deeper level, the use of street titles confirms the works' metaphorical significance.

Echoing his earlier use of maps, they identify the paintings' imagery with the experience of moving through an urban setting, and the process of their making with going on a journey. Sometimes there are further connections. A particular painting will be linked with the personal associations generated by a specific place. For example, *Sul Ross* (1981) was named after the street in Houston, Texas on which the Rothko Chapel stands, and the painting was made after a visit there. Alternatively, the sound of a street name, or the ideas it evokes, may resonate with the character of a work. The militaristic connotations of *Rampart* convey something of the sense that, for Irvin, a painting is the outcome of the battle waged with materials in order to capture an image.

This struggle to give shape to feelings and states of mind is in no sense, however, a negative or destructive force. Rather, it is the creative essence of Irvin's art and during the 1970s this ethos hardened. In a later interview he observed: 'Paint used with vitality reflects the nervous energies of the artist and communicates directly with those of the spectator'.[13] During a decade when the critical pendulum had gradually but decisively swung away from autographic expression and towards idea-based art, this stance was becoming increasingly difficult to maintain; not least at Goldsmiths, which had become closely identified with conceptual art. Throughout this period, while he continued to teach there, Irvin found considerable support in the company of painters such as Basil Beattie.

Before the painting school moved to Surrey Docks in 1972, a further source of strength arrived in the shape of Harry Thubron. This charismatic and influential teacher had been Head of the Art Department at Leeds. Though only in his fifties he seemed much older, such was the power of his personality, the strength of his convictions and the inspirational force of his ideas. Occasionally immoderate in his artistic preferences, Thubron spoke clearly and with authority and had an unerring ability to go to the heart of any issue. Irvin accompanied him on occasional forays collecting found objects and rubbish, which Thubron would incorporate in his paintings and collages. Watching the older man work and observing the confidence of his actions was, for Irvin, a confirming experience. There were endless discussions and frequent arguments. But from these exchanges Irvin emerged encouraged. For, despite the robustness of the finished paintings, Irvin's work advanced in a considered way and many decisions were tinged with doubt. Thubron was a good sounding board.

**Albion**
1977
acrylic on canvas
244 x 427 cm
(96 x 168 in)
Oliver and Nyda Prenn
on long loan to the
Warwick Art Centre

Even so, Irvin's ability to assess his own work objectively remained an effective tool. In 1976, he showed a selection of the new acrylic paintings at the New Art Centre – his last exhibition with that gallery. There had been organisational changes the previous year and after thirteen years it seemed a good moment to part. Looking now at these works, he began to feel that the hierarchy of shapes he had been developing was becoming too limiting. In particular, it was starting to feel too much like a landscape arrangement of earth and sky: a figurative connotation he did not want to sustain. Moreover, the wildness of the paintings, while contained at present, could only go towards greater shapelessness if pursued. While tapping a visceral well-spring continued to be a central concern, Irvin was aware that undisciplined self-expression would lead to chaos. It would be necessary therefore to find a new pictorial structure.

## 15. Strategy and ecstasy

In many ways Irvin's art arises from a marriage of opposites. In visual terms this theme is present in his work from the beginning. His earliest paintings drew figures into situations which stressed their formal relationships; and the argument between figuration and abstraction defined the course of his art in the 1950s. After his conversion to a language of non-depictive shape and colour, he exploited contrast and contradiction between these abstract elements to invest the images with life. But such dichotomies were not only visual.

The idea of opposition or, more precisely, of resolution between contrary forces, is central to his artistic ethos. From such considerations his work takes its meaning. The visual tension he derives from complementary colours and shapes is identified with the polarities of human experience – male/female, war/peace, happiness/sadness, life/death and so on. On an individual level, arguably, our experiences are coloured by the balance, or imbalance, between head and heart. Taking the apprehension of life as its central subject, Irvin's art is predicated, therefore, on the inter-relationship of thinking and feeling and on the need to hold these two dimensions in equilibrium. In this respect he identifies strongly with an attitude expressed by the pianist Alfred Brendel who, describing his own artistic process, observed that 'it is a mixture of the intellect and the emotion, of strategy and ecstasy'.[14] The search for a structure for feeling defines Irvin's work at the end of the 1970s, and the solutions he evolved laid the foundations for the development of his art to the present day.

Insofar as painting can be considered a language, in 1977 Irvin began again by returning to basics, re-examining the vocabulary and grammar. He wanted to find the simplest mark, the most direct visual gesture he could make, that would record and communicate feeling. Looking

at the paintings of Van Gogh, a life-long passion, as always Irvin was impressed by the simple expressiveness of Vincent's brushstrokes. Often these are just straight dabs of paint which, in addition to denoting some object or figure, carry a great weight of feeling. What if that kind of mark could be released from description and used in a *purely* expressive way? In keeping with his own right-handedness, Irvin found that the most natural gesture he could make was a diagonal – a line running from top right to bottom left – as used for shading in drawings. This idea was the basis for *Albion* (1977), the first painting which used this fundamental element as a starting point.

Irvin commenced the painting with little or no idea of where it would lead. But having planned this opening gambit, he was able to act freely, informing the idea with something more visceral. Working on a bare canvas, and using a squeegee to move the paint, he made a series of large diagonal marks. Almost immediately this felt stronger, more dynamic. The marks violated the space as aggressively as possible. They recorded a thrust of energy which contradicts the shape of the painting, setting up a rhythm at variance to its horizontal-vertical format. Instead of creeping around the edges of a room, this was more like striding across the floor. Seeking, as ever, a reactive element, Irvin then arrested the progress of these shapes with a complementary form – a near-horizontal rush of red which lifts from the base of the picture. In the end, however, Irvin was troubled by the painting. He felt that parts of it were overworked and too much agonising had gone into it. Nevertheless, *Albion* is significant, for it suggested a structure replete with potential, not least in the way it provided a container for feeling while simultaneously suggesting movement through space.

During the following year Irvin focused on this formal equation, producing a number of paintings which are reductive in terms of colour so that he could concentrate exclusively on the way the image fitted together. The development of these paintings reveals Irvin testing and refining the syntax, a process which yielded a progression towards a simpler, more schematic visual premise. *Trafalgar* (1978) belongs to the beginning of this inquisition. Unlike *Albion*, which employs complex colour relationships, *Trafalgar* uses only two main colours: burnt umber and raw umber. Also, the cluster of diagonals is tighter and more definite than in the earlier work. Irvin has tipped this group upwards at the left, a simple device which produces greater variety in the length of each element so that they activate the space with less regularity. As before, these collide with an opposed shape which confirms the bottom of the canvas.

*Flodden* (1978) came towards the end of the series and, in spelling out the essential features of the new approach, can be seen as a kind of lexicon for his future development. In addition to its formal organisation, the viability of which seemed proven, the painting also marks a number of other advances. The first of these was to do with process. In contrast to his previous practice,

the painting was worked on in its entirety while it was laid flat. This differs from *Trafalgar*, even though it was painted shortly before, whose vertical drip marks betray the old approach. From this point on, Irvin would paint all his works while they were in a horizontal position. One reason for this was that he now wished actively to avoid this kind of gravity-governed mark. They figured largely in John Hoyland's paintings and, though he admired that painter's work, he was aware of the need to stake out his own territory. Moreover, painting the works flat was closer to his own needs and objectives – moving *across* the painting rather than *down* felt more like journeys made outside the studio. A further development was the introduction of tiny incidents along the bottom edge of the canvas. These prop up the horizontal slab of red. They also 'finger' it – a delicate, intimate contact – which contrasts with the bludgeoning above. This echo of the Infanta's fingers, which had appeared in Irvin's black paintings, introduces a change in scale. It also brings to the scheme of opposed forms a subsidiary element – a counterpoint to the main theme. The entry into the action of a range of such minor figures, and their progressive involvement in the plot, is one of the themes of the way the work would now unfold.

But first there had to be the familiar reckoning. In 1978 Irvin had a one-man exhibition at Newcastle Polytechnic Gallery which included the best of the paintings which marked the formation of the new grammar. These included *Trafalgar* and *Flodden* as well as a number of collages made from the cardboard scrapers he had used in making these paintings. His overriding impression was that the direction he was taking was confirmed, but the paintings were becoming too schematic. *Flodden* looked almost like a cut-out; the hard-edged shapes seemed to sit on the surface of a flat, undeveloped space. In establishing an appropriate framework, he had felt the need to put colour aside. Paradoxically, it now appeared that reducing the role of colour was working against the works' architecture because it was inhibiting the feeling of space. In painting against a bare canvas, for example, almost every colour he put down was darker than the unpainted background and therefore appeared to be in front of it. In order to suggest a deeper, three-dimensional pictorial space, he needed to be able to put down shapes which occupied the picture in a more sophisticated way, so that they advanced from the picture plane but, in some instances, were apparently behind it. He therefore now addressed the question of how to explore the works spatially, an issue inextricably bound up with the question of colour.

From the early 1980s, Irvin's paintings demonstrate a progressive immersion in colour. This aspect of his work is so unrestrained, and so persuasive, that it is surprising to reflect that this was not always the case and that his conversion was gradual. Indeed there was a time, especially in the late 1960s, when he was convinced that dark, sombre colours were necessary to give a painting gravitas. Even during the 1970s, his use of colour has an intense quality – blood reds,

**Cathay**
1979
acrylic on canvas
213 x 305 cm
(84 x 120 in)
Sheffield Galleries and
Museums Collections

hot oranges and deep blues – which precludes whole areas of the spectrum. The works made after the Newcastle exhibition, however, reveal a growing realisation that virtually all colours can be brought into play without diminishing the weight of the image. Indeed, he began to see colour as one of the main factors at his disposal in generating drama. In that respect, Irvin's use of colour was developed expressively rather than descriptively and was deployed in order to give him a dynamic comparable to the structure he was exploring.

This is not to suggest that the paintings have no connection with the observed world. On the contrary, Irvin's use of colour is informed by his perception of an urban context – its shop fronts, lights, cars, houses and fashions. But colour in Irvin's paintings is not *of* any of these things; it is *about* them. It does not depict – it evokes. One reason for this is that his use of colour is primarily relational. Passages are never conceived in isolation but are judged in terms of the way they will behave in the context of other hues. He does not attach specific readings or significance to particular colours. No doubt he would dispute Delacroix's assertion that 'Everyone knows that yellow, orange and red suggest ideas of joy and plenty'.[15] On their own – possibly; but in an Irvin painting these colours, in combination with others, yield a vast wealth of different emotive effects. In particular, one of his favourite devices is to take a single colour across a background of contrasting hues in order to inflect its character, revealing the range of its responses depending on its context. He thus uses colour to convey and inspire emotion but that transaction is never fixed or narrow. The drama of colour relationships – fighting or charming each other – is linked with a changing kaleidoscope of human feeling.

*Plimsoll* (1979) was one of the first paintings in which Irvin deliberately used colour as a means of exploring space. Instead of commencing with an intrusion of diagonals, as had been his previous practice, he began the painting by staining the background with a single overall colour. This gave the canvas tone, but did not simply create a coloured backdrop. The pale blue, soaking into the weave, immediately denied the surface. As well as generating atmosphere – a psychological dimension to which he could respond – it implied depth: a pictorial space he could explore and develop. He then introduced an ambiguous element. Working wet into wet, he moved over the surface, creating sweeping brushstrokes which both return the eye to the picture plane and yet stir up the space, investing it with movement. This phase of activity, which Irvin describes as 'sullying', is done freely, echoing action-painting in its quick, automatic gestures. Its purpose is to advance the argument of the painting, introducing elements of chance and accident to which he can form a subsequent, considered riposte. In this instance, the use of the brush seems to have invited a reaction against this work's immediate predecessors. Whereas those paintings had been made principally using squeegees and card, *Plimsoll* marks a return to more conventional tools. Rather than flat and emphatic, the diagonals which followed appear as an

exuberant flurry of yellow and white brushmarks, floating above a convoy of strokes in blue.

*Plimsoll* is more complex spatially. It also reveals Irvin striving to break out of the rigid matrix exemplified by *Flodden* by opening up the painting process to a range of ways of working. Among these, his reconciliation with the brush is significant. After a decade of relative relegation, from now on this instrument – variously adapted and modified – would figure increasingly. As the decade progressed, he improvised a large battery of brushes with extended handles, which enabled him to reach across the surface of the paintings. For Irvin, the painter's traditional means of expression has a significance which is both pragmatic and symbolic. In a primary sense it facilitates an expansion in the range of inflection. A brushmark can be strident or it can caress the canvas with great delicacy. The voice, as it were, does not have to be continually loud but can, if necessary, drop to a whisper. It also represents one of his central convictions, namely that painting should not illustrate pre-conceived ideas. Expression is found in the substance and movement of paint. As such the brush is a kind of icon. In *The Unknown Masterpiece*, Balzac has his central protagonist Porbus declare: 'Painters should only meditate brush in hand.'[16] These words encapsulate Irvin's ethos.

After *Plimsoll* he made a number of paintings using brushes only. *Vincent* (1979), *Severus* (1980) and *Pilgrimage* (1980) extend the implications of the preceding work, creating images which, despite their size, are like giant scribbles, so free and so like an extension of the wrist are their expressive passages. At the same time, in such paintings as *Nelson* (1979) he continued mainly to use squeegees and cardboard scrapers. These two approaches are complementary, like two sides of the same coin – the one graceful and sensuous, the other assertive and muscular. Some works use a combination of these techniques. In *Cathay* (1979), for example, the diagonals have been scraped into shape and in places the paint allowed to puddle. As a result they appear like enormous crystals: a source of golden light in a muted grey space. Below them, the Infanta's fingers have grown in size, becoming in themselves a contrapuntal element in the form of a brushed fringe.

It is remarkable that, in less than two years, Irvin moved from the stern articulation of *Flodden* to the imaginative freedom of such paintings as *Prospect* (1979) and *Tasman* (1979). In these works Irvin travelled far beyond the simple diagonal/near-horizontal opposition which commenced this phase. These later images both point to the future in the way that the diagonals are becoming less dominant – still an active element, but now sharing the top half of the space with another player. This move to greater complexity – formally, spatially and in terms of colour – would define the course of Irvin's work in the next decade. But on the eve of those developments, this prolific period closed with a climactic painting, one of Irvin's finest. *Boadicea* (1979) is an extraordinary image. Apparently simple, a group of tonally related

diagonals – variations on a theme of red – occupy an ambiguous, hot space. Underlined by a stripe of green, they glow with an implied heat that moves between the physical and the psychological. These are the embers of feeling: as if the grammar had yielded a fragment of poetry.

## 16. Breaking through

The year 1980 was something of an annus mirabilis for Irvin. This year, more than any other, marked a real breakthrough in terms of the growing interest in his work and the overwhelmingly positive response which a string of exhibitions received. As painting in general once again began to command increasing critical attention, his reputation now identified him as a vital force in that resurgence. After this point there is a sense of his career moving forward at a different pace, propelled by its own internal momentum and drawing strength from, rather than seeking, a respectful audience.

It began with an exhibition at the Acme Gallery, in Covent Garden, in April–May 1980. His close friend John Bellany knew Rita Harris, one of the gallery's partners. She was already an admirer of Irvin's work and between them they engaged the attention of Jonathan Harvey, the gallery's Director. He visited Irvin's studio, where he was able to see the fruit of almost two years' work – over fifteen large paintings made after *Flodden*. Not having had an exhibition in London since 1976, Irvin was keen to give these an outing and was pleased when Harvey invited him to show a selection of works later that year. The final line-up comprised eleven paintings, including *Boadicea*, *Plimsoll*, *Prospect*, *Nelson* and *Tasman*. It was a convincing display that announced the arrival of an artist – albeit approaching his sixtieth year – in possession of a new-found sense of purpose and direction.

Despite an already long exhibiting career, for the first time Irvin was aware of the impact the work was having, particularly among other artists, whose approval was especially welcome. The response in the press was also warm. Ian Jeffrey, writing in *Art Monthly*, observed: 'These are, in short, generous and coherent works by a master painter.'[17] Word spread and John Hoyland came to see the show. Until then Irvin was only distantly acquainted with the younger painter, though he respected his work and valued his opinion highly. Somewhat earlier, Hoyland had been appointed as the selector for the fourth *Hayward Annual*, the purpose of these exhibitions being to represent the best current British art. He was enthusiastic about the Acme exhibition and expressed interest in making a studio visit. Irvin was delighted when he then asked him to participate in the *Hayward Annual*. As Hoyland pointed out in his catalogue introduction, the average age of the eighteen painters who formed the core of his selection was forty-six. At fifty-eight, Irvin was the oldest and he appreciated this gesture of support for an artist who might be

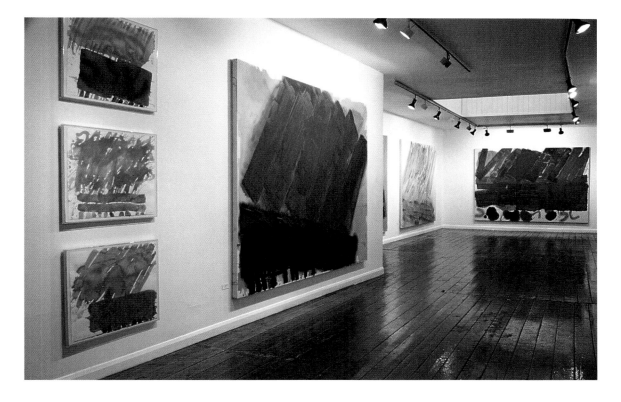

Installation view
1980
Acme Gallery, London

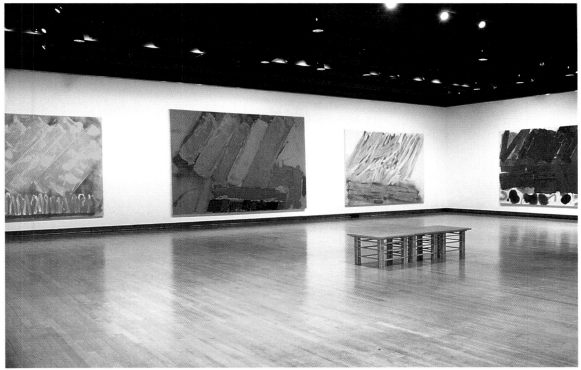

Installation view
1980
*Hayward Annual*
selected by John Hoyland,
Hayward Gallery, London

**Kestrel**
1981
acrylic on canvas
213 x 305 cm
(84 x 120 in)
Simon and Yasmin
Le Bon

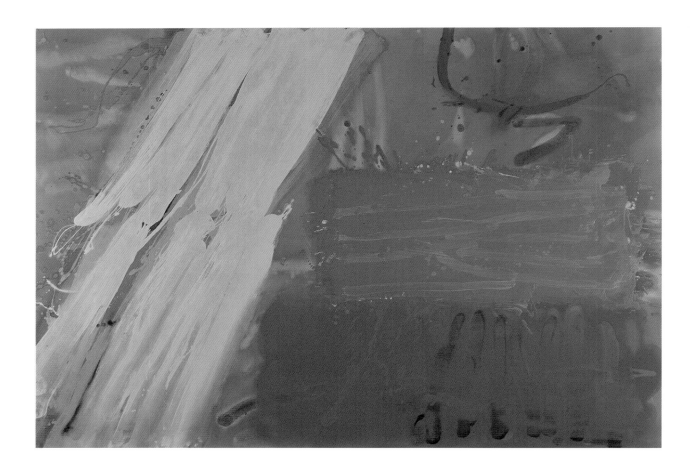

thought to have had his chance. Hoyland's catalogue introduction simply but percipiently referred to artists who have 'been known as "painters' painters" for years. They have experimented and they have had their failures. They have not moved on the level of public recognition and they have not been marketable. They are not whizz-kids but people who have spent half their lives searching for answers through the practice of their craft.'[18] Whether or not he was thinking of Irvin, the sentiment was well placed.

Between August and October that year, Irvin was represented at the Hayward by six recent works: *Boadicea*, *Nelson*, *Paradise*, *Cathay*, *Severus* and *Orlando*. He had a module to himself and *Boadicea* was the centrepiece of this strong group. Coming on the back of the Acme exhibition, this further platform in London, which drew a large audience, felt like a high-point. The icing on the cake came when three of the works sold. The roll seemed destined to continue when Irvin was then invited to have an exhibition at the Bede Gallery in Jarrow. Though not as prestigious as the Hayward, this venue was an exciting prospect because of its location and associations. As a youth in 1936 he had been aware of the famous march of unemployed shipworkers from Jarrow to London, an event that forever after evoked the Great Depression that coloured his own early years.

Perhaps more than any other manifestation of Modernism, abstract art has been taken to task for being 'difficult' and beyond the reach of the uninitiated. Irvin was aware of this and, in relation to his own aims, always regarded this as ironic. He had resorted to abstraction precisely in order to communicate as directly as possible common human feelings. Shostakovich, who suffered from criticisms of elitism throughout his career, once observed: 'I should like my music to help people to live more easily, work more happily, and love more deeply.'[19] This humanitarian ethic is one with which Irvin identified completely. That his paintings would be seen in Jarrow, with all its resonance of anti-elitism, was thus personally very moving.

The exhibition at the Bede Gallery opened in late November 1980 and the circumstances of the private view seemed to encapsulate the frantic pace of the preceding months. Nine of the recent large paintings were sent up to Jarrow, travelling rolled up. The Irvins followed and on the Monday that preceded the opening they spent the day restretching the paintings and hanging the display. The following day they flew to Manchester. They then took a train to Liverpool to attend the lunchtime opening of the *John Moores Exhibition* at the Walker Art Gallery, in which Irvin had a painting. Unable to get a return flight, they returned to Jarrow by road, driving all night through a howling blizzard, in order to be back in time for the Bede opening the next day. Once again, the press response was favourable. William Varley's review in *The Guardian* concluded that the paintings 'are powerful manifestations of the Abstract Sublime'.[20]

In terms of sales, however, the pace had been more sedate. Without a dealer, he had been more or less reliant on his income from Goldsmiths. Not that this had worried him unduly. Throughout his career, he had grown used to dealers and collectors repeatedly asking him to paint smaller so that the works could be accommodated in a domestic setting. On this he had refused to back down. The scale of the paintings was inseparable from his intentions and he felt they had to be made and to exist on his terms – whether they sold or not. He now encountered this sticking point again. In 1981 the art dealer Peter Gimpel came to see him. Gimpel had followed Irvin's work for several years and, in the light of the recent exhibitions, his interest had been rekindled. There was further support from the Gallery's younger partner, René Gimpel, who had seen and admired the Acme show. Irvin respected the reputation of Gimpel Fils, not least because of the gallery's links with Lanyon, Alan Davie and Roger Hilton, among others. There was talk of the gallery representing Irvin, but when Gimpel wanted him to paint on a more manageable scale he had to refuse. It seemed that the familiar impasse had been reached. At the last minute, however, a compromise was agreed. Irvin let the gallery have a painting, *Salamanca* (1981), for their summer show. It would be a test case. When the painting sold it appeared that a point had been made. Irvin was promised an exhibition the following year – his first in a West End gallery.

This precipitated a new round of activity. Between the Hayward and Bede exhibitions he had completed a new painting, *Mile End* (1980), which pointed the direction he would take. This work is significant for, in its free and loose painterliness, it signals a growing fascination with investigating the expressive potential of a range of different brushes. Irvin's intention here is not facility or virtuoso effects for their own sake, although these characteristics are certainly evident in marks which run the gamut from the broad, incisive strokes in blue, to the dripped tracery of the white passages, lashed and flicked with total spontaneity. *Orlando*, completed around the same time, is a virtual manifesto for the brush. Its surface is laid out in discrete areas, each positing a different way of applying paint – fast stokes, slow strokes, long, short, opaque, transparent – it is as if the vocabulary is being spelt out. But rather than fluency, this activity is the evidence of a painter exploring the limits of his language, finding new nuances and fresh constructions.

The development of space, too, is progressive in the works which he now executed. In such paintings as *Mile End* and *Kestrel* (1981), Irvin opened up a deep, recessive backdrop in which the foreground characters float. For the most part these advancing shapes do not overlap or make contact, and they all occupy approximately the same plane. As a result, although Irvin creates a believable arena within the picture, the deployment of the elements within it is rather rigidly structured. The actors do not interact, and they are mostly confined to the front of the

stage. Irvin was aware of this and of the need to get the action choreographed in a more complex way. *Rivoli* (1981), was the first of a series of paintings, made over the next two years, which investigated and then dismantled the diagonal structure in order to dispose these elements more dynamically.

Based on *Composition 9* (1936) by Kandinsky, *Rivoli* replicates the main elements of the earlier work but develops the space on either side of the central motif. Several minor characters are introduced which, being overpainted in white, appear uncertainly, as if through mist. Corralled by blue fencing, they remain separate, though they appear to probe and push against the diagonals. *Sultan* (1982) took the implications of this situation a step further. The diagonals have been pulled apart and they fan out across the surface of the painting in four great swathes of colour. Glimpsed in the interstices between them, there is a suggestion that a horizontal passage of green and white stripes moves across the background and thus behind the larger forms. This is nicely ambiguous, for these shapes also intrude very slightly in front of the yellow, blue, green and red. But in the main, the space of the work is around and behind these shapes. It was not until *Empress* (1982) that Irvin was able to create an image in which the constituent elements are fully integrated and appear to occupy numerous different distances from the viewer.

Like its predecessor, *Boadicea*, there is a sense that with *Empress* he drew together the discoveries and achievements of a phase of work, forging these into a grand image which both encapsulates his progress and opens the door to new developments. This was the last of the paintings he made in the run-up to the Gimpel Fils exhibition. It had been an extraordinary outpouring of sustained intensity. In less than two years he had completed over fifteen large canvases. Taken as a whole, these reveal the gradual but irresistible expansion of the language whose terms he had laid down at the end of the previous decade. During the same period he had also participated in the making of a film for the BBC, *A Feeling for Paint*, in which he was one of four featured painters talking in detail about their work. At the end he was exhausted but elated. It was in that mood of celebration – and the freedom to take risks – that he embarked on this key painting.

In an unusual departure from the practice he had been following, he returned to the idea of painting directly on the unprimed canvas. He commenced by laying down four massive blue shapes which traversed the space from corner to corner. At some subsequent point, he cancelled this overture, obliterating these elements with the single powerful red diagonal which is the work's dominant and distinctive motif. This is an arresting passage. In addition to its majestic colour, the surface is a torrent of activity: the result of his use of four-ringed dusting brushes. These are tradesmen's tools – long-bristled brushes – used normally for cleaning mouldings.

**Empress**
1982
acrylic on canvas
213 x 305 cm
(84 x 120 in)
Tate Gallery, London

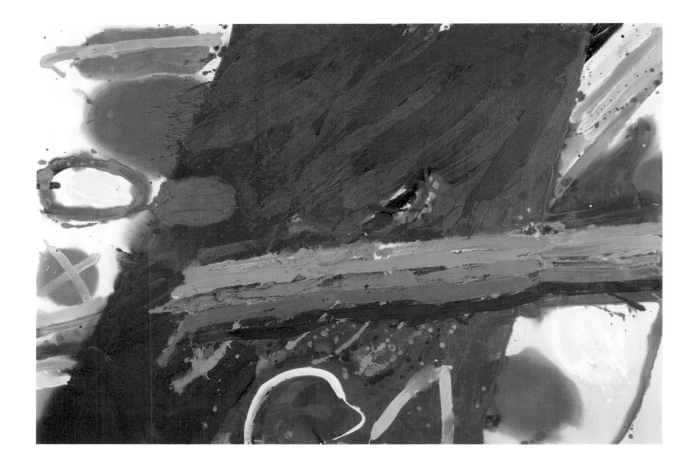

Here they are used almost as an extension of his fingers' nerve-endings, allowing energy to flow directly into the paint, and making this life-force visible. As in *Rivoli* and *Sultan*, the main motif is surrounded by smaller incidents, some of which appear to pass behind it. Significantly, however, for the first time a number of these elements also intrude in front – apparently occupying the space *between* the viewer and the diagonal. Having been previously lateral, the organisation of the painting now, additionally, proceeds relative to the picture plane. It superimposes shapes which are indicative of movement so that they appear to advance from, and to recede, into the surface. This development would mean that henceforward the space of the canvas could be thought of in three-dimensional terms – encompassing his presence in a way that approximated more to the real world.

The year concluded in a flurry of activity and with a sense of achievement. As an artist working in the East End, he maintained contact with the *Whitechapel Open* and for the second time he had a work accepted. He also continued to compete in the *John Moores Liverpool Exhibitions* and this time the painting he submitted, *Saxon* (1982), secured him a prize. But the sweetest accolade was yet to come. Between October and November he had two simultaneous exhibitions, one at Gimpel Fils, the other at Goldsmiths College Gallery. Between them, these joint venues displayed sixteen 7 x 10 feet paintings, a telling sweep of work which summarised the state of his art at that moment. Gimpels sold everything, *Mile End* going to the Contemporary Art Society. Most gratifying was the purchase of *Empress* by the Tate Gallery. It was the third time he had been considered by the national collection of modern art and, in the year of his sixtieth birthday, a fitting distinction.

## 17. Painterly constructivism

The psychoanalyst Anton Ehrenzweig, who was a colleague at Goldsmiths, once inscribed a phrase on the wall of Irvin's studio. The words, which have remained to the present day, read: 'painterly constructivism'. This epigram is obviously paradoxical for it brings together two inimical ideas and art-historical tendencies. On one side there is the ethos of autographic, intuitive expressiveness. This is matched, on the other, by an approach to art emphasising structural principles that are the result of a planned approach to formal organisation. Despite the apparent contradiction, Ehrenzweig's observation can be taken as an encapsulation of how he saw Irvin's work. This understanding is not only accurate but also remarkably far-sighted. For, though this meeting took place in the 1960s, Ehrenzweig's comment summarises precisely the nature and course of Irvin's work in the 1980s and thereafter.

In essence, the notion of painterly constructivism relates to the way Irvin's paintings became

**Monmouth**
1984
acrylic on canvas
213 x 305 cm
(84 x 120 in)
Frederick Schwartz

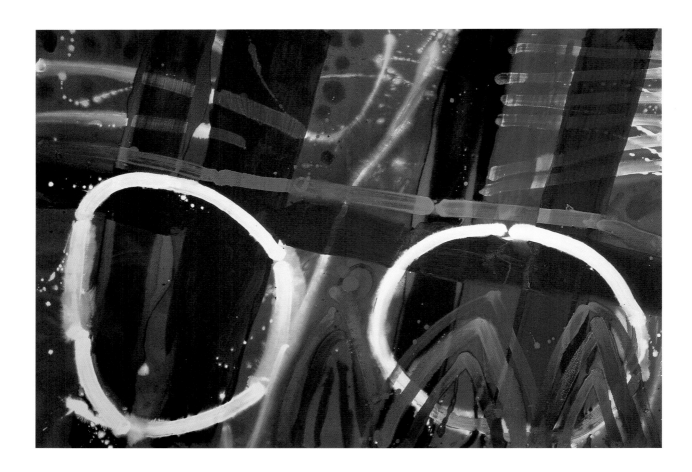

increasingly sensuous; yet at the same time this celebration of inflected shape and vibrant colour was subject to a growing formal complexity arrived at through deliberation and planning. Such developments extended the advances made in the works completed by the end of 1982. *Linden* (1983) was made following the Gimpel Fils exhibition and it takes up themes advanced in *Sultan* and *Empress*. Like *Sultan*, this new painting proposes a number of large divergent diagonals as its principal theme. Now, however, the treatment of the surrounding space has become more sophisticated, being cut into two contrasting zones by a traversing horizontal. This is Irvin delighting in taking a line of colour across a contrasting background on a grand scale. The red at far right, for example, is sharp and strident as it passes through the purple. But when it reaches the orange below it takes on a different mood, sulking in the presence of this hot competitor. Its neighbour does something different – the blue against purple is passive, but entering the complementary orange it springs to life. At the bottom of the painting, we see the appearance of a new cast of characters: three large crosses – successors to the small shape which made its debut in *Empress*. And, as in *Empress*, these interlocking shapes stand in front of the diagonals, developing the suggestion of different elements occupying a variety of positions in deep space.

The paintings made after this point use the overlapping and stacking of shapes to create a pictorial situation in which the viewer moves not simply across the painting arena, but penetrates *inwards* – encountering, en route, a succession of visual events which are apparently further and further away. This is clear in *Calabria* (1984). At furthest remove there is the space – the world – which everything else inhabits. Moving into that place, we find – in turn – a double barrier of white and orange; a cluster of large overlapping shapes; a line of diagonals; a thread of orange which weaves between these forms; and, beyond that, two parallel courses in white. The introduction of this further dimension permits the exploration of a space which is much more fully developed in its internal parts and proportions.

Alongside these explorations, Irvin's exhibiting schedule quickened and found new audiences further afield – as if the broadening of his pictorial horizons reflected his travels. In 1983, his solo exhibitions at the Third Eye Centre Gallery, Glasgow travelled to Aberdeen Art Gallery and the Ikon Gallery, Birmingham. The following year he was included in *ROSC '84* where he showed, *Beatrice* (1982), *Yupon* (1983) and *Avalon* (1981). Surprisingly, this was the first large international survey of contemporary art in which he had participated.[21] It followed the impression he had made at the Hayward and sowed the seeds of his reputation in Ireland. This process was confirmed by a one-man exhibition held at the Butler Gallery in Kilkenny Castle in 1985. In the same year, he had an exhibition at the Coventry Gallery in Sydney, Australia, for which he made a two-month visit to that country.

During that trip he was based in Sydney, staying for a while with the painter John Walker in Melbourne and making full use of his time there to look at Aboriginal art. It would be presumptuous to suggest that, during this relatively brief sojourn, his acquaintance with Aboriginal culture influenced his work. But he was fascinated by the painting he saw and inevitably he perceived shared concerns in the way that Aboriginal art uses a complex symbolism of circles, dots, lines and other pictograms to express the idea of real journeys. At the very least it can be suggested that in the paintings he made following his return there is the evidence of an increased concern with evoking a sense of travel between places. His exhibition at Gimpel Fils in 1986, for instance, included a number of works in which long, thin traversing lines take the eye on meandering or circuitous journeys through an ever-changing visual environment.

*Cammeray* (1985) is a virtual network of such conduits – interlocking, overlapping and doubling back on themselves. *Sauchiehall* (1985), whose title links with his visit to Glasgow's main street, expands this idea through the introduction of directional marks of many different scales. It is interesting to compare this work with a related painting, *Buchanan* (1987), painted two years later. Clearly the two have a similar lay-out and, in terms of colour, *Buchanan* repeats many aspects of the earlier painting. But the two are nevertheless very distinct works, the earlier one being predominantly bright and exuberant, the other being darker, rather contrasting in feeling. The comparison evokes the sense of being in the same place on different days; the landscape is the same but somehow everything has changed – the weather, the atmosphere, even one's mood.

What these, and works made at the same time, do have in common is a concern with developing a kind of composition which Irvin has described as a 'basket of space'. The central characteristic of these works is an approach in which the formal organisation is not only overlapped but progressively *interwoven*. *Monmouth* (1984) and its descendant, *Isca* (1985), demonstrate an emphasis on bringing together the constituent elements in complex interactions so that the same part moves in front of, through and behind its neighbours, creating a strange filigree space. In these works, the relation of parts is brought to the fore and, for that reason, though painterly there is a strong sense of structure. Indeed, in their making, the paintings proceeded in an additive way – one component being laid across another, then a further part superimposed over that combination. In terms of their marks, the paintings are made urgently and expressively; but as compositions they are constructed. The seeds of this process, surprisingly, originated in printmaking, an activity which he pursued parallel to the paintings after 1980.

Jonathan Harvey introduced him to Chris Betambeau in 1980. Formerly an apprentice to the master screenprinter Chris Prater at Kelpra Studio, in 1967 Betambeau had set up

Irvin and Chris Betambeau
at Advanced Graphics,
working on *Druid I* and
*Druid II*, 1984

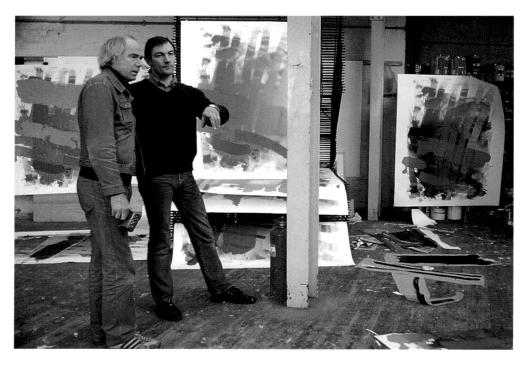

**Druid I**
1984
screenprint, edition of 35
152 x 129 cm
(60 x 51 in)

**Druid II**
1984
screenprint, edition of 35
152 x 129 cm
(60 x 51 in)

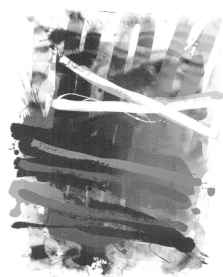 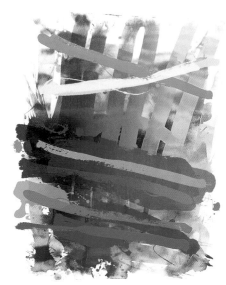

Advanced Graphics, his own screenprinting workshop. Betambeau combined a high degree of technical skill with an approach to his craft that was experimental and innovative. At Kelpra during the 1960s he had worked with a number of major artists, including David Hockney, Eduardo Paolozzi and Bridget Riley. Since then he had widened his field of collaboration significantly, working with such artists as John Hoyland, Bernard Cohen and John Walker. Even so, when Irvin first met him he was attracted by Betambeau's personality – at once deeply committed and yet wayward – but doubted the suitability of screenprinting to his own artistic ends. Irvin linked the medium to Pop Art, thinking the technique removed from the direct expressiveness of the artist's hand, and primarily a means of making flat, hard-edged, rather impersonal marks and images.

Working with Betambeau opened Irvin's eyes to the potential which screenprinting possessed for vitality and immediacy. Irvin came to Advanced Graphics uninitiated in the technical aspect of the process and in Betambeau he found a sympathetic and imaginative guide. For his part, he explained to the young printer his aims and needs. Between them they found a way of working which permitted the spontaneity, degree of improvisation and painterly 'touch' that Irvin required, while placing all these things in the context of the discipline necessitated by printmaking. Through Betambeau, Irvin became familiar with the rudiments of screenprinting, a procedure which, in essence, involves using a squeegee to push ink through a mesh screen onto a sheet of paper. The shape of the resulting motif is determined by blocking out parts of the mesh so that the ink penetrates through the unmasked area only. Different screens are then used for each colour and the image is built up as a series of superimposed colours. Building on these fundamentals, Irvin was able to evolve an approach appropriate to his own way of working.

He would begin a print by using black ink to create brushmarks on pieces of Kodatrace – clear plastic sheets – in whatever size he needed. Usually each piece would bear a discrete mark and, in this way, he was able to create a vocabulary of shapes for future use. After the ink had dried and the brushmark fixed, a photographic positive was made. These transparent sheets could then be arranged in whatever position he liked on the screens: overlapped, abutting or in any other relation. This allowed him to preview the composition and to make adjustments whenever necessary. The marks acted as masks or stencils, preventing light from reaching parts of the screen, which was coated in a light-sensitive emulsion. When exposed, the screen hardened in the areas uncovered by the marks, forming a barrier. In the areas corresponding to the marks, the emulsion remained soft and could be washed away, creating shapes through which ink could pass. The image would then be constructed – literally. Decisions would be taken about what colours to use for each screen and, as the print progressed, additional screens could be made which introduced further superimposed shapes. Initially, having to explain what

**Kingston**
1993
Polaroid sequence
showing the
development of the
painting

11 Nov
'93

16 Nov
'93

17 Nov
'93

26 Nov
'93

3 Dec
'93

22 Dec
'93

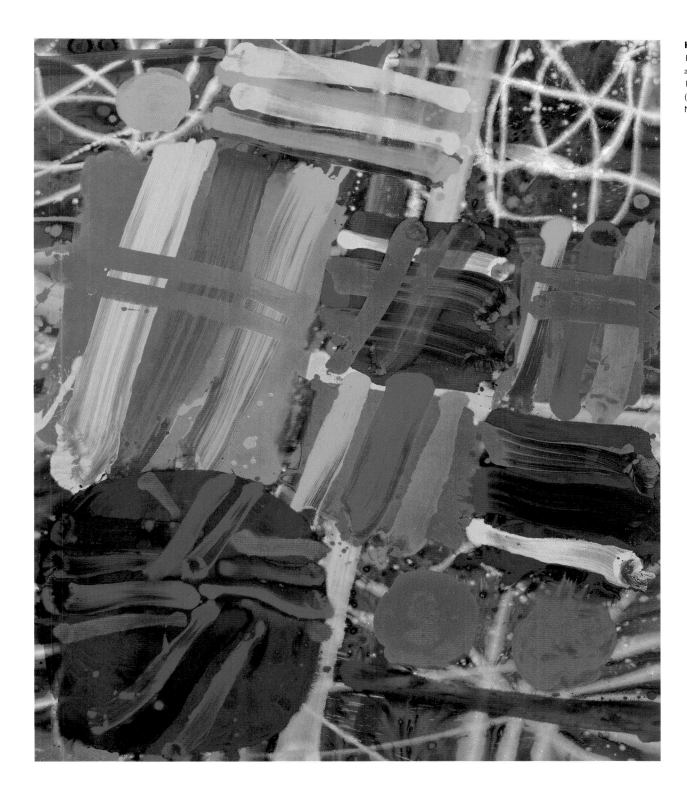

**Kingston**
1994
acrylic on canvas
183 x 152 cm
(72 x 60 in)
Manfred Braun, Munich

Studio activity:
Irvin working on
*Cavendish*, 1993

he was trying to do was unfamiliar to Irvin. But he soon found that having to articulate his intentions not only clarified his ideas but had implications for the way he thought the paintings could be made.

What most impressed him about making screenprints was that the process was essentially concerned with *layering*. It forced him to think about constructing an image in which one part is added to another, piece by piece, so that the motif is built up from the surface in an accretion of superimposed strata. He also responded to the way screenprinting invites – or rather requires – planning and rehearsal. The deployment of brushmarks is governed by experiment and deliberation but, even so, the final image conveys a sense of complete spontaneity and excitement. *Tooley* (1980) was Irvin's first print and after that promising start he felt in his element with the new medium. He grew to welcome Betambeau's input, which was not confined to technical matters but frequently forced Irvin to develop the image in unexpected ways. The later pair of works *Druid I* and *Druid II* (1984) are among Irvin's most impressive prints, demonstrating an early mastery of the technique. Formidably complex in the multi-layering of the component elements, they nevertheless convey an impression of sudden, explosive energy. Since then, Irvin has gone on to make over thirty screenprints at Advanced Graphics including, since Betambeau's tragic early death in 1993, a number of prints combining screenprint with woodblock – the results of a new phase of collaboration with Betambeau's partner, Bob Saich.

From the outset of making screenprints, Irvin recognised that he was not making reproducible paintings. The medium had its own unique characteristics which he could explore and exploit. As such, printmaking is an important aspect of Irvin's work – but not only because of the images it has yielded in its own right. His involvement with prints has a further, fundamental significance because of the radical effect it has had on his painting: influencing his technical procedures in that area and, increasingly from the mid-1980s, even affecting the look of the paintings. As demonstrated by the *Druid* prints, for example, their combination of formal strategy and expressive freedom precisely mirrored the balance between structure and urgency he was seeking in his activity on canvas. Comparing these prints to such paintings as *Easter* (1984), which was made around the same time, it is clear that in some respects the graphic works are more advanced. Although emphatically gestural, they have a formal density and a tautness of composition not yet achieved in the contemporaneous painting, but clearly apparent in a later work such as *Madison* (1988).

This is not to suggest that the prints led the paintings. But there is a close interactive relation between his work in both media, a connection cemented by an approach to painting which, like the prints, became increasingly strategic. Over the years, he had evolved various ways of

entering into a dialogue with the work and of advancing the argument. As seen, the initial 'sullying' phase created a kind of chaos to which he could react, imposing order. In that subsequent, constructive phase, a central scheme has been his use of coloured paper and photographs. During the painting process, Irvin temporarily places on the canvas pieces of newspaper, cut roughly to the shape of brushmarks and overpainted with a single colour. This device addresses one of the main dilemmas faced by any abstract artist who, unlike many of his figurative counterparts, would normally not work from an observed subject. Whereas the painter working from an external motif can refer to that object, an abstract painter has nothing to go by, nothing to direct his actions. His engagement is with the developing image only. As a result, every mark is fraught with danger – the painting could go wrong with every addition.

There is the further problem of knowing what to do to the image and how to do it – should a touch of red be added and, if so, where precisely should it go? Tacking a piece of papier collé to the image enables Irvin to preview the effect of any proposed mark. Taking a polaroid photograph preserves the plan and creates a reference when the paper is removed. The mark can then be made swiftly and instinctively – but with some foreknowledge of its consequences. The introduction of this planning stage is analogous to the movement of the Kodatrace brushstrokes in screenprinting. Although this preview technique was established before he began making prints, Irvin became increasingly reliant on using papier collé after the screenprints suggested the possibility of creating more complex, layered images. And in the paintings of the late 1980s, which weave an ever more intricate syntactical web, this organising principle is their driving force.

The decade closed – appropriately for Irvin – with his first ever retrospective exhibition, the largest group of his paintings that had been assembled. The exhibition opened in November 1989 at the Talbot Rice Gallery at the University of Edinburgh, and it transferred to London's Serpentine Gallery in February– March 1990. It subsequently toured in a modified form to Spacex Gallery, Exeter and to Oriel and Chapter Galleries, Cardiff. As ever, Irvin saw this as an opportunity to take stock. And, in covering so wide a period, it was a cause for some anxiety. He was concerned about how the older works would stand up in the company of the radical changes he had made since 1977. He was also keen to assess the impact of the new work. The Edinburgh and London venues showed work made after 1975, concentrating on the 1980s and including three new large works painted for the exhibition. These were *Roxburgh* (1989) and *Northcote* (1989), both 10 x 10 feet; and *Nicolson* (1989) – at 10 x 20 feet this was the largest painting he had made since the ceiling commission, *Illumination* and *Jubilee* in the early 1970s. In the event, it proved to be an inspired piece of programming by Alister Warman, the Serpentine's Director. The selection was focused and spaciously hung; and entering the gallery

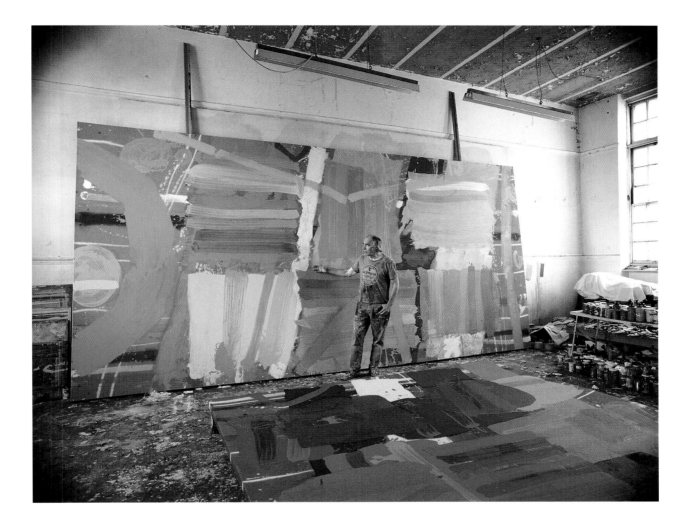

The studio, Stepney
Green, 1989
*Nicolson* against the wall,
*Northcote* on the floor

**Nicolson**
1989
acrylic on canvas
305 x 610 cm
(120 x 240 in)

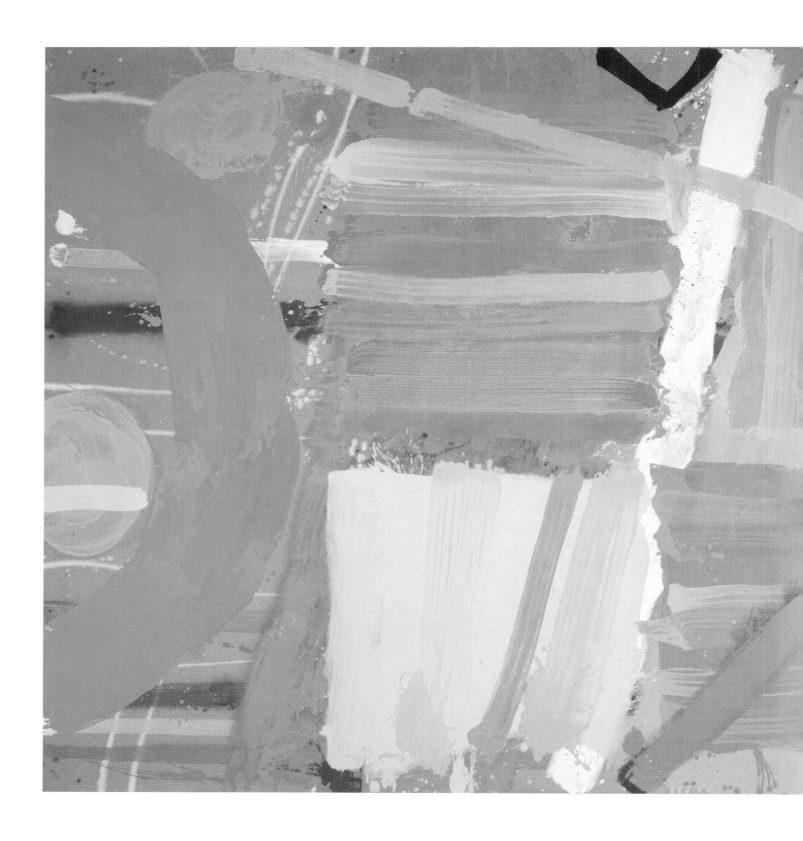

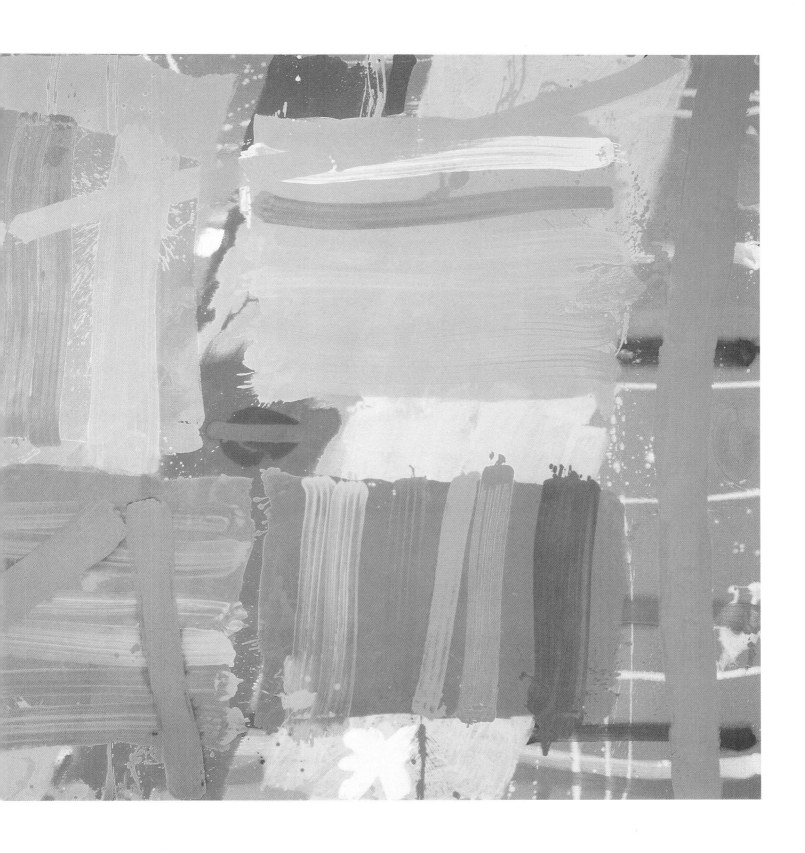

Installation view, 1991
Goldsmiths College
Centenary exhibition.
During 1991, there
were four exhibitions to
celebrate the centenary
of Goldsmiths College.
The first was selected
by Michael Kenny, the
second by Irvin, the
third by Michael Craig-
Martin and the fourth
by Richard Wentworth.

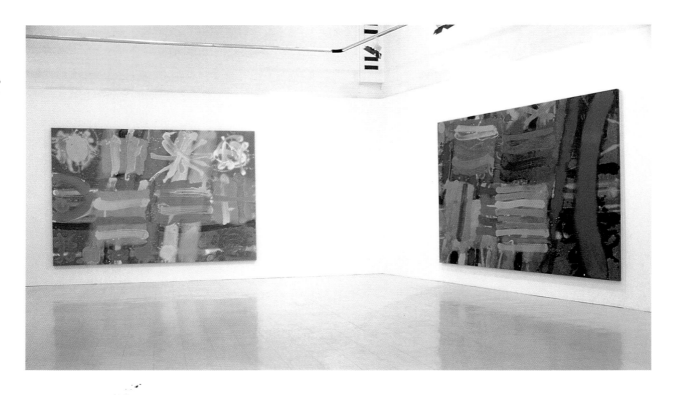

on a cold, grey February morning to be confronted by a blaze of colour was, for many, an unforgettable, uplifting experience.

Inevitably, Irvin looked hardest and most critically at the new works. Hung as triumvirate on three separate walls, they dominated the lofty main gallery. There was some personal significance in dedicating this space to these works alone for, as encoded in their titles, they referred to the three women in Irvin's life – his wife and two daughters. *Nicolson* refers to the street adjacent to the Talbot Rice Gallery and is Betty's maiden name. *Roxburgh* and *Northcote* are the names of the London streets where his daughters, Priscilla and Celia, then lived. Segregating the works was also a concession to their scale and physical presence which would have overwhelmed any other work hung in proximity. But a further consideration was the works' character. This seemed both to connect with slightly earlier works such as *Sandymount* (1987) and *Madison* (1988), but also to herald a new visual chapter.

In terms of colour they were more vibrant than anything Irvin had attempted previously. In each case, the entire field is activated by strong local contrasts and by large traversing shapes which meander through a spectrum of colour. Formally, too, these paintings were the most ambitious and the boldest he had then made. In *Northcote* and *Roxburgh* lines and coloured shapes are superimposed to a surprising degree so that, within the illusory depth of these paintings, the composition advances and retreats. At the same time, there is a directness – almost an innocence – in the way the shapes are resolved into relatively simple characters – circles, rectangles and lines. *Nicolson*, in particular, has an unrestrained quality of celebration which recovers something of the freshness of childhood. This seeming formal simplicity led some critics to compare these elements to flags. It is not a reading that the artist would encourage. Such an interpretation implies illustration of a real object, an implication that runs counter to Irvin's entire way of thinking. Like semaphore, Irvin's use of abstract form functions expressively. But there the connection ceases, for the shapes employed by Irvin are directly affective, have no specific connotation, and are open to imaginative interpretation. In this respect, the paintings move closer to the condition of music.

It is true, however, that in some ways these paintings – compared to those that followed – now appear somewhat unnuanced. The vocabulary and the grammar are spelt out without inflexion. As with *Flodden*, it is as if Irvin is defining the terms. And, as with that earlier painting, these works are progenitors. In this instance they commence a body of work that continues to the present.

## 18. The architecture of imagination

In his book *The World as Will and Representation*, the philosopher Arthur Schopenhauer observed: 'Every artistic apprehension of things is an expression … of the true nature of life and existence … [and is] an answer to the question, "What is life?"' [22] In relation to Irvin's art, these words are the equivalent of true north. They define the course of a career which continues its insistent interrogation and celebration of what it is to be alive. Insofar as Irvin's art has sought to provide a site or structure for consideration of such questions, it is perhaps natural that over the years he has drawn inspiration from architecture: from great historic buildings to the domestic and everyday. As a container for human experience architecture has been a rich metaphor, underlying his identification of the picture with habitable space. In Irvin's recent work, the connection with architectural form has deepened and become more explicit.

In this respect, Britain's rich heritage of cathedral architecture has been a potent influence. In particular Durham Cathedral, which Irvin visited in the early 1980s, made a deep impression. The stay in Durham lasted two days and Irvin spent most of this time exploring the great edifice. It informed his thinking in a number of ways. In common with all who enter the building, he was struck by the monumental power of its load-bearing columns and their soaring height. But he was especially fascinated by the orchestration of different kinds of space and the transitions between them. Moving between the columns and from arch to arch, the rhythm of the building could be sensed. Herein lies the power of great architecture. Its capacity to use abstract shape and interval affectively – inspiring awe, wonder, vertigo and spiritual comfort – makes tangible the relationship between an individual and his surroundings.

This memorable visit influenced Irvin's visual language. There is a greater feeling for complementary scale – visually exciting transitions from large to small elements – in his paintings of the 1980s and 1990s. In *Waring* and *Skipper* (both 1991), proportion and interval are central concerns. *Waring* derives its drama, for example, from carefully orchestrated contrasts in shape and size – a tension which is not simply local but now sustained throughout the image. As the eye moves through the painting, it must weave through an endless variety of structures, adjusting to each in turn. A number of Irvin's motifs can be traced to architectural sources. The chevrons in *Monmouth* and *Nicolson* are overtly derived from the carvings on the columns at Durham. Others are less obvious. For example, the persistent circular form would seem to refer to its rose windows. His increasingly interwoven compositions also received vital inspiration from the cathedral's lattice patterns in low relief.

But Durham was not the only exemplar. In the 1990s, a host of new pictogram-like characters appeared, among them squares, asterisks and crosses. Their origins are manifold and

Irvin in Durham
Cathedral, 1978

Durham Cathedral
1978
The chevron and
lozenge patterns on the
columns and the lattice
carvings in low relief
were an important
inspiration for Irvin.

**Ely series no.10**
1995
Gouache on paper
56 x 76 cm
(22 x 30 in)

**Ely series no.11**
1995
Gouache on paper
56 x 76 cm
(22 x 30 in)

they represent an increasing interest in developing the character of individual shapes. Most notable is the quatrefoil which appears in several paintings but most obviously in *San Marco* (1994). This began to occur after a visit to Venice in 1994, and echoes the marvellous series of quatrefoils above the loggia on the Doge's Palace.

In *Ely* (1995), which is arguably one of Irvin's most significant paintings, the influence of the artist's relation to his environment is profound. In that year he was offered a retrospective exhibition at the Royal Hibernian Academy Gallagher Gallery in Dublin. Irvin was excited by the prospect – not only because it would be his largest ever show, but also because the project included an invitation to work for a while in the newly built studio at the top of the RHA building. During the planning of the exhibition, Irvin visited Dublin and was impressed by the workspace being offered. Designed for life-drawing, it was spacious, well-lit and airy, with enormous windows giving views over the surrounding rooftops. As on previous occasions, he was keen to paint a work especially for the exhibition; and, though *Nicolson* would be included, he wanted to finish a new, large piece which would represent more recent developments. The RHA studio was attractive and seemed ideal for his purposes. He was also intrigued by the possibility of being its first occupant. Nevertheless, there were logistical problems. Not only was he unused to working in an unfamiliar setting, there was also the issue of transporting all his materials – paint, stretchers, canvas, brushes and so on.

These conflicting feelings set him thinking: not only about the space in Dublin but about the *idea* of the studio – what it is and means to an artist. Can a painter simply uproot, move and immediately begin working somewhere else? Or is there more to it than that – to do with the atmosphere and personal history of the place? For Irvin the studio is many things: a retreat, a bastion, a workshop, a rubbish tip – even a sanctuary. Most of all it is a place where an artist communes – with himself. As he was well aware, these considerations had also made the studio a fertile subject for artists throughout the history of art. In our own century, Picasso, Braque, Matisse and Giacometti – to name but a few – had been fascinated by the special character of the studio. In the previous century, Courbet's gigantic painting *L'atelier du peintre* (1854–5) is one of the pinnacles of this genre. Described by Courbet as 'a real allegory summing up seven years of my artistic and moral life', its ambition and mystery had long intrigued Irvin.

From these thoughts he devised both a working stratagem and the theme of the painting he was planning. Basically he felt it was not feasible to attempt a large work in an unfamiliar studio; yet at the same time he wanted to make a painting which responded to that place. He resolved, therefore, to stay in Dublin for several weeks, working in the RHA's studio, but using that time to make small gouaches on paper. These could then be transported back to Stepney where he

would work on the large-scale canvas. Thus it was. In the summer of 1995, Irvin made over thirty works on paper: the *Ely Series*. This medium was in itself nothing new. Throughout his career, he had made small watercolours and gouaches alongside the larger works – never as studies, but as independent images which fed into and responded to the larger works. The character of the *Ely Series* is intimately bound up with the surroundings which produced them. The sheets were spread out over the studio floor and Irvin worked on them simultaneously. Moving from one image to another, he would consider each in turn and then make rapid, fluid gestures. To a degree unprecedented in his work, the sights and sounds of his environment are trapped in the motifs he invented. The large, angular studio windows and the smaller oriel and Georgian windows of the houses opposite are all echoed in a new vocabulary of ciphers. Throughout this period, the studio resounded with the cacophony of Dublin seagulls, whose erratic movements – darting and wheeling – are evoked in a recurrent trace of white.

*Ely* was painted back at Stepney Green. Rather than being based on the gouaches, it continues and extends their imagery, drawing his own experiences into the wider, thematic context suggested by Courbet's painting. Though formally unrelated to the earlier work, its vast proportions are similar. And in terms of its subject, like the Courbet, *Ely* can be considered as a kind of allegory – a situation, centred on the studio, which provides a context for a flight of imagination. Within those parameters, such adjectives as grand and epic are not misplaced. Confronting the painting, the viewer moves in a world of energy and feeling – shape and colour – rhythmically disposed according to its own laws. The visual drama enacted brings a cast of characters into a fully integrated relationship with their setting. Each has its own pictorial per-sonality – strident reds, genuflecting yellows, a hatch of pinks. Yet the way they connect never seems simply the stuff of picture-making, but, rather, somehow strangely human – they fight, hide, touch and flirt. Some do not really get on; others seem in love, they go so well together. The fascination of *Ely* is that it has this pronounced abstractness, yet it connects with the world in an intimate way. Though non-depictive, its shapes move towards, but stop short of, descrip-tion. And, while abstract, its enormous marks are so large as to cease to be simply pictorial. We confront them, move past them, walk between them, as we would real objects in the physical world. The painting has an architecture which moves from the imaginative to the real.

This sense of a more pronounced connection with the physical world can be related to two commissions undertaken by Irvin in 1987 and 1995 in which the architectural setting was a key issue. The first of these was for the then newly built Homerton Hospital in London's East End. When the hospital committee first approached him, as ever he was reluctant to take on a com-mission. In this instance, however, he was persuaded by the context. As the work was intended for the maternity wing, he felt that the project had a life-affirmative significance to which he

**Celebration**
1987
acrylic on canvas
305 x 264 cm
(120 x 104 in)
Installation view at
the Maternity Wing,
Homerton Hospital,
London

could respond. In practice, however, there were aspects of the proposal which rendered it less than straightforward. It was clear, for example, that the painting had to have some relation to its setting. Positioned on a landing linking two staircases, any image could easily seem like a pointless intrusion unless it had some demonstrable relevance. A further consideration related to the physical conditions governing how the work would be seen. Because of the location, its principal views were from above, looking down on the work; and from below, looking up. It would be essential, therefore, that the image should be able to deal with the sharp perspective involved in both directions.

The completed work is an ingenious solution to all these implications. The image takes its place in the character and space of the site by continuing the features evident in its immediate proximity. The maternity wing is identified by the use of yellow – seen in the handrails which guide hospital visitors to their destination. *Celebration*, as the painting became known, deftly deploys this idea in the yellow lines which take the eye through an uplifting field of bright colour. Similarly, the scale of shapes at the top and bottom of the painting are deliberately large and assertive so that they are not weakened by the diminishing effect of distance.

Just before leaving for Dublin in summer 1995 Irvin completed a second hospital commission, this time for the Chelsea and Westminster Hospital on the Fulham Road in London. Through the auspices of its enlightened administrators, the hospital had a forward-looking attitude to the role of art in a healing context and they had commissioned a number of artists to make works for different parts of the hospital. Irvin was initially asked to make a painting for the enormous atrium. Bringing some previous experience to bear, he foresaw the shortcomings of this idea and declined. In particular, he was concerned that whatever he did would be lost in such a space; not simply as a result of its size but, more specifically, because in being unable to relate the work to anything, it would appear simply as a marooned decoration – like a brooch. He was enthusiastic, however, when asked to consider making a work for the Fracture and Orthopaedic Clinic: a smaller, self-contained area with a specific character.

This project posed problems rather different from the Homerton Hospital commission. Unlike that newly completed, unoccupied building, the Chelsea and Westminster was fully operational with an existing staff working in the area he had been allocated. In addition to the logistics of the space itself – which was wide but had a rather low ceiling – his concerns were focused therefore on the human question. The last thing he wished was to impose a work of art on people who might not want it, or like it, but would have to live with it. Proceeding with this sensitive issue in mind, he decided that the best route was via consultation and explanation and – only after these – installation.

Having considered the context, therefore, he executed a number of gouache studies which

outlined possible ideas. The space itself stimulated the shape of his response. The wall was long but not high and he saw it, therefore, principally as a frieze. As such, the natural corollary was that the image should be about movement. This was appropriate given the function of the department and, from that point onwards his thinking tended towards progression of shapes. They should move laterally, episodically, with definite rhythm and direction. In fact, they should dance. Having hit upon the notion of choreographing the composition, the test images came fluently. Irvin arranged for a selection of these to be exhibited at the hospital. The staff were invited to offer their opinion and their enthusiastic response supplied the initiative he needed.

The painting he then commenced was certainly the most unusual shape he had ever used. Just over four and a half feet high by twenty-two feet wide, his own activity within it could only be lateral. He began by delineating the word ORTHOPAEDIC within the canvas. This was his starting point – a kind of verbal 'sullying' of the canvas – in order to get the image moving. As it progressed, he was mainly concerned to evoke a sense of fluid activity in either direction. The finished painting looks like a series of stills through which a passage of rhythmic life pulses. Nor is this rhythm constant. The shapes seem to sweep, hop, glide, separate, come together, bend and turn around. Throughout the painting episode, the idea of Fred Astaire and Ginger Rogers was in his mind's eye. The legendary dance duo had been idols of Irvin's ever since the 1930s and their combination of grace and harmonised energy perfectly encapsulated the qualities he wanted the painting to express. He called it *Hollywood*.

*Elan vital* is a phrase frequently employed by Irvin in relation to his artistic aims and, in a primary sense, his work seeks both to contain and to transmit that feeling. Certainly the 1990s have seen a quickening of the pace and a sharpening of the senses. In August 1992, Irvin celebrated his seventieth birthday. In tribute the Tate Gallery displayed *Tabard,* which he had then just completed. It was shown in a dedicated space in the ambulatories near the main entrance, its warm tones illuminating the marbled halls as if the summer sunshine had been admitted. Around the same time, he had a solo show at Gimpel Fils, appropriately entitled *Three Score and Ten*. This comprised a selection of the works which had followed *Skipper* and *Waring*. As new works like *Ludwig* (1992) and *Braubach* (1992) revealed, complexity had found a counterpart in subtlety, nuance and transparency.

The mid-1990s was also a time of renewed travel. In addition to a first visit to Venice and his extended stay in Dublin, the Irvins made trips to Berlin – their first since the Wall came down – and also to Paris and Vienna. In November 1994– January 1995 Irvin had a further solo show at Gimpel Fils and this included several works which alluded to some of those visits, among them *San Rocco* (1994), *San Marco* (1994) and *Brandenburg* (1994). The show sold well. *Soho* (1994) was acquired by the Irish Museum of Modern Art in Dublin. *San Giorgio* (1995) was

painted too late to be included but was shown in the *John Moores Liverpool Exhibition 19* in October 1995–January 1996 – Irvin's seventh showing there. That work also found a home, being purchased by the National Westminster Bank. *Saint Germain* (1995) was also finished later and in 1996 this work, together with *Flodden*, entered the Tate Gallery's collection, extending his representation there to three paintings.

As these new works showed, the structure in his paintings was becoming more organised yet, paradoxically, more flexible and freer. The reasons for this lie in the way Irvin's work draws on ideas relating not only to architecture but also its sister: music. Proportion, space, rhythm, relation and harmony are the abstract – directly affective – constituents of architecture; and in those elements Irvin found analogous ways of giving pictorial order to feeling. Like architecture, music uses abstract elements – sound rather than shapes – and it draws these things into an order which appeals to the intellect and the senses. However, music has an imaginative freedom, and an ambiguity, denied to architecture. Music is structured – yet it arises from the imagination and is unfettered.

Throughout his life, Irvin has been passionate about all kinds of music – from jazz and dance to the classical repertoire. But he has always identified closely with the agenda set by modern and contemporary music. While teaching at Goldsmiths he met John Cage, Earl Browne and Morton Feldman, who became a friend. Their emphasis on a sound world of pure abstraction, on improvisation, and the way their work embraced dissonance, all defined an outlook which was entirely congruent with his own. But, in a wider perspective, it is the essential capacity of music to bring together the intellect, the imagination and the spirit – affirming life, yet creating something which has its own life – that has always been a compelling force. The deep sympathy between music and visual expression was of course articulated persuasively by Kandinsky, who observed: 'A painter, who finds no satisfaction in mere representation, however artistic, in his longing to express his inner life, cannot but envy the ease with which music, the most non-material of the arts today, achieves this end. He naturally seeks to apply the methods of music to his own art.'[23] The sense that painting can aspire to the expressive condition of music lies at the heart of Irvin's most recent work.

In one way this connection with music refers to the principles of invention which have informed the paintings' organisation. *Saint Germain* (1995), for example, is essentially an improvisation. Its 'motive' – defined by the composer Webern as 'the smallest particle in a musical idea'[24] – is, as ever, the diagonal. Irvin takes this shape and, through repetition and the use of interval, spins a phrase across the foreground of the canvas. A simple, regular rhythm is established, yet, expressively, it is compelling. Colour inflects the passage – red, green, blue, green – investing each incident with a different shade of feeling. To the left, we find inversion

**Ely**
1995
acrylic on canvas
305 x 610 cm
(120 x 240 in)

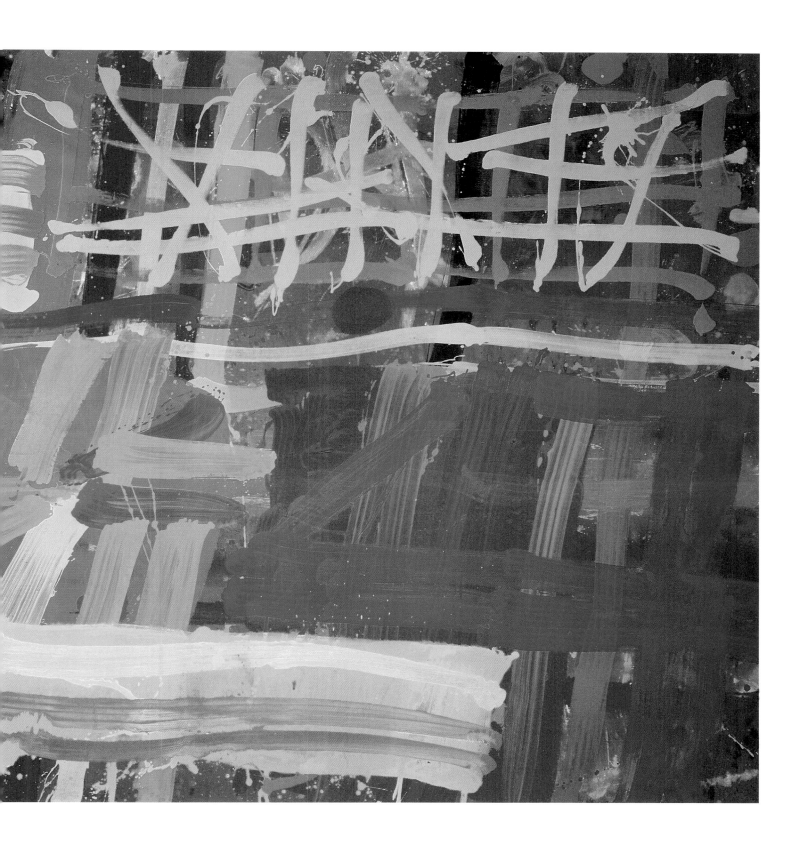

and variation. The four-line structure is turned on its side and set in a different key – green, orange, red, blue. Above and around these progressions, Irvin sets up embellishments – contrapuntal shapes and ornaments – which punctuate the argument, adding emphases, harmonies and texture.

In the related painting, *San Giorgio* (1995), the main theme is developed further. The diagonals are drawn into chord-like structures – groups of parallel brushstrokes. Like notes sounding simultaneously, these complexes comprise discrete elements which we apprehend as one event. These blocks of form interconnect in different ways, being contrasted in terms of scale, colour and direction. Some elements combine in harmony, others establish dissonant relationships. Set in a surrounding envelope of interlaced lines and clustered shapes, the resulting complex motto resonates – powerfully and silently. This is not to suggest, however, that such paintings are analogous to musical notation. On the contrary, rather than preceding interpretation – they *are* the performance: a flight of invention at one with its enactment.

This dense formal texture is nevertheless always accompanied by transparency and space. In *Strand* (1997), for example, we look through the structure, sensing the interaction of incident and interval. And in imagination we are able to move around it. The framework has a history: each step, decision, change of mind and fresh idea is encoded as visual evidence. We are able, therefore, to reconstruct the stages in its creation, observing underlying and partially obscured passages. This is analogous to the composer's ability to reveal a musical structure, so that the listener can 'move' within the piece, recognising and recalling previous material and anticipating ideas before they actually take place. And, as in a piece of music, time is important, Irvin uses scale to create gaps between shapes, so that we move between parts of the picture sequentially. We inhabit an invented structure, manoeuvring within it according to the feelings it evokes.

The fertility of this ongoing language is evident in the way that many of the recent works have evolved as variations on a theme. For example, *Soho* (1994), *Beaufort* (1994) and *San Giorgio* (1995), are all related but, at the same time, obviously distinct. Turning on a central idea, the introduction of different thought – a change in the colour of a shape, the transposition of parts – sets up a train of consequences which lead to diverging destinations. The titles of the works hint at this musical-geographical connection. *Ludwig, Brandenburg, Nimrod* are still street names, but in their various ways they allude to musical minds, places and pieces. Some carry private, autobiographical significance. *Thurloe* (1997) refers to the site of a restaurant frequented by Irvin during the Promenade Concerts: a place inseparable from ideas of conviviality, talk and friendship.

On a certain level Irvin's paintings are intimately connected with our time. Such paintings

as *Golden* (1997), for example, are impressed with the suggestion of experiences which could only be of the twentieth century – the flash of neon, the brashness of advertising and livery, a vapour trail inscribed in air. Fundamentally, however, the concerns they address are timeless. The track of white, threading through an arena of radiant, joyful colour, speaks of life in all its fullness – poignantly, perhaps, in defying its opposite. In that sense they are a celebration of being and the freedom of imagination.

'Can I make a painting about human experience,' Irvin once asked, 'without having to depict appearances? Can I paint the human spirit rather than noses and feet? Can I reveal the splendours and agonies of life through space, colour, light, shape, line, confrontation, rhythm and inflections in the paint?'[25] During the course of his career, these questions have marked the way. They are still his imperative. And in the paintings he is making now, his responses to these preoccupations have found a new, poetic synthesis. *Speranza* (1998) is one of the most recent and, as the title reveals, its tenor speaks of hope and confidence. The first mark on a painting, the improvised phrase, the step that continues the journey – all look to the future and proceed in a spirit of wonder and discovery.

## Notes

1  Quoted in *The New American Painting*, exh. cat., Tate Gallery, London, February–March 1959, p.48

2  Unless otherwise indicated, all statements by the artist are from discussions with the author, September–December 1997

3  Webern, *The Path to the New Music*, English edition, Theodore Presser Co. Pennsylvania, 1963, p.48

4  Quoted in *The New American Painting*, op.cit., p.14

5  Nearly forty years later he was invited by a later president, Roger de Grey, to show a painting in – what Irvin considered to be – a much changed Royal Academy. He accepted and showed *Longstone*, which was dedicated to the memory of his friend Brian Fielding

6  *The New American Painting*, exh.cat. Tate Gallery, London, February–March 1959, p.23

7  ibid p.24

8  Published in *Art News*, New York, LI, December 1952, pp.22–3

9  *The Scotsman*, 20 September 1960, p.8

10  Interview with Mike von Joel in *Art Line*, Vol.3, No.1, 1986, p.13

11  Quoted in *The New American Painting*, op.cit., p.80

12  *Contemporary British Painting*, exhibition broadsheet, The Wilmington Society of the Fine Arts, January–February 1969, p.2

13  Interview with Peter Hill in *Albert Irvin*, exh. cat., Butler Gallery, Kilkenny Castle, Dublin, August–September 1995, p.8

14  Quoted in article by Michael Owen in *The New Standard*, 30 January 1981

15  Quoted in Wassily Kandinsky, *Concerning the Spiritual in Art*, 1914, republished by Dover Publications, New York, 1977, p.27

16  Balzac, *Gillette or The Unknown Masterpiece*, trans. Anthony Rudolf, The Menard Press, London, 1988, p.21

17  Ian Jeffrey, *Art Monthly*, May 1980

18  *Hayward Annual 1980 Contemporary Painting and Sculpture selected by John Hoyland*, exh. cat., Hayward Gallery, London, August–September 1980, p.5

19  Quoted in *Shostakovich 1906–1975*, The London Symphony Orchestra, London, 1998, p.9

20  Eric Varley, *The Guardian*, 9 December 1980

21  The exhibition comprised a work by fifty-two artists including: Andre Baselitz, Beuys, Chia, Clemente, Cragg, Gilbert & George, Kapoor, Kiefer, Long, Paladino, Penck, Polke, Schnabel, Scully, Shapiro, Serra, Woodrow and Weiner

22  Arthur Schopenhauer, *The World as Will and Representation*, Vol.II, trans. E. F. J. Payne, New York and London, 1966, p.406

23  Kandinsky, op.cit., p.19

24  Webern, op.cit.

25  Quoted in *Freeing the Spirit: Contemporary Scottish Abstraction*, exh. cat., The Crawford Centre for the Arts, St Andrews, September–October 1988, p.4

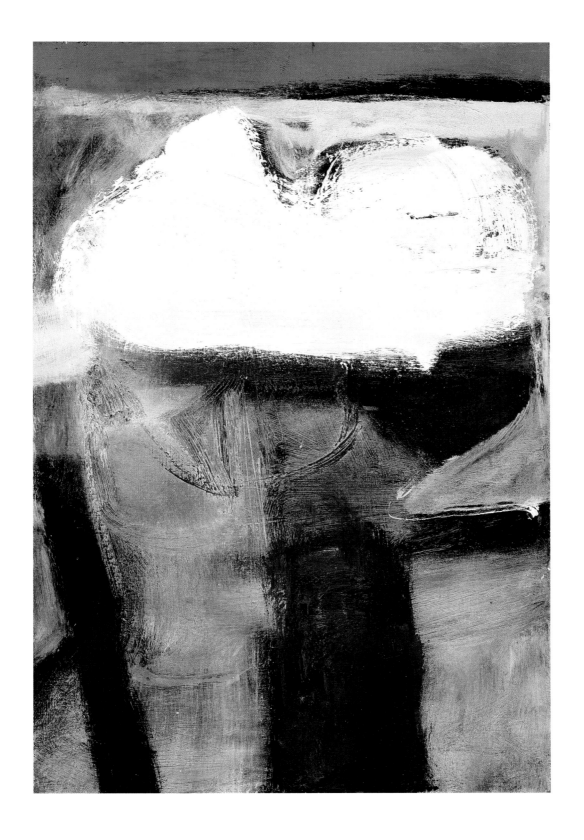

**Open Sky**
1962
oil on canvas
76 x 51 cm
(30 x 20 in)

**Around the Square**
1963
oil on paper
56 x 38 cm
(22 x 15 in)

**Place**
1964
oil on canvas
203 x 153 cm
(80 x 60 in)

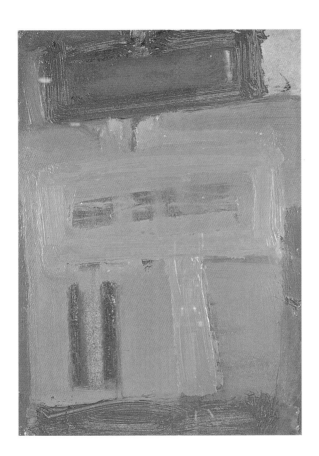

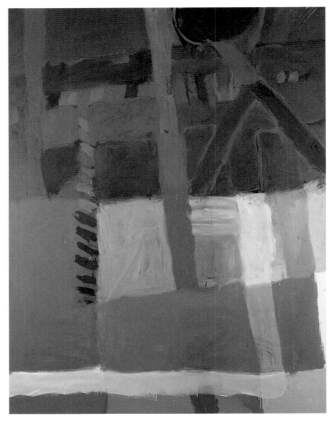

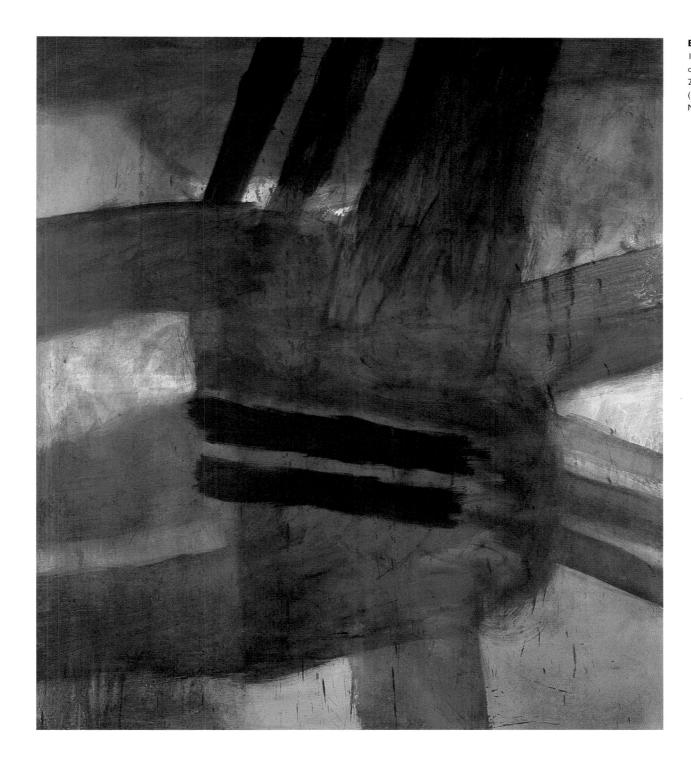

**Blue Junction**
1965
oil on canvas
203 x 178 cm
(80 x 70 in)
Mr and Mrs Jack Butler

**Nostos**
1965
oil on canvas
203 x 153 cm
(80 x 60 in)

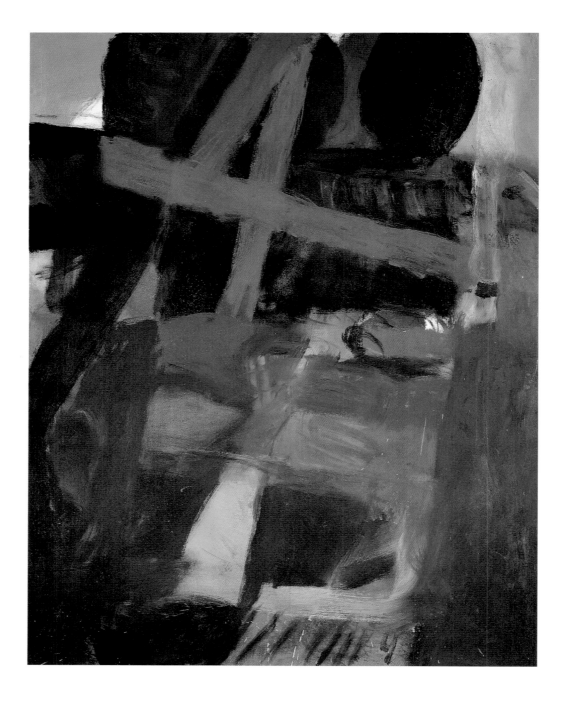

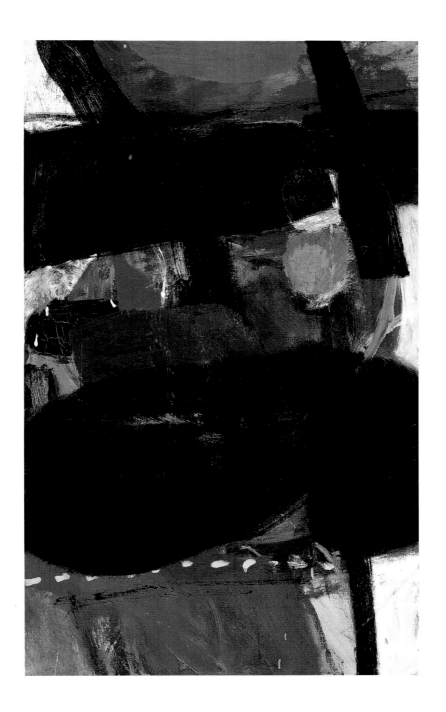

**Black Moves**
1964
oil on canvas
127 x 76 cm
(50 x 30 in)

**Rider**
1969
oil on canvas
203 x 178 cm
(80 x 70 in)
Blackburn Art Gallery

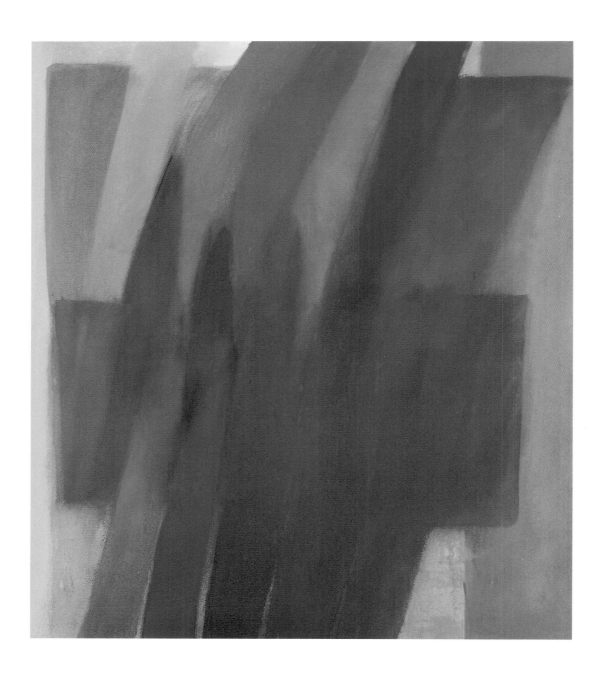

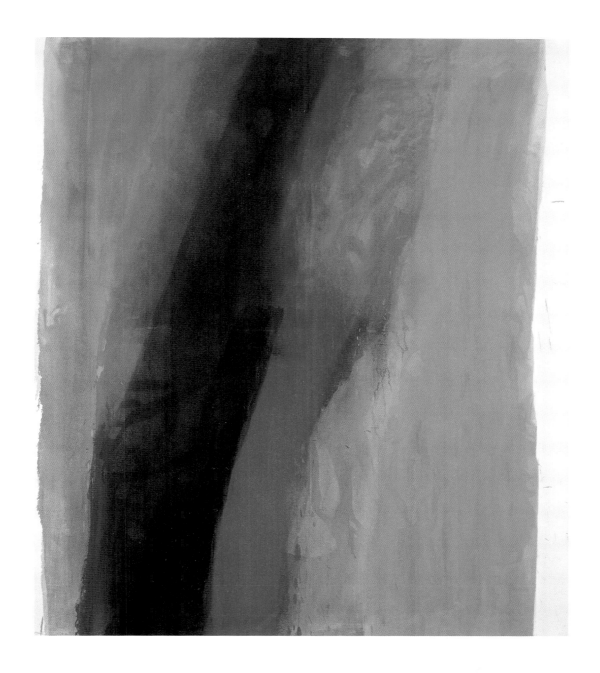

**Saint K**
1970
oil on canvas
203 x 178 cm
(80 x 70 in)
Chase Manhattan Bank

**Hannibal**
1975
acrylic on canvas
244 x 427 cm
(96 x 168 in)

**Varden**
1976
acrylic on canvas
213 x 305 cm
(84 x 120 in)

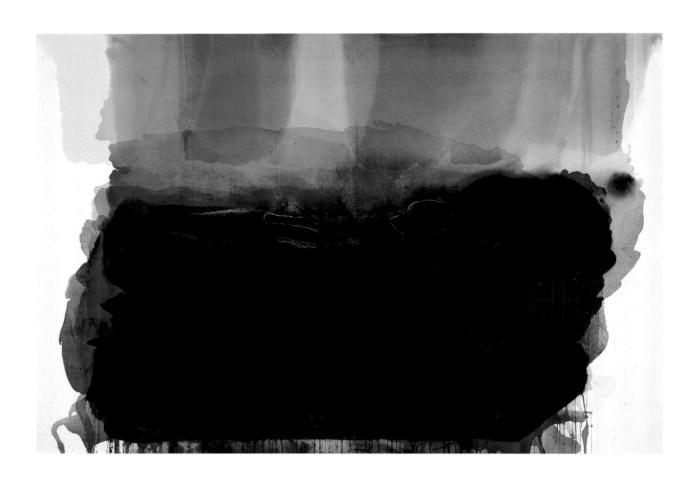

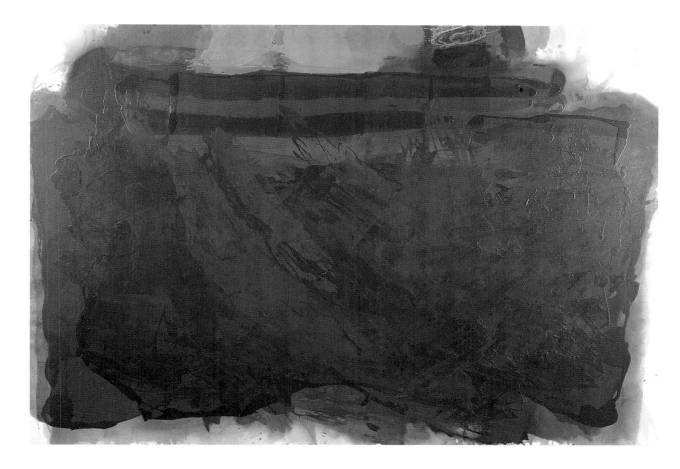

**Cephas**
1976
acrylic on canvas
213 x 305 cm
(84 x 120 in)

**Rampart**
1976
acrylic on canvas
213 x 305 cm
(84 x 120 in)

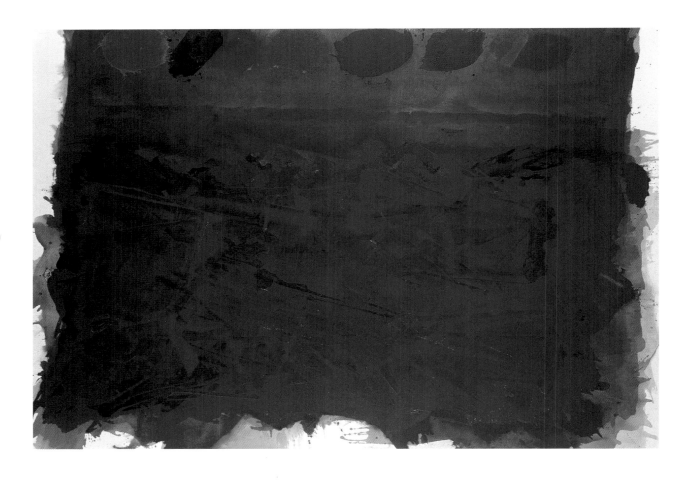

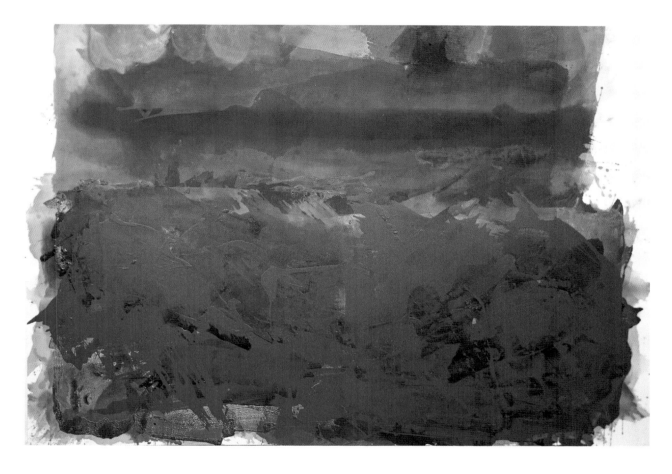

**Senrab**
1975
acrylic on canvas
213 x 305 cm
(84 x 120 in)

**Flodden**
1978
acrylic on canvas
213 x 305 cm
(84 x 120 in)
Tate Gallery, London

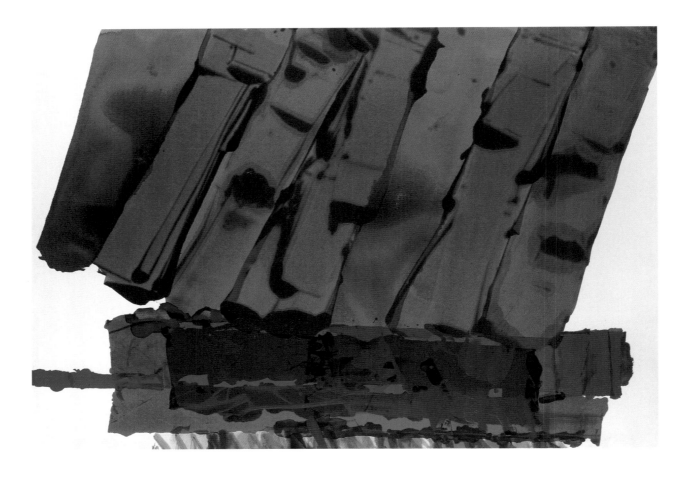

**Nelson**
1979
acrylic on canvas
213 x 305 cm
(84 x 120 in)
Mr and Mrs Jack Butler

**Vincent**
1979
acrylic on canvas
213 x 305 cm
(84 x 120 in)

**Prospect**
1979
acrylic on canvas
213 x 305 cm
(84 x 120 in)
Chandler Coventry,
Sydney

**Boadicea**
1979
acrylic on canvas
244 x 366 cm
(96 x 144 in)
Peter Borthwick, Sydney

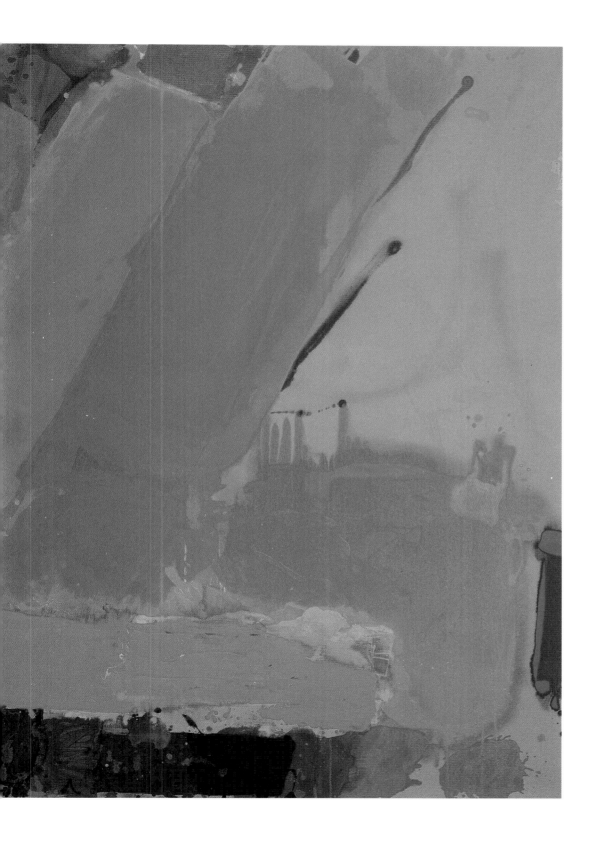

**Severus**
1980
acrylic on canvas
213 x 305 cm
(84 x 120 in)
Mobil, London

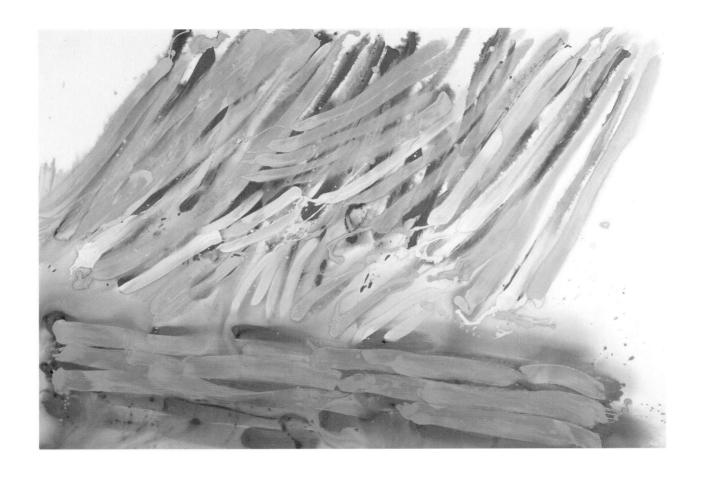

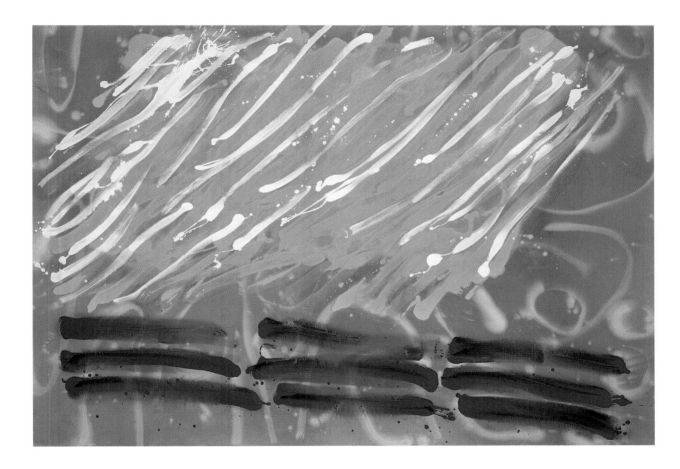

**Plimsoll**
1979
acrylic on canvas
213 x 305 cm
(84 x 120 in)

**Tasman**
1979
acrylic on canvas
213 x 305 cm
(84 x 120 in)
Pensacola Museum,
Florida

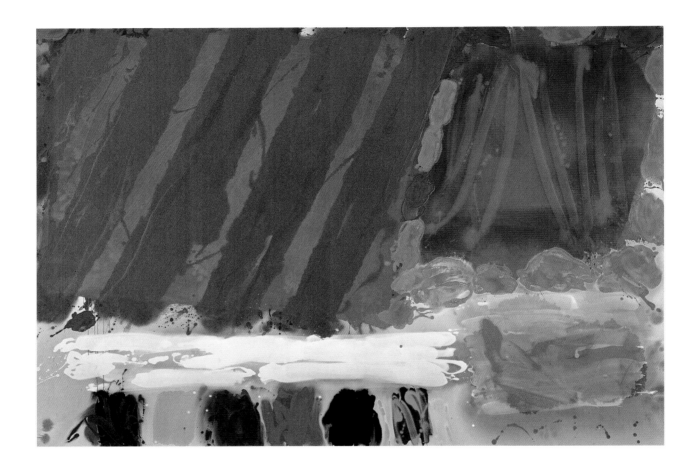

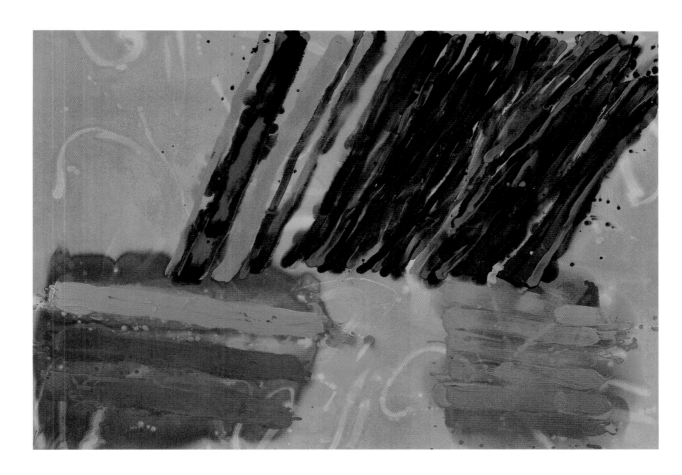

**Pilgrimage**
1980
acrylic on canvas
213 x 305 cm
(84 x 120 in)

**Paradise**
1979
acrylic on canvas
213 x 305 cm
(84 x 120 in)

**Orlando**
1980
acrylic on canvas
213 x 305 cm
(84 x 120 in)
Jacqueline Geddes,
London

**Salamanca**
1981
acrylic on canvas
213 x 305 cm
(84 x 120 in)
Private collection

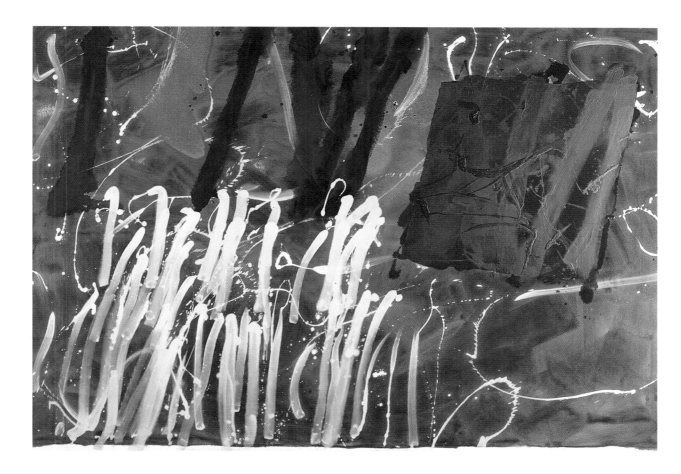

**Mile End**
1980
acrylic on canvas
213 x 305 cm
(84 x 120 in)
Huddersfield Art Gallery

**Admiral**
1981
acrylic on canvas
213 x 305 cm
(84 x 120 in)
Arts Council Collection

**Sul Ross**
1981
acrylic on canvas
213 x 305 cm
(84 x 120 in)
John Cigarini

**Sultan**
1982
acrylic on canvas
213 x 305 cm
(84 x 120 in)

**Rivoli**
1981
acrylic on canvas
213 x 305 cm
(84 x 120 in)
Oliver and Nyda Prenn

**Festival**
1983
acrylic on canvas
213 x 305 cm
(84 x 120 in)
Angela Flowers

**Calabria**
1984
acrylic on canvas
213 x 305 cm
(84 x 120 in)
Max Weitzenhoffer,
New York

**Linden**
1983
acrylic on canvas
213 x 305 cm
(84 x 120 in)
Tim Dawson, London

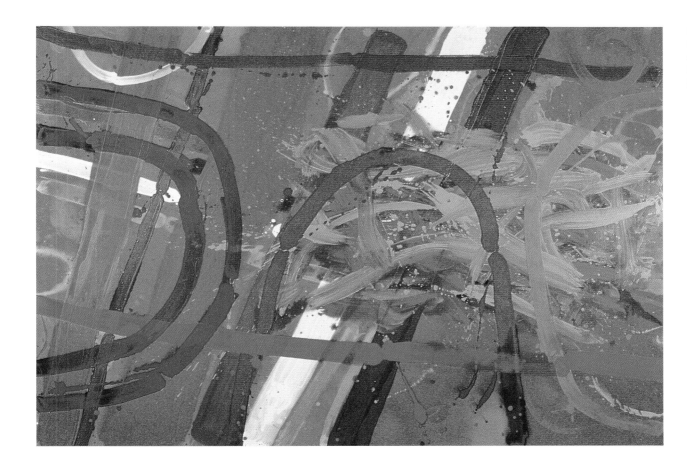

**Cammeray**
1985
acrylic on canvas
213 x 305 cm
(84 x 120 in)

**Sauchiehall**
1985
acrylic on canvas
213 x 305 cm
(84 x 120 in)
Private collection

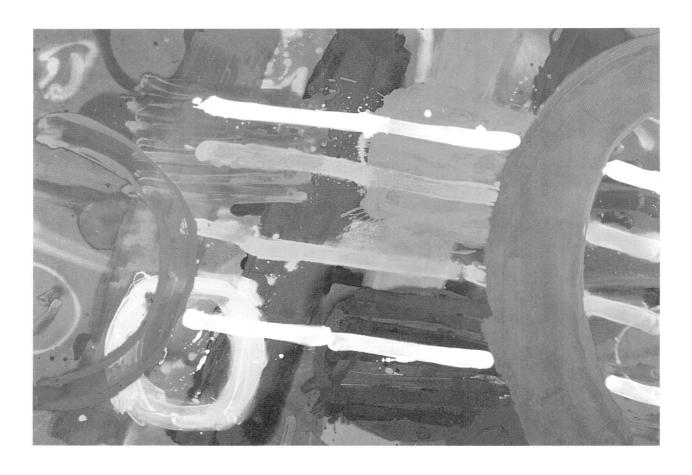

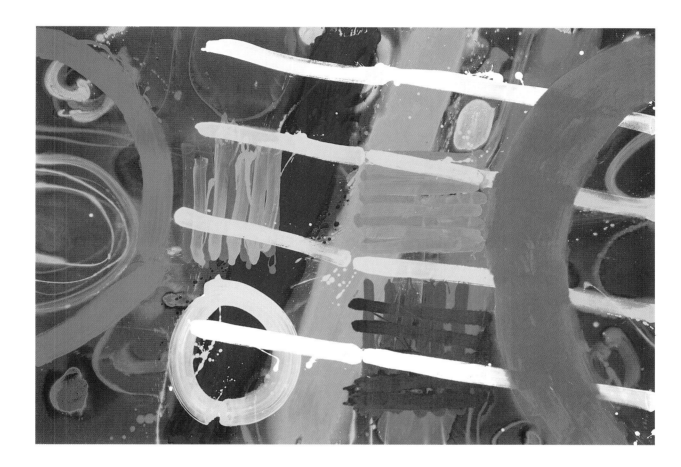

**Buchanan**
1987
acrylic on canvas
213 x 305 cm
(84 x 120 in)
Dr Barry Ramer,
California

**Roxburgh**
1989
acrylic on canvas
305 x 305 cm
(120 x 120 in)

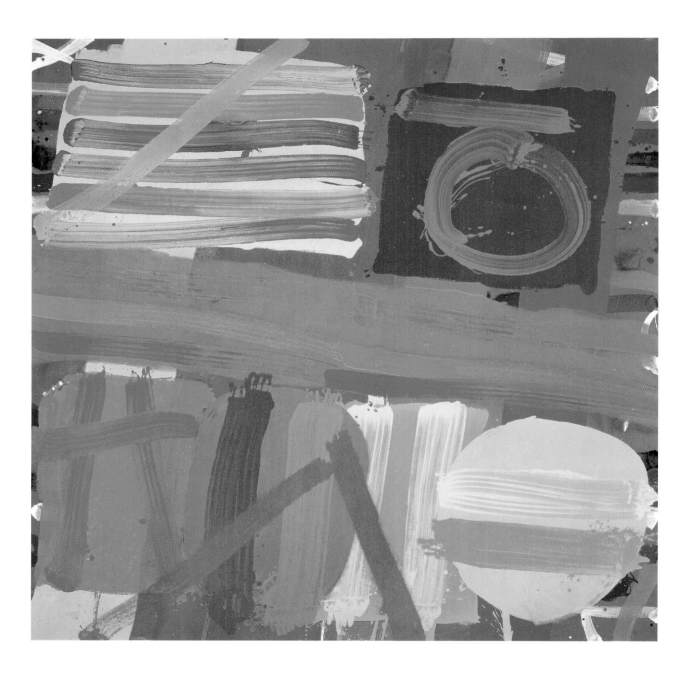

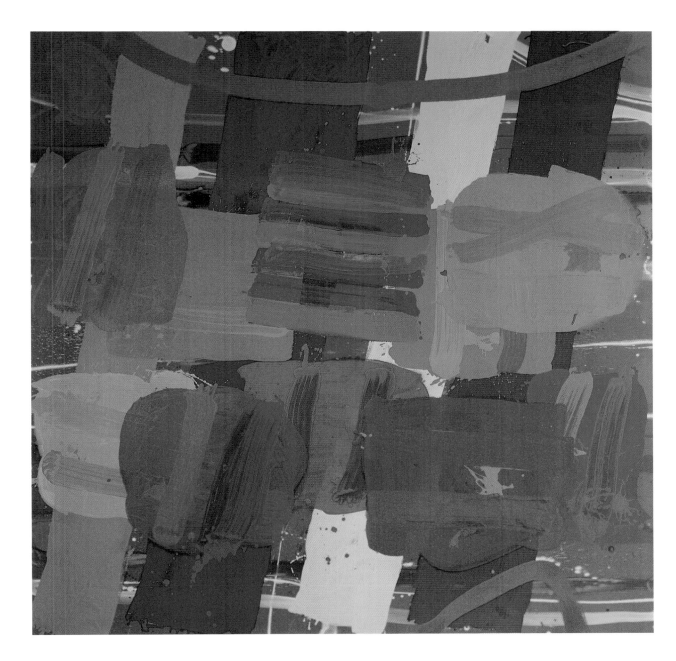

**Northcote**
1989
acrylic on canvas
305 × 305 cm
(120 × 120 in)

**Easter**
1984
acrylic on canvas
213 x 305 cm
(84 x 120 in)
Mr and Mrs Sargent

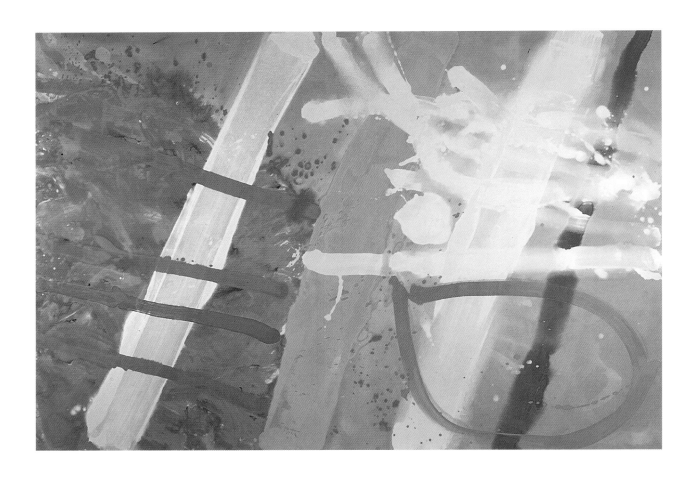

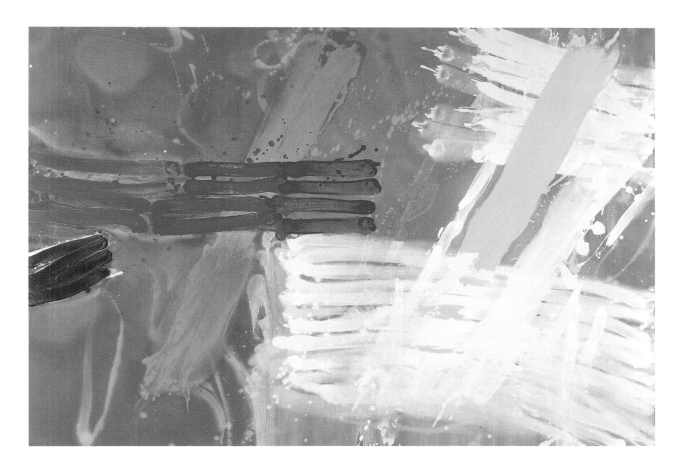

**Beatrice**
1982
acrylic on canvas
213 x 305 cm
(84 x 120 in)
Private collection

**Yupon**
1983
acrylic on canvas
213 x 305 cm
(84 x 120 in)
Art Gallery of New
South Wales, Sydney

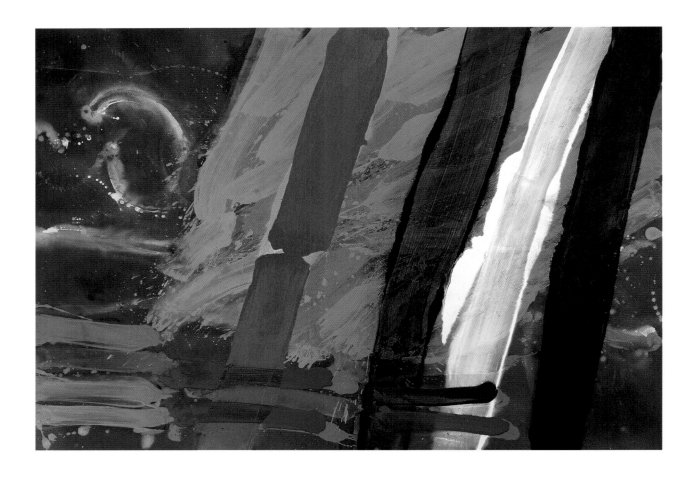

**Blue Anchor**
1989
acrylic on canvas
213 x 305 cm
(84 x 120 in)

**Waring**
1991
acrylic on canvas
213 x 305 cm
(84 x 120 in)

**Skipper**
1991
acrylic on canvas
213 x 305 cm
(84 x 120 in)

**Saint Germain**
1995
acrylic on canvas
213 x 305 cm
(84 x 120 in)
Tate Gallery, London

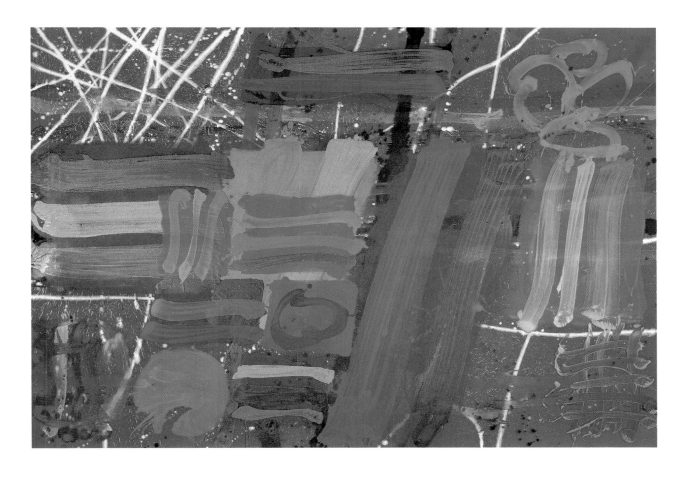

**San Giorgio**
1995
acrylic on canvas
213 x 305 cm
(84 x 120 in)
NatWest Group Art
Collection

**Roscoe**
1991
acrylic on canvas
213 x 305 cm
(84 x 120 in)
Emo Capodilista

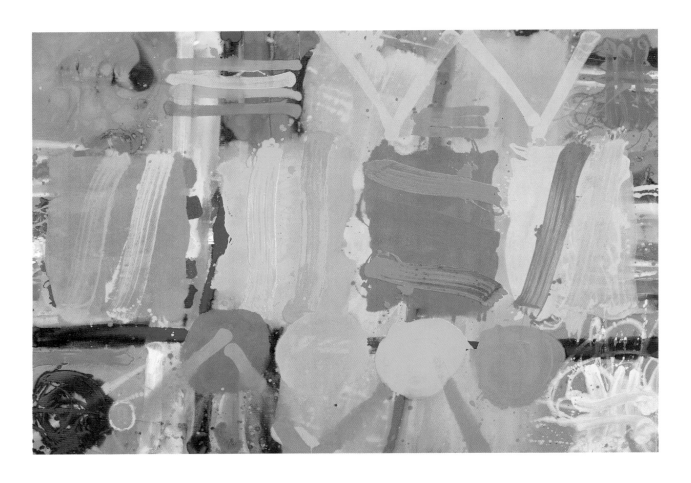

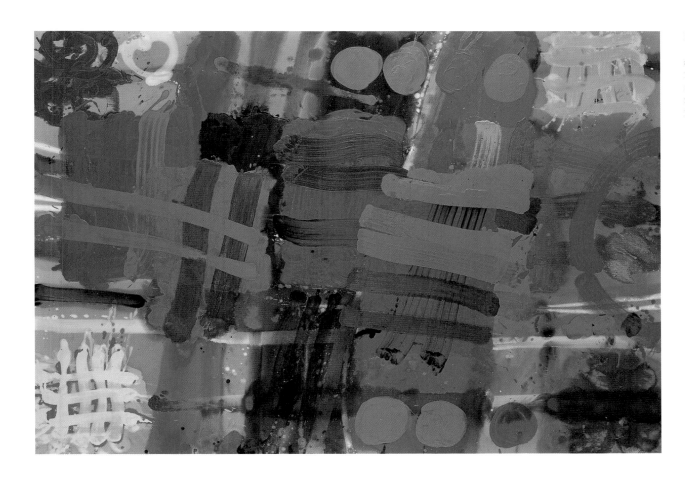

**Ludwig**
1992
acrylic on canvas
213 x 305 cm
(84 x 120 in)
Schindler Collection,
Zurich

**San Rocco**
1994
acrylic on canvas
183 x 153 cm
(72 x 60 in)
Michael Aukett

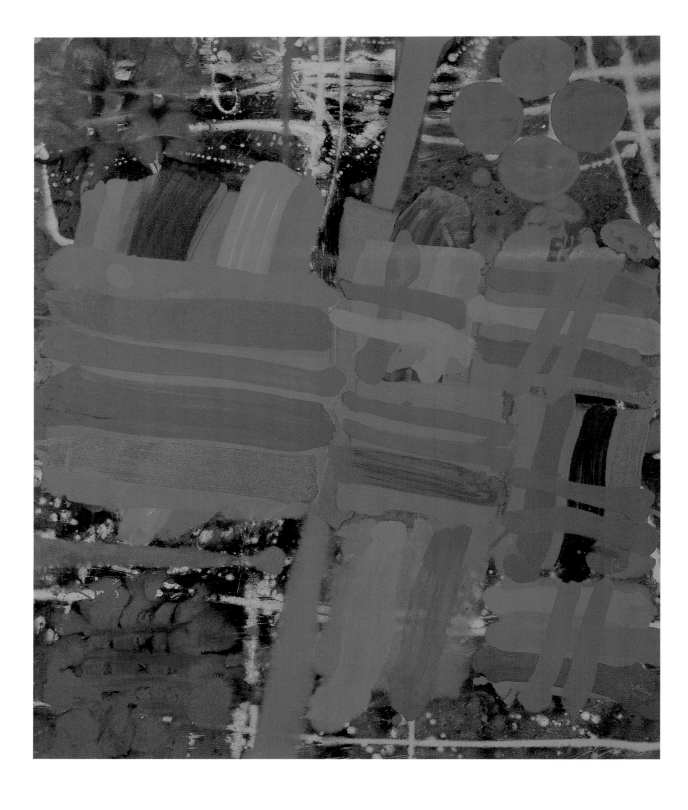

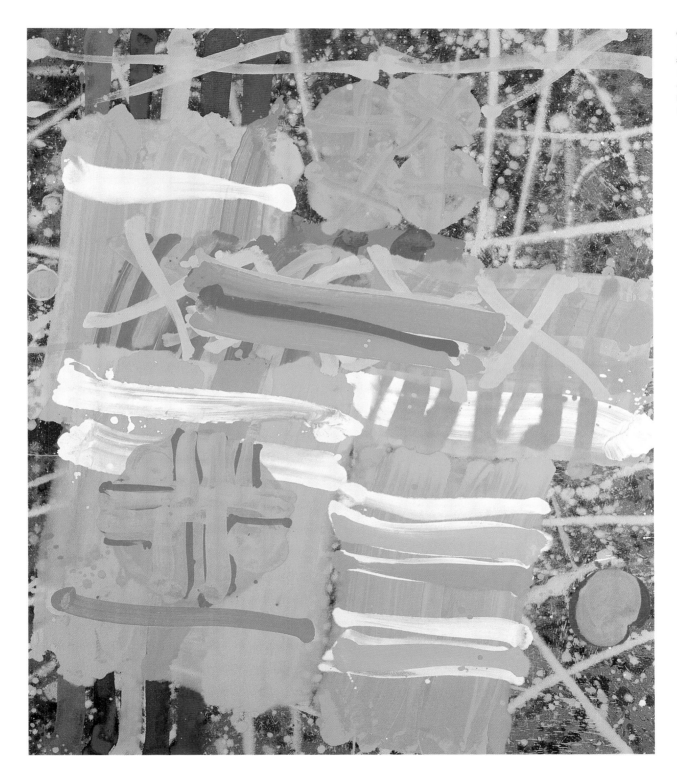

**Golden**
1997
acrylic on canvas
183 x 153 cm
(72 x 60 in)
Private collection,
London

**Beaufort**
1994
acrylic on canvas
213 x 305 cm
(84 x 120 in)

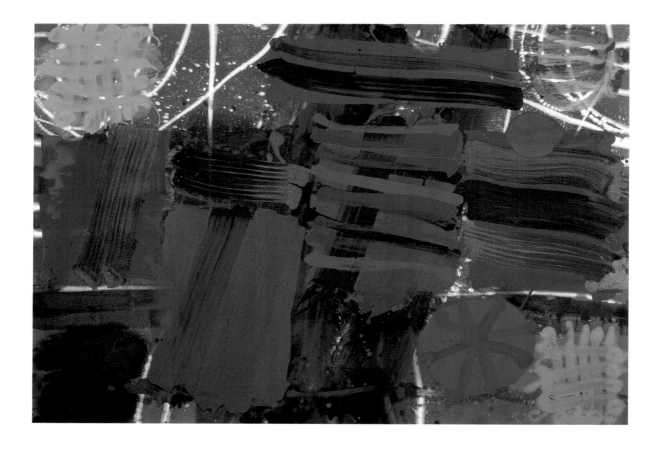

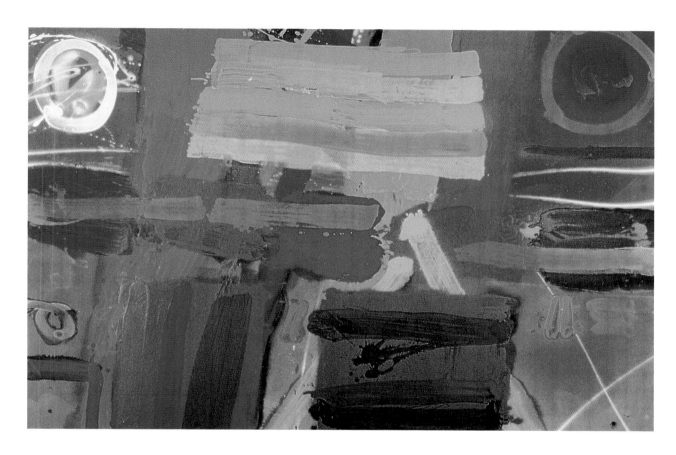

**Madison**
1988
acrylic on canvas
213 x 305 cm
(84 x 120 in)

**Hackford series
no.8**
1990
Gouache
66 x 86 cm
(26 x 34 in)

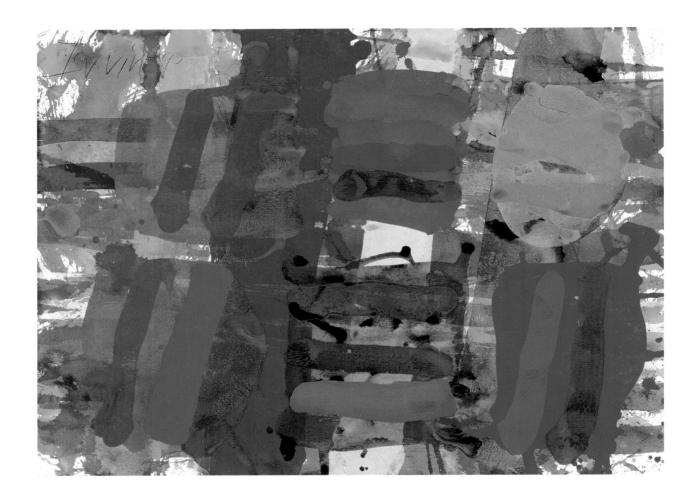

**Hackford series
no.4**
1990
Gouache
66 x 86 cm
(26 x 34 in)
Simone Betambeau

**San Marco**
1994
acrylic on canvas
183 x 153 cm
(72 x 60 in)
Sir Charles Chadwyck-
Healey

**Cavendish**
1993
acrylic on canvas
183 x 153 cm
(72 x 60 in)

**Cleveland**
1992
acrylic on canvas
183 x 153 cm
(72 x 60 in)
Wolfgang Wassermann,
Munich

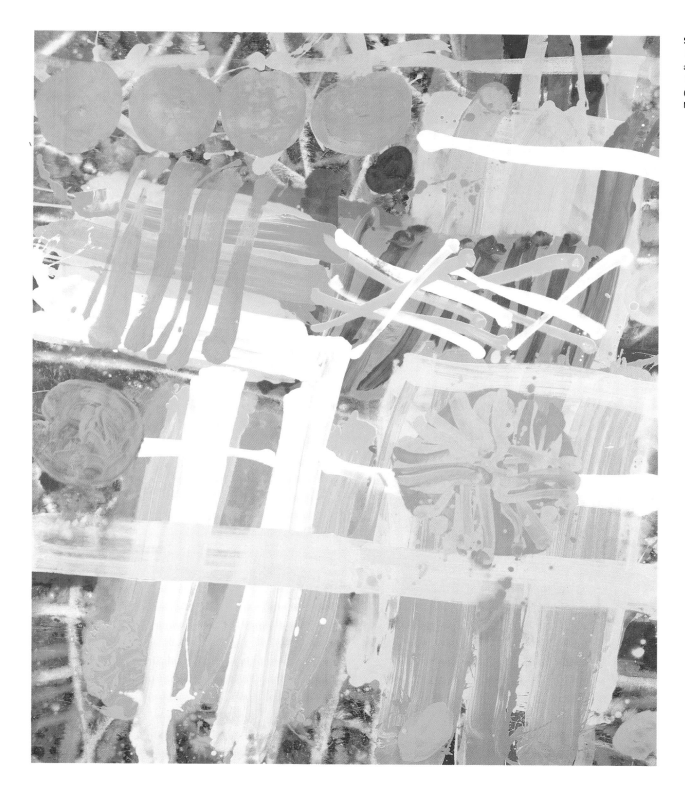

**Strand**
1997
acrylic on canvas
183 x 153 cm
(72 x 60 in)
Manfred Braun, Munich

**Hollywood**
1995
acrylic on canvas
138 x 686 cm
(54 x 270 in)
Chelsea and
Westminster Hospital,
London

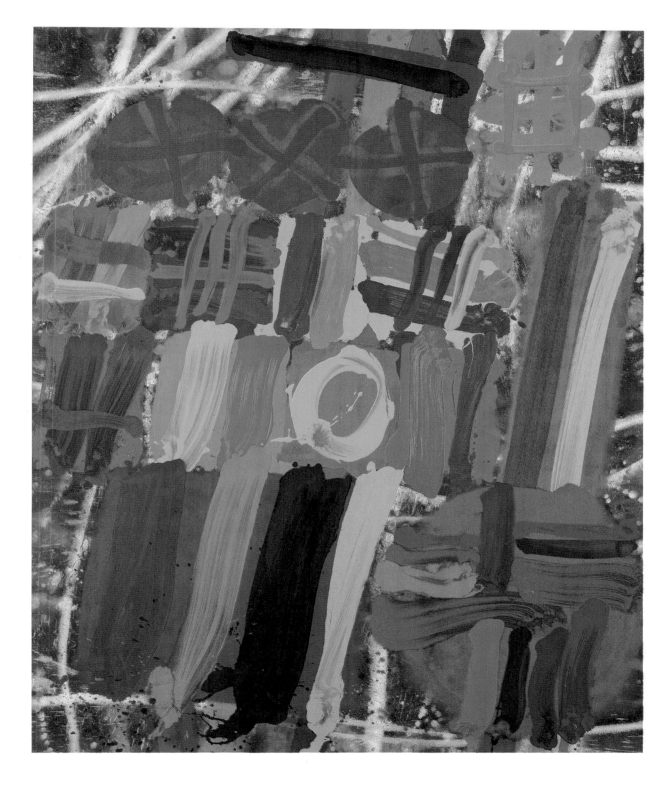

**Palace**
1997
acrylic on canvas
183 x 153 cm
(72 x 60 in)

**Nimrod**
1997
acrylic on canvas
100 x 180 cm
(40 x 71 in)
Private collection,
Munich

**Lupus**
1997
acrylic on canvas
84 x 122 cm
(33 x 48 in)

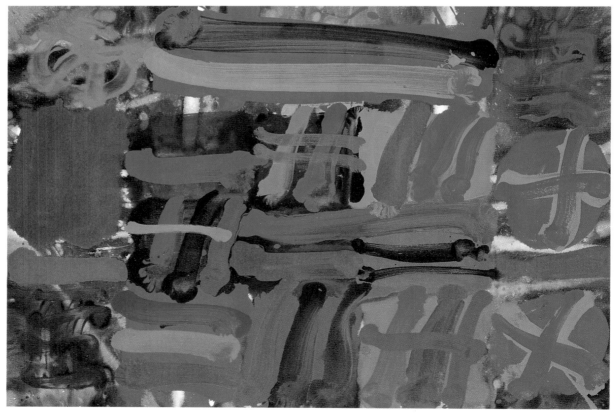

**Soho**
1994
acrylic on canvas
213 x 305 cm
(84 x 120 in)
Irish Museum of
Modern Art, Dublin

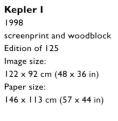

**Kepler I**
1998
screenprint and woodblock
Edition of 125
Image size:
122 x 92 cm (48 x 36 in)
Paper size:
146 x 113 cm (57 x 44 in)

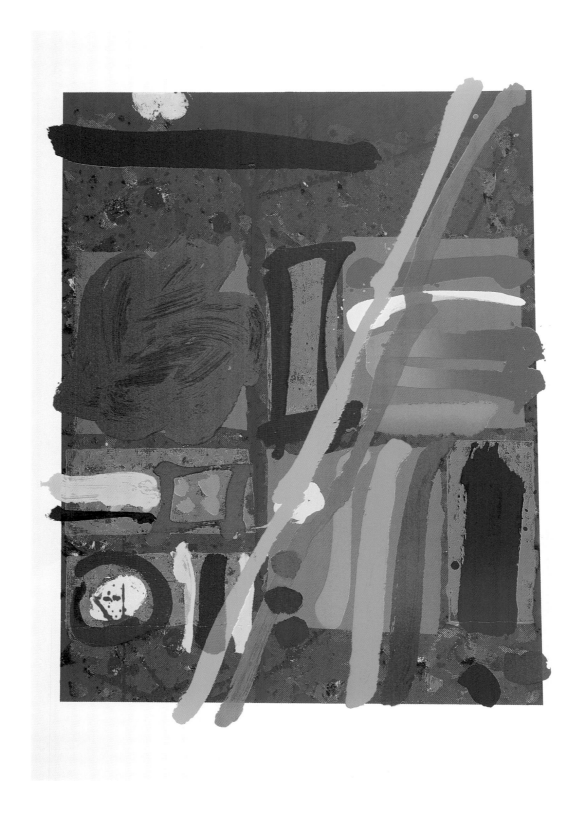

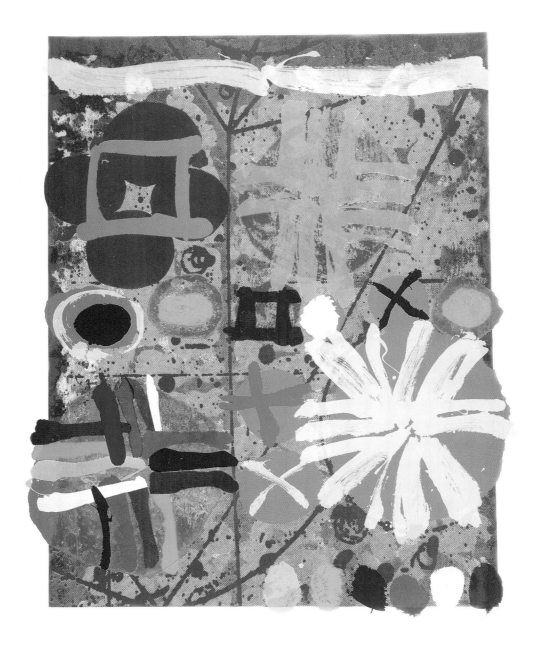

**Kepler II**
1998
screenprint and woodblock
Edition of 125
Image size:
122 x 92 cm (48 x 36 in)
Paper size:
146 x 113 cm (57 x 44 in)

**Palazzo**
1996
acrylic on canvas
183 x 153 cm
(72 x 60 in)
Arthur Andersen

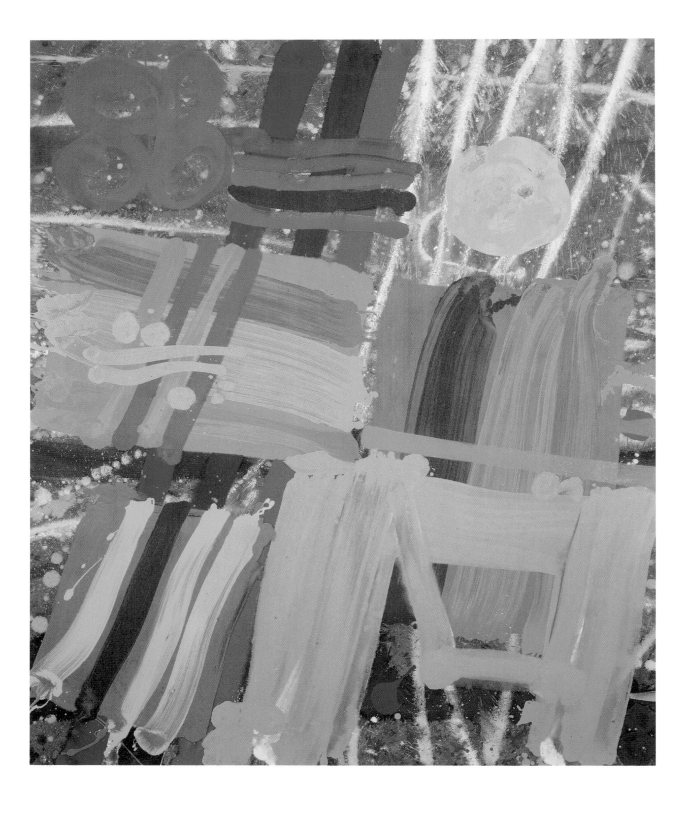

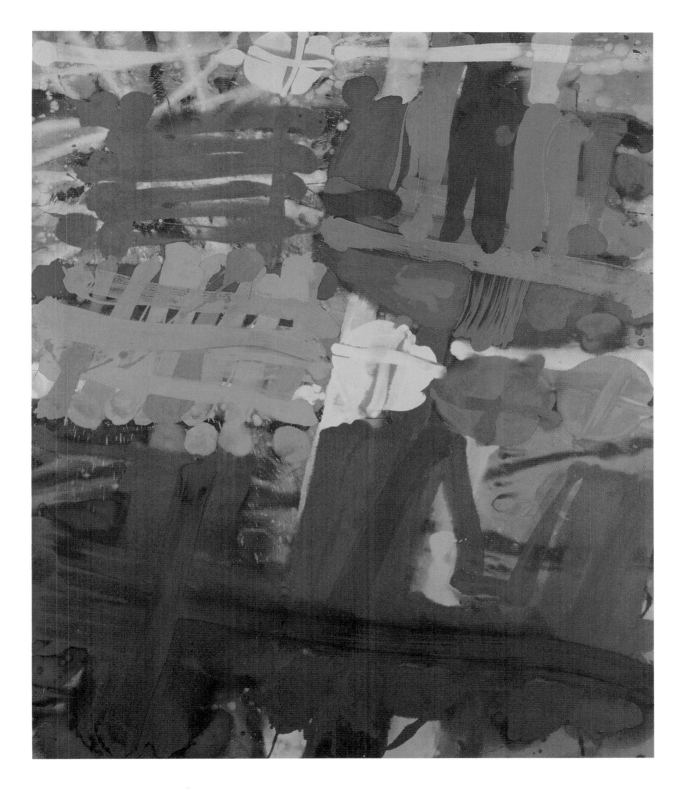

**Savoy**
1996
acrylic on canvas
183 × 153 cm
(72 × 60 in)
Christoph Wald

# Biography

| | |
|---|---|
| 1922 | Born London |
| 1940-1 | Northampton School of Art |
| 1941-6 | Royal Air Force |
| 1946-50 | Goldsmiths College School of Art University of London |
| 1962-83 | Teaching at Goldsmiths College School of Art |
| 1965 | Elected member of London Group |
| 1968 | Arts Council Award to visit USA |
| 1975 | Arts Council Major Award |
| 1983 | BBC2 television film 'A Feeling for Paint: Four Artists and their Materials', directed by Anne James Gulbenkian Award for Printmaking |
| 1990 | BBC Radio 3, 'Third Ear' interview with Joan Bakewell |
| 1993 | Design for Diversions Dance Company |
| 1994 | BBC2 television 'Off the Wall: The Byker Show' |
| 1998 | First performance of 'Holyrood' a composition by Barry Guy, based on a work by Irvin. |

## Solo exhibitions

| | |
|---|---|
| 1960 | 57 Gallery, Edinburgh |
| **1961 and 1963** | |
| | New Art Centre, London |
| 1964 | Edinburgh University |
| 1967 | Richard Demarco Gallery, Edinburgh |
| 1969 | Exe Gallery, Exeter |
| 1971 | New Art Centre, London |
| 1972 | Galerie Folker Skulima, Berlin, and regularly during the 1970s Galerie Klaus Lüpke, Frankfurt |
| 1973 | New Art Centre, London |
| 1974 | Städtische Kunstsammlungen, Ludwigshafen Galerie 2, Stuttgart |
| 1975 | Deutsche Oper, Berlin |
| 1976 | New 57 Gallery, Edinburgh Aberdeen Art Gallery Galerie Klaus Lüpke, Frankfurt |
| 1978 | Newcastle Polytechnic Gallery |
| 1980 | Acme Gallery, London Bede Gallery, Jarrow |
| 1981 | Manchester Polytechnic Gallery |
| 1982 | Gimpel Fils, London Goldsmiths College Gallery, London |
| 1983 | Third Eye Centre Gallery, Glasgow |

| | |
|---|---|
| | Aberdeen Art Gallery Ikon Gallery, Birmingham |
| 1984 | *Gimpel Fils at Advanced Graphics*, London *Demarcation*, Edinburgh Festival Jersey Arts Council Gallery |
| 1985 | Coventry Gallery, Sydney Butler Gallery, Kilkenny Castle, Kilkenny Arcade Gallery, Harrogate |
| 1986 | Gimpel Fils, London Hendriks Gallery, Dublin |
| 1987 | Carine Campo Gallery, Antwerp |
| 1988 | Gimpel & Weitzenhoffer Gallery, New York |
| 1989 | Talbot Rice Gallery, Edinburgh Carine Campo Gallery, Antwerp |
| 1990 | Serpentine Gallery, London Gimpel Fils, London Spacex Gallery, Exeter Oriel and Chapter Galleries, Cardiff Castlefield Gallery, Manchester Gallery Monochrome, Brussels |
| 1991 | Playhouse Gallery, Harlow Peter Scott Gallery, Lancaster University |
| 1992 | Galeria Punto, Valencia Chelmsford Cathedral Festival Oxford Gallery Galerie Klaus Lüpke, Frankfurt Gimpel Fils, London Wolf at the Door, Penzance |
| 1993 | Campo Vlaamse Kaai, Antwerp Bodilly Gallery, Cambridge Flowers East, London |

Bert and Betty on the steps of the Glasgow School of Art, 1983

| 1994 | Powell Moya Partnership, London |
| | Gimpel Fils, London |
| | Wassermann Galerie, Munich |
| | Chapter Gallery, Cardiff |
| | Woodlands Art Gallery, London |
| 1995 | Royal Hibernian Academy, Gallagher Gallery, Dublin |

**1996 and 1997**
Gimpel Fils, London

| 1997 | Cambridge Contemporary Art, Cambridge |
| | Galerie Stühler, Berlin |
| | Wassermann Galerie, Munich |
| 1998 | Dean Clough, Halifax |
| | Centre d'Art Contemporain, Meymac |
| | Edwin Scharff Haus, Neu Ulm |
| | Vonderau Museum, Fulda |
| | Galerie Markt, Bruckmühl |

## Selected group exhibitions

**1949 and 1950**
*Young Contemporaries*, RBA Gallery, London

| 1950 | Royal Academy, London |
| 1951 | *London Group* and regularly since |
| 1953 | *Football Association Centenary Exhibition*, Park Lane Gallery, London |
| 1954 | *Young Artists Chosen by Collectors*, Parsons Gallery, London |
| 1955 | *6 Young Artists*, Gallery One, London |
| 1956 | *Daily Express Young Artists Exhibition*, New Burlington Gallery, London |
| 1960 | *3 British Painters*, Galerie im Griechenbeisl, Vienna |
| 1961 | *2 British Painters*, Galerie Wulfengasse, Klagenfurt |
| | *John Moores Liverpool Exhibition*, and in 1980, 1982 (prizewinner), 1987, 1989, 1991 and 1995 |

**1963 and 1964**
*Spring Exhibition*, Bradford City Art Gallery

| 1964 | *British Painting 1961–64*, Arts Council Touring Exhibition |
| 1966 | *Open Painting Exhibition*, Arts Council of Northern Ireland, Belfast and Dublin |
| 1967 | *Edinburgh Open 100*, University of Edinburgh |
| 1971 | *SPACE in Belfast and Dublin*, Arts Council Gallery, Belfast; Municipal Gallery of Modern Art, Dublin |
| | *London Now in Berlin*, Messehalle, Berlin |
| 1972 | *Spring in the A.I.R.* Scottish Arts Council Gallery in Glasgow and Edinburgh |
| 1974 | *British Painting '74*, Hayward Gallery, London |
| 1975 | *From Britain '75*, Helsinki, Jyväskylä and Tampere |
| | *Whitechapel Open*, Whitechapel Art Gallery, London and regularly since |

| 1977 | *British Painting 1952–77*, Royal Academy, London |
| 1979-80 | *The British Art Show*, Mappin Art Gallery, Sheffield; Laing Art Gallery, Newcastle upon Tyne; Royal West of England Academy, Bristol |
| 1980 | *Hayward Annual: Contemporary British Painting and Sculpture*, Hayward Gallery, London |

**1981 and 1983**
*Tolly Cobbold Eastern Arts National Exhibition*

| 1982 | *Hayward Annual: British Drawing*, Hayward Gallery, London |
| 1983 | *Contemporary British Painters*, Museo Municipal de Madrid |
| 1984 | *ROSC '84*, Dublin |
| | *New Works on Paper*, British Council Tour |
| 1985 | *Home and Abroad*, Serpentine Gallery, London |
| 1986 | *Bradford Print Biennale* (prizewinner) and in 1990 |
| 1987 | Royal Academy and regularly since |
| 1988 | *3 British Painters: Beattie, Hoyland, Irvin*, Northern Centre for Contemporary Art, Sunderland |
| | *European Biennale of Graphic Art*, Baden-Baden |
| | *Freeing the Spirit*, Crawford Centre for the Arts, St Andrews and Gracefield Arts Centre, Dumfries |
| 1988-9 | *Presence of Painting*, Mappin Art Gallery, Sheffield; Hatton Gallery, Newcastle upon Tyne; Ikon Gallery, Birmingham |
| 1989 | *International Print Biennale*, Ljubljana |
| | *The Experience of Painting*, Laing Art Gallery, Newcastle upon Tyne; Mappin Art Gallery, Sheffield; City Museum and Art Gallery, Stoke-on-Trent |
| 1990 | *Great British Art Show*, McLellan Galleries, Glasgow |
| 1991 | *Bradford Print Biennale*, Royal College of Art, London |
| | Gimpel Fils – Bath Festival (with Alan Davie) |
| | *Downeen Collection*, Co. Cork |
| | *European Large Format Printmaking*, Guinness Hop Store, Dublin |
| | Goldsmiths Centenary Exhibition: Basil Beattie, John Bellany, Albert Irvin, Harry Thubron, Goldsmiths College Gallery, London |
| | *Peter Stuyvesant Collection,* Stedelijk Museum, Amsterdam |

(from left to right)
Irvin, Henry Mundy,
William Mills,
Harry Thubron,
John Bellany at a
private view
Early 1980s

**1991-3** Courtauld Institute Loan Collection, Courtauld Institute, London

**1993** *Hoyland and Irvin*, CCA Gallery, London
Egyptian International Print Triennale
The Byker Art Show, Newcastle upon Tyne

**1994** *Here and Now*, Serpentine Gallery, London
*Painters and Prints I, Beattie, Frost Hoyland, Irvin*, Curwen Gallery, London
Castlefield 10th Anniversary, Castlefield Gallery and Whitworth Art Gallery, Manchester
*British Abstract Art Part I: Painting*, Flowers East, London
*Critic's Choice* by Clare Henry, NS Gallery, Glasgow
*Twelve Contemporary British Printmakers*, Karelian Republic Art Museum, Russia

**1995** *Cabinet Art*, Jason and Rhodes, London
*10 Years in Galerie im Griechenbeisl*, Vienna
*British Abstract Painting*, Atkinson Gallery, Millfield School, Somerset

**1996** *British Abstract Art Part III: Works on Paper*, Flowers East, London

**1997** *The Subjects of Art*, NatWest Group Art Collection
*Advanced Graphics Celebrating 30 Years of Printmaking*, Berkeley Square, London
*Libero Blu*, Galleria Blu, Milan

**1998** *The Discerning Eye*, Mall Galleries, London
*25 Years of the Visual Arts*, Butler Gallery, Kilkenny

# Public collections

Aberdeen Art Gallery
Art Gallery of New South Wales, Sydney
Arts Council Collection
Bede Gallery, Jarrow
Birmingham City Art Gallery
Blackburn Art Gallery
British Council
Buckinghamshire Education Committee
Chase Manhattan Bank
Chelsea and Westminster Hospital
Churchill College, Cambridge
City of Cambridge Education Committee
Contemporary Art Society
Department of the Environment
Goldsmiths College, University of London
Hertfordshire Education Committee
Homerton Hospital, Hackney
Huddersfield Art Gallery
Irish Museum of Modern Art, Dublin
Jesus College, Cambridge
Kilkenny Art Gallery Society
Lancaster University
Liverpool University
Manchester City Art Gallery
Mobil Oil
NatWest Group Art Collection
Neue Galerie der Stadt Linz
New England Regional Art Gallery, New South Wales
Nuffield Foundation, London
Pensacola Museum, Florida
St John's College, Oxford
Schindler Collection, Zurich
Sheffield Galleries and Museums Collections
Southampton University
Städtische Kunstsammlungen, Ludwigshafen
Stoke City Art Gallery
Stuyvesant Collection, Amsterdam
Tate Gallery, London
Trinity College, Dublin
Unilever, London
University of Northumbria
Victoria & Albert Museum, London
Vonderau Museum, Fulda
Warwick University Arts Centre
Westinghouse Corporation
Wolverhampton Art Gallery

## Selected bibliography

**1971** Bernard Denvir, 'London Letter', *Art International*, March
Andrew Forge, 'Albert Irvin', *Studio International*, March

**1974** Fenella Crichton, 'London Letter', *Art International*, January
*Albert Irvin Werke 1968–73*, exh.cat. Städtische Kunstsammlungen, Ludwigshafen, with an introduction by Hermann Wiesler, July
*One Magazine*, personal statement, July

**1976** *Artscribe No.1*, interview with Stephen Carter, January
*Albert Irvin*, exh.cat. New 57 Gallery, Edinburgh and Aberdeen Art Gallery, with an introduction by Cordelia Oliver, May/June

**1978** *Albert Irvin*, exh.cat. Newcastle upon Tyne Polytechnic Art Gallery, with an introduction by William Packer

**1979** Malcolm Quantrill, 'Aspects of environment: the work of Albert Irvin and Michael McKinnon', *Art International*, May

**1980** *Albert Irvin Paintings 1979–80*, exh.cat. Acme Gallery, London, with an introduction by Tim Hilton, April
Ian Jeffrey, 'Albert Irvin', *Art Monthly*, May
Conversation with Jon Thompson, *Aspects No.13*, Winter

**1982** Caryn Faure Walker, introduction to exh.cat. Gimpel Fils, London and Goldsmiths College Gallery, September
Margaret Garlake, *Art Monthly*, October

**1983** *Albert Irvin '77–'83*, exh.cat. Third Eye Centre, Glasgow, Aberdeen Art Gallery and Ikon Gallery, Birmingham with an introduction by Mary Rose Beaumont and an essay by Alexander Moffat, April
Peter Hill, *Art Monthly*, June
William Packer, *Mercury*, Winter

**1984** *ROSC '84*, Dublin, exh.cat. artist's statement

**1985** Terence Maloon, *Sydney Morning Herald*, 23 March
Paul Moorhouse, *Tate Gallery Catalogue of Acquisitions 1982–84*
Interview with Peter Hill, exh.cat. Butler Gallery, Kilkenny Castle, Kilkenny, August
*Albert Irvin Paintings 1981–5*, exh.cat. Coventry Gallery, Sydney with an introduction by William Packer

**1986** *Artline*, interview with Mike von Joel, February
Michael Tooby, introduction to exh.cat. Gimpel Fils, London and Hendriks Gallery, Dublin April/September
Paul Moorhouse, *Artscribe International*, September/October

**1987** Dorothy Walker, *Alba*, Spring

**1988** *Freeing the Spirit*, exh.cat. Crawford Centre for the Arts, St Andrews and Gracefield Arts Centre, Dumfries with a preface by Albert Irvin

**1989** *The Experience of Painting*, exh.cat. Laing Art Gallery, Newcastle upon Tyne, edited interview with Mel Gooding, January/July
*Albert Irvin Paintings 1960–1969*, exh.cat. Serpentine

Gallery and Talbot Rice Gallery, London with a foreword by Andrew Forge and essays by Paul Moorhouse and Alexander Moffat

**1991** David Lillington, 'Visible energy', *Frieze*, pilot issue

**1992** Bill Hare, 'Don't stop the carnival – Albert Irvin at 70', *Contemporary Art*, vol.1, no.2, Winter

**1993** Interview, 'An exuberance of gesture', *Storming Heaven*, *Stride*, no.35

**1994** *Albert Irvin*, exh.cat. Gimpel Fils, London, with an introduction by A.S. Byatt
'Manifestos for the Brush', Albert Irvin in conversation with Marina Vaizey, Lecon Arts, London

**1995** *Albert Irvin's Paintings and Prints 1980–1995*, exh.cat. RHA Gallagher Gallery, with an essay by Paul Moorhouse, November/December

**1996** *Ely*, exh.cat. Gimpel Fils, London, with an introduction by Sacha Craddock

**1998** *Albert Irvin*, exh.cat. Centre d'Art Contemporain, Meymac with essays by Françoise-Claire Prodhon, Gaya Goldcymer-Taieb and Paul Moorhouse

A visit by Tate Gallery staff to Irvin's studio 1995
(from left to right) Jeremy Lewison, Richard Morphet, Irvin, Paul Moorhouse, Nicholas Serota (Director).
In that year, the Tate acquired a further two paintings by Irvin.

# Index of works

## Albert Irvin
**life to painting**

First published in 1998 by
Lund Humphries Publishers
Park House
1 Russell Gardens
London
NW11 9NN

British Cataloguing in Publication Data
A catalogue record for this book is available from the British Library.

ISBN 0 85331 719 4

Distributed in the USA by
Antique Collectors' Club
Market Street Industrial Park
Wappingers Falls
NY 12590
USA

Designed by Kate Stephens
Typeset by Tom Knott
Origination, printing and binding in Singapore
under the supervision of MRM Graphics

The half-title quotation is from *Bonnard*, Sascha M. Newman (ed.), Thames and Hudson, 1984, p.51

**All measurements provided as height x width**

## Photographic credits

Sue Adler  112 (all)

AKG London/Erich Lessing  64 (left)

Chelsea Arts Club, London  28 (top)

Prudence Cuming  31, 34, 37 (both), 38 (both), 46, 49

Roy Fox  179

FXP Photography  Frontispiece

Karl Hashmi  206

John Hunnex  61, 71, 76–7, 82–3, 88–9, 93, 138, 139, 142, 143, 144, 145, 147, 148, 149, 150–1, 152, 153, 154, 155, 156

Betty Irvin  74 (top), 97 (both), 108 (top), 118, 121 (top left and right), 168, 180, 205 (both)

John Jones  121 (bottom left and right)

Klaus Kindermann  111, 190

Ingeborg Lommatzsch  74 (bottom)

Alexander Moffat  203

Museum of Modern Art, New York  44

Pallant House Gallery, West Sussex  16 (bottom right)

John Riddy  6, 9, 54, 62, 115, 116-17, 124, 128–9, 133, 134 (both), 136, 137, 140-1, 170, 171, 175, 176, 177, 181, 184, 186, 187, 189, 192–3, 197, 200

Miki Slingsby  108 (bottom left and right), 198, 199

Tate Gallery, London  64 (right), 102, 146, 178

Todd White  98, 104, 157, 158, 159, 160, 161, 162, 163, 164, 165, 166, 167, 169, 172, 173, 174, 182, 183, 185, 188, 191, 194, 195, 196 (both), 201, 202